WORLD OF CULTURE

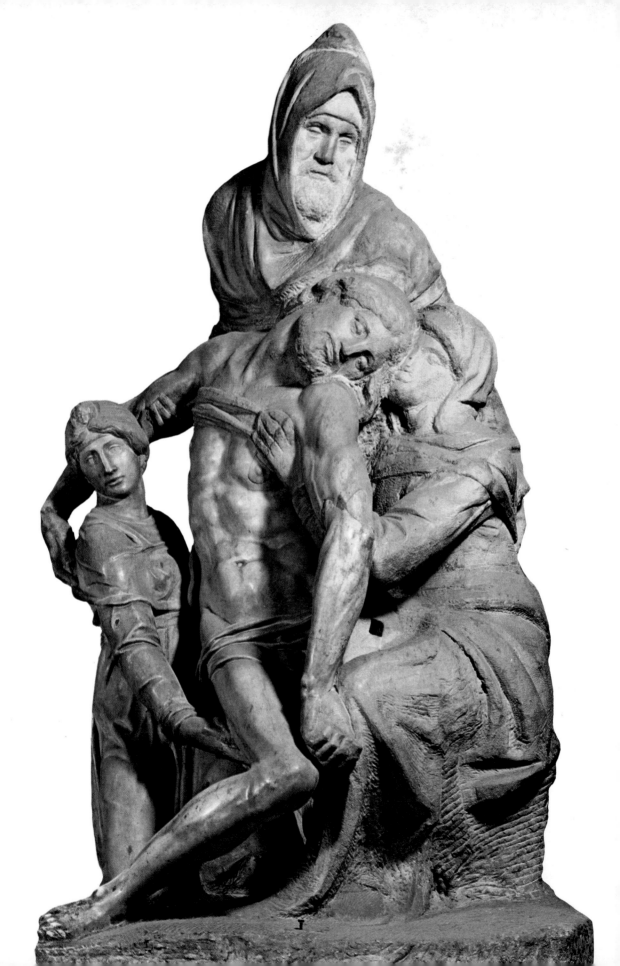

SCULPTURE

by the Editors of Newsweek Books

Newsweek Books, New York

NEWSWEEK BOOKS

Joseph L. Gardner, Editor

Janet Czarnetzki, Art Director
Edwin D. Bayrd, Jr., Associate Editor
Laurie Platt Winfrey, Picture Editor
Frances J. Owles, Copy Editor
Ellen Kavier, Writer-Researcher

S. Arthur Dembner, President

ARNOLDO MONDADORI EDITORE

Mariella De Battisti, Picture Researcher
Giovanni Adamoli, Production Coordinator

Frontispiece: The Florentine *Pietà* by Michelangelo

Grateful acknowledgment is made for the use on pages 154–79 of excerpted material from the following works:
Excerpts from an autobiographical statement by the artist that appears in *Alberto Giacometti.* Copyright © 1965 by The Museum of Modern Art, New York. Based on a revised English translation of a letter from Alberto Giacometti to Pierre Matisse. First published in New York: Pierre Matisse Gallery, Exhibition of Sculptures, Paintings, Drawings, New York, January 19–February 14, 1948. Reproduced by permission of Pierre Matisse and The Museum of Modern Art, New York, All rights reserved.
Aristide Maillol. Edited by Andrew C. Ritchie. Copyright © 1945 by the Buffalo Fine Arts Academy, Albright Art Gallery. Reprinted by permission of the Albright-Knox Art Gallery.
"The Story of My Prometheus" by Jacques Lipchitz in *Art in Australia,* June 1942, ser. 4, no. 6. Copyright © 1942 by The Sydney Morning Herald Publications. Reprinted by permission of Mrs. Yulla Lipchitz.
"Rodin's Reflections on Art" by Henri Charles Etienne Dujardin-Beaumetz in *Auguste Rodin: Readings on His Life and Work,* edited by Albert Elson. Copyright © 1965 by Prentice-Hall, Inc. Reprinted by permission of Prentice-Hall, Inc., Englewood Cliffs, N.J.
Barbara Hepworth: A Pictorial Autobiography. Copyright © 1970 by Barbara Hepworth. Reprinted by permission of Praeger Publishers, Inc. and Moonraker Press.
David Smith by David Smith. Edited by Clive Gray. Copyright © 1968 by Holt, Rinehart and Winston, Publishers. Reprinted by permission of Holt, Rinehart and Winston, Publishers.
Gabo: Constructions, Sculpture, Paintings, Drawings, and Engravings. Copyright © 1957 by Lund Humphries. Reprinted by permission of Naum Gabo.
"The Sculptor Speaks" from *Henry Moore on Sculpture* edited by Philip James. Copyright © 1966, 1971 by Philip James and Henry Moore. All rights reserved. Reprinted by permission of The Viking Press, Inc. and MacDonald and Jane's Publishers.
Louise Nevelson by Arnold B. Glimcher. Copyright © 1972 by Praeger Publishers, Inc. Reprinted by permission of Praeger Publishers, Inc.
On My Way by Jean Arp. Copyright © 1948 by Wittenborn, Schultz, Inc. Reprinted by permission of Wittenborn Art Books, Inc.
From a statement by Alexander Calder, first published in *What Abstract Art Means to Me,* Bulletin of The Museum of Modern Art, New York, Volume XVIII, No. 3, Spring 1951. All rights reserved by The Museum of Modern Art and reprinted by permission.
Statement by Henri Laurens in *XXe Siecle,* January, 1952. Copyright © 1952 by Leon Amiel/*XXe Siecle*, Paris. Reprinted by permission of Leon Amiel Publisher.

Contents

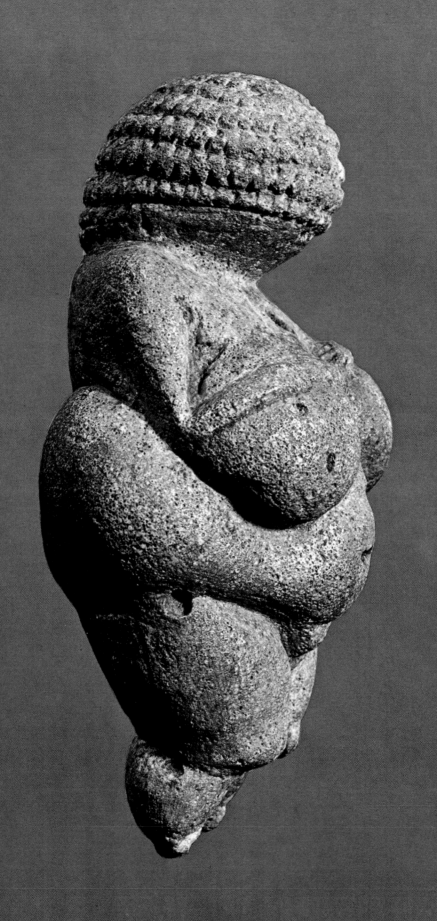

1

Man the Imagemaker

SCULPTURE is almost as old as mankind. For uncounted millennia man roamed the earth in an aimless, migratory existence, his evolution marked by false starts and dead ends. His first significant step forward was as man the toolmaker. The second, and more significant, step marked his emergence as man the imagemaker.

The dark galleries of prehistoric caves show our ancestors' preoccupation with the concrete image. In his painting and sculpture, early man was trying not to copy nature but to control it. His images reflected the world of nature, but originated in his mind, and therefore depicted things not just as they were but as he desired them to be.

Art serves many purposes: to glorify the living, honor the dead, placate the gods or give them bodily form; but fundamentally it deals not with the actual but with the ideal. Ideals, obviously, vary from one society to another, but what all ideals have in common is that they reflect not objective reality but reality shaped to bring it closer to the heart's desire. For Paleolithic man, the ideal world was simple, teeming with animals to eat and big fruitful women to ensure the continuance of the tribe.

Man the toolmaker preceded man the imagemaker; the flaking of stone tools was already a form of sculpture. For centuries man had shaped stone and softer materials like wood, bone, and horn to serve his practical ends. When he became aware that the image in his mind could be given concrete form, he already possessed the technology to do so. From stone axe to stone image is a relatively small step. The giant stride came when man first realized that his thoughts and desires could be translated into solid reality.

Our immediate ancestor, Cro-Magnon man, first appeared in Europe during the Upper Paleolithic, or Old Stone Age (c. 30,000–10,000 B.C.). At that time, much of Europe was overlaid by glaciers of the last ice age, but where the ice had retreated, expansive grasslands provided grazing for the great herds that roamed at will, ceaselessly harried by packs of predators, the most ruthless and efficient of which was man. Prehistoric man lived and hunted in bands, group effort compensating for individual weakness. He invented such weapons as the spear-thrower and the bow and arrow that greatly increased his capacities.

Cro-Magnon religion was animistic, that is, based on the belief that everything in nature has a soul. Through supernatural control of these

Squat and rotund, with attenuated limbs and an exaggerated coiffure, the so-called Venus of Willendorf *(opposite) is anything but the epitome of female beauty. She is, however, one of the world's first known works of art, and she is almost certainly 25,000 years old. Like similar figurines found elsewhere in Western Europe, this fist-sized limestone statuette may have been used in connection with prehistoric man's fertility rites.*

spirits, man could manipulate nature for his own benefit. To capture
the soul of an animal was to capture the animal itself; to this end, our
ancestors used what is called sympathetic magic: an image of the
desired object was created and the spirit was "trapped" within it. Sym-
pathetic magic rests on the belief that an image does not merely imitate
the real thing but is in some way identical to it.

Art thus first emerged as the handmaiden of magic. The best-known
examples are the cave paintings of southwestern Europe, where animals
were drawn realistically, then carefully "killed" by a painted spear. But
even earlier, the sculptured image was created to control or influence
an awesome force of nature—the power of fertility.

If the painted animals document man's preoccupation with food, the
female statuettes and reliefs of the Paleolithic attest to his concern for
the survival of the tribe. Woman's ability to conceive and give birth
must have seemed to Paleolithic man a miracle beyond comprehension;
on this miracle depended the survival of the group. The so-called
Venus figures represent man's first attempt to modify nature by pro-
jecting onto it his vision of the ideal image. To prehistoric man the
female ideal was no seductive, nubile girl, but rather the Mother God-
dess, huge, gravid, awe-inspiring.

The *Venus of Willendorf* is the most famous and impressive of
these fertility figures. Squat, brooding, powerful, she projects a monu-
mentality far beyond her actual size. The head is featureless, anony-
mous. Insignificant arms are draped limply over enormous breasts
Huge buttocks are counterweighted by an equally huge belly; a well-
marked vulva is sheltered by bulging thighs tapering to rounded calves.
The feet are not shown. No unessential details interfere with the image
of fecundity. Similar though less overwhelming Venus figures have
been found throughout Europe, carved in ivory or stone. Approxi-
mately fist-size and easily portable, they may have functioned as sacred
fertility relics of a tribe, handed down from generation to generation,
and carried the length and breadth of Europe.

By contrast, the *Venus of Laussel* was carved on the convex surface
of a rock in the Dordogne valley in southwestern France. Yet again the
figure has huge breasts, a swelling belly, and heavy thighs. The feature-
less head is turned as if to gaze at the horn, a sacred fertility object, in
her right hand. Her maternal potency is no longer contained within
herself but is projected onto the horn, a symbol of the mystery.

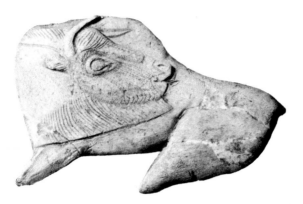

Animals were carved and painted on the walls and ceilings of caves. The sculptured animals, like their painted counterparts, were naturalistic and attest to Paleolithic man's powers of observation. These were the animals he feared, hunted, and possibly worshiped. Commonly depicted were the large mammals—mammoth, bison, horse, deer; occasionally, the lion or bear. They are usually shown in profile, carved in shallow relief on rock walls or on ceremonial implements of bone or horn.

The Paleolithic period was followed by the Mesolithic, or Middle Stone Age. The climate had warmed up, thick forests encroached on the grasslands, and the larger mammals died out, unable to adapt to the new climate. With their passing, the culture that depended upon them also died.

The Neolithic, or New Stone Age, emerged around 8000 B.C. in the Fertile Crescent of the Near East, the cradle of civilization. Forced to abandon his nomadic life as a hunter, man became a herdsman and eventually a farmer, settling in permanent village communities. A surplus of food permitted the population to expand, and specialized crafts developed. Social, technological, and artistic skills advanced rapidly. The Neolithic artist made statuettes of the Mother Goddess, descendants of the Paleolithic Venuses, from stone and clay. He modeled clay bas-reliefs of animals on temple walls and painstakingly worked over in plaster the skulls of animals and humans, attempting to give them a

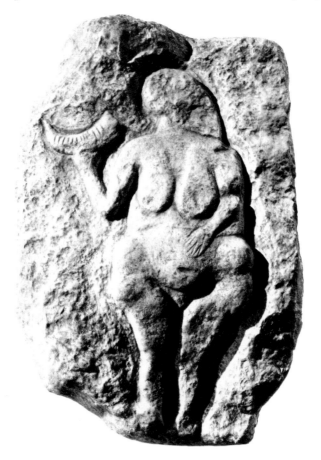

The proliferation of artifacts in the Paleolithic era—hand axes, projectile points, borers, and burins such as those above— indicate man's early awareness of the concept of "significant form." The first great sculptural advance came with the realization that an image—of a bison (left), for instance—could be given concrete form. The famed Venus of Laussel *(right), once set into a cave frieze in southwestern France, still bears traces of its original ochre paint.*

9

semblance of life. Sculpture still served magic and religion.

By 3000 B.C. the first major civilizations were taking shape in the eastern Mediterranean, especially in the valleys of the Tigris-Euphrates and the Nile. Village communities developed into major urban centers. Complex social, economic and religious hierarchies were established, metalworking was introduced, and writing was invented. For this area, the age of prehistory had passed, but in other parts of the world—the western hemisphere, for example—man the hunter continued to follow the herds.

Man discovered the New World perhaps as early as 30,000 B.C. when he crossed the land bridge that linked northeast Asia and Alaska. His culture was that of the Paleolithic hunter, and he roamed through North and South America, settling wherever food and water were abundant. When the ice age ended, the glaciers melted, flooding the land bridge to Asia. As they had in Europe, the large mammals became extinct. The first Americans were on their own and, like their Old World counterparts, had to rely on small game, food gathering, and farming. For most native American societies hunting remained the badge of manhood, but the major cultures of the Americas were based on the patient tilling of the soil.

The New World teemed with exotic plants that adapted readily to agriculture, but the great agricultural leap forward was the cultivation

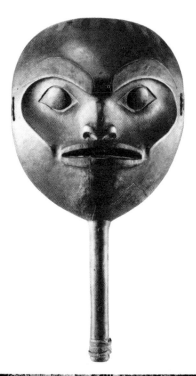

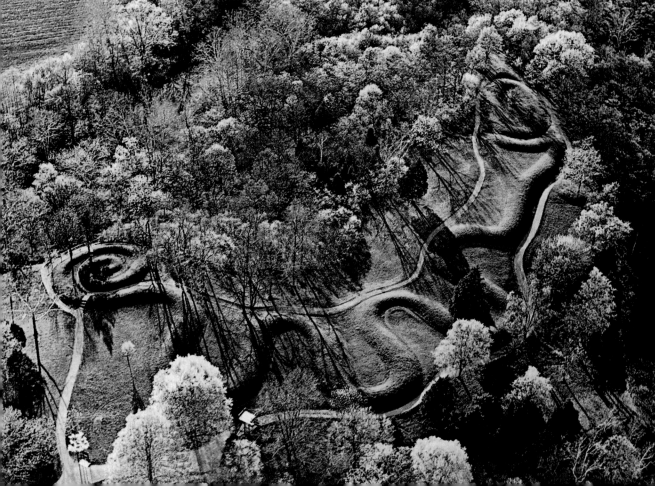

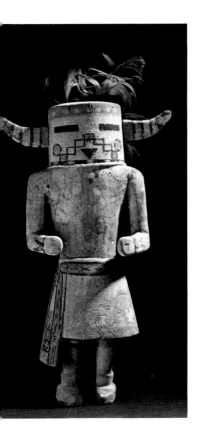

Between 30,000 and 10,000 B.C. Paleolithic man was to cross the Bering Strait land bridge, bringing the hunter's culture to the Americas. By 2000 B.C. settled communities had taken root throughout the Pacific Northwest. These tribes included the Tsimshian, creators of the wood, fibre, and leather rattle seen above, at left. Tribes indigenous to the Ohio and Mississippi river valleys were to construct a series of enigmatic effigy mounds during the last millennium B.C. The most splendid of these is the mile-long Great Serpent Mound (left), with its gaping jaws and coiled tail. Maize farmers of the Southwest such as the Hopi still carve, paint, and decorate Kachina, the gaily-colored spirit dolls (above) that represent an ancient sculptural tradition.

of maize, Indian corn. Without it, American man might never have risen from the squalor of the Mesolithic. Corn was the foundation of the great urban civilizations of Mesoamerica and South America—Maya, Aztec, Inca—cultures that rivaled those of the ancient Near East. By contrast, the native American cultures that lacked corn never developed much past the stage of hunting and gathering.

Nonagricultural societies flourished where food was unusually plentiful. Northwest Coast Indians provide an outstanding example of the cultural richness a hunting society could achieve. The tribes of this region lived on the bounty of the sea and the rivers. Their society was complex and vigorous, and they developed a tradition of sculpture rich in formality, symbolism, and technical excellence. From wood they produced totem poles, house posts, masks, and other regalia, elegantly carved and brilliantly painted. The heyday of the Northwest Coast Indian culture was quite late, dating to the early nineteenth century, when the fur trade brought the white man's metal tools to the region.

Food gathering and limited agriculture characterize the next step up the economic ladder. One of the outstanding archaic civilizations of North America was the Adena-Hopewell culture, which flourished in the Ohio Valley between 1000 B.C. and A.D. 700. These people worked copper into ornaments and produced pottery and sculpture, both in relief and in the round. They also developed elaborate mortuary customs, burying their important men in tombs which they then covered with huge barrows; Adena-Hopewell Indians are accordingly known as the Mound Builders. The largest of their mounds were designed for ritual rather than funerary purposes. The Great Serpent Mound is the most spectacular of these mighty earthworks.

The Mound Builders apparently lived in small forest villages that have left only the faintest of archaeological traces. By contrast, their cousins, the Pueblo Indians of the Southwest, built permanent communities of adobe brick. The early cultures—Hohokam, Anasazi, Mogollon—spread across the arid plateaus of Arizona, New Mexico, Utah, and Colorado. They practiced intensive agriculture, influenced by the advanced farming techniques of ancient Mexico. Their great arts were architecture and ceramics, but they also produced sculpture on a limited scale and in perishable materials. The colorful and sacred Kachina dolls, still made today by the Hopi, perhaps reflect the sculptural traditions of earlier eras.

The birthplace of the great Mesoamerican cultures was the Tehuacán valley in the Mexican state of Puebla. Here, sometime around 4000 B.C., a genetic miracle took place: repeated crossings of wild grasses resulted in the development of corn. Cultures based on this bountiful crop expanded rapidly—successive phases of these ancient Mexican cultures are called Preclassic (2000 B.C.–A.D. 300), Classic (A.D. 300–900) and Postclassic (A.D. 900–1520).

The most advanced of the Preclassic cultures, the Olmec, emerged in the Gulf Coast area between 2000 and 1000 B.C. The Olmec people built great ceremonial centers to serve their religious needs and thereby set a pattern later followed throughout Mexico and South America. Indeed, the Olmec is considered the parent culture of advanced Mexi-

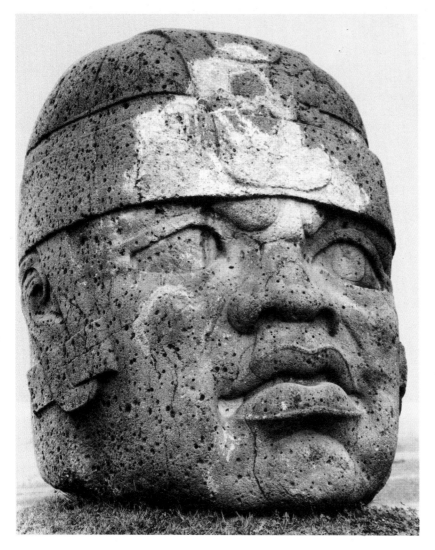

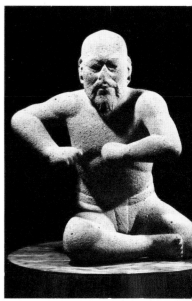

The Olmec is not only the old-
est, it is in many ways the most
intriguing of all Mesoamerican
cultures. Indeed, the sculptural
tradition in Central America is
sometimes said to begin and end
with the Olmec, so varied and
sophisticated are their artifacts.
These range from monolithic
basalt heads (left), weighing up
to ten tons, to the superbly ani-
mated statue seen above. Al-
though dubbed The Wrestler,
this figure is actually believed to
be a ballplayer.

can civilization. Many Olmec traditions and elements of their artistic style were widely diffused throughout Mesoamerica.

The Olmec were accomplished sculptors, working with equal ease in ceramic and stone. Their most impressive monuments are the gigantic stone heads from La Venta, a ceremonial center located on a small, swampy island. The stones for the monuments were transported there from a site about sixty miles away, a major engineering feat. The heads, which date from 800–400 B.C., stand six to ten feet high and wear close-fitting helmets. Powerful and awesome, they are modeled with force and sensitivity. Colossal stone altars or thrones are also found in the area, apparently dedicated to the jaguar god.

Olmec art is realistic; its forms are simple, almost abstract, yet firmly based in reality. Never again in the native American cultures was sculpture to exhibit so much freedom and three-dimensional force.

In contrast to La Venta, which was a ceremonial site with a minimal permanent population, Teotihuacán in the Valley of Mexico was the sacred center of a large city. Begun in the late Preclassic Period, it flourished throughout the early Classic Period (A.D. 300–600), and its ruins were venerated by the Aztecs of the Postclassic Period. Major stone

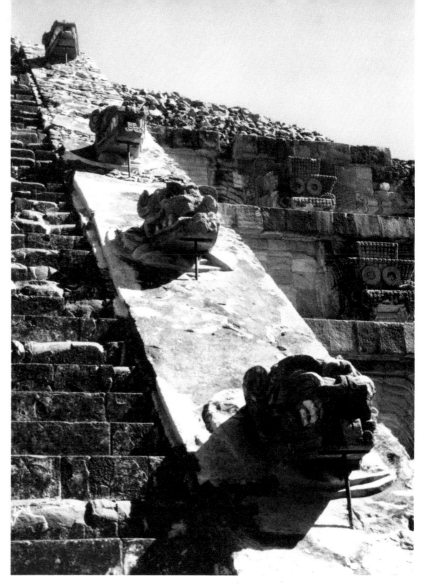

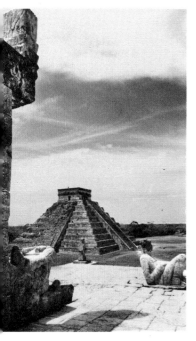

The Maya, inheritors of the Mesoamerican tradition, were to perpetuate their predecessors' enthusiasm for monumental sculptural works in such metropolises as Chichén Itzá (below). Massive stepped temples were not a Mayan invention, of course, but drew their inspiration from the major temple-city of Teotihuacán, first true cosmopolis in the Americas. The sloping sides of Teotihuacán's Temple of Quetzalcóatl (right) are studded with serpent heads.

sculpture is comparatively rare at Teotihuacán. A few stone figures exist, as well as carved heads of plumed serpents and Tlálocs (rain gods), tenoned into the terraces of the pyramid dedicated to the god Quetzalcóatl. The style is rigid, severely formal, and decorative. Here Olmec naturalism has vanished. Teotihuacán was destroyed around A.D. 600, probably by barbarians from the north who for a time squatted in the ruins of the once majestic city.

Quetzalcóatl, the Plumed Serpent, was both a culture hero and a god. As the former, he was credited with introducing learning and art to Mesoamerica; as a god, he personified the forces of good and the essence of life itself. He was worshiped first at Teotihuacán, later at Tula, and eventually at Tenochtitlán, the great city of the warlike Aztecs. As Kukulkán he was venerated by the comparatively peaceful Maya of Guatemala, British Honduras, and the Yucatan.

The Mayan civilization emerged perhaps as early as 300 B.C. and flourished throughout the Classic Period. The ruins of this culture show the usual pattern of great stone-built ceremonial centers supported by agricultural communities. The Maya made notable contributions to mathematics, astronomy, and writing. Their sculpture was pri-

marily architectural and executed in relief. Stone sculpture in the round was produced at some centers, such as Copán, and there was a lively tradition of ceramic sculpture. Their relief sculpture is the most complex and intricate in all the Americas. The forms—human, hieroglyphic, purely decorative—seem to flow together in endless patterns. The style is rich, sophisticated, and sensuous, totally removed from the austere rigidity of Teotihuacán.

Around A.D. 800 building ceased at Copán, and the site was gradually abandoned. During the following century the same thing happened at Tikál, Uaxactún, Piedras Negras, and other southern lowland centers. The reason for the collapse of the culture is not known, although it may be that the peasantry refused to accept any longer the enormous burden of these essentially parasitic cities of the gods. At any rate, the decline of the Maya remains an unsolved mystery.

The Aztecs, the best known of the Mexican tribes, were relative

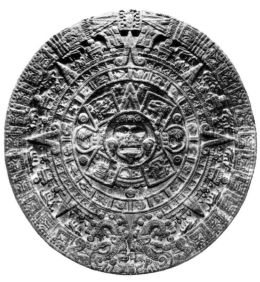

latecomers. Savage nomads from the north, they migrated to the Valley of Mexico and founded their twin capitals of Tenochtitlán and Tlatelolco in the first half of the fourteenth century. They soon emerged as the dominant power of the area, a highly organized kingdom with an absolute monarch.

The sculpture of the Aztecs borrows heavily from the artistic traditions of earlier cultures. Intricate, formal, and grimly beautiful, it reflects the brutality of their religion. There are graceful exceptions—a touchingly innocent corn goddess, or the elegant Xochipilli, god of music, dancing, and love.

The Aztecs adapted many elements of their culture from the older civilizations around them: Quetzalcóatl, however, was now honored with sacrifices of still-beating human hearts, in marked contrast to the butterflies previously felt suitable for his altar. Other gods—Tezcatlipoca, Huitzilopochtli, and the creator goddess Coatlicué—exacted similar tribute. The priests of Xipe, god of spring and fertility, often

During the eighth century A.D. the Maya raised enormous temple complexes across the Yucatan, structures banded with striking bas-reliefs (left, above). Then, around A.D. 800, these centers were abruptly abandoned, and Mayan civilization entered a sharp decline. The Valley of Mexico now belonged to the mighty Aztec, carvers of the twenty-four-ton basalt calendar stone above. This great solar disk reflects the intellectual as well as the artistic achievements of the Aztecs.

Xochipilli, Prince of Flowers (below), was unquestionably the freest spirit in the Aztec pantheon. As the patron god of love, summer, dancing, and the theater, he was customarily shown bedecked in blossoms and encircled by butterflies. Such whimsy was the exception, not the rule, in Aztec spiritual life, however. The turquoise and shell pectoral at right, below, is far more typical of Aztec religious art. It represents a double-headed fire serpent, servant of the almighty sun god.

dressed in the skins of human victims. Human sacrifice was practiced on an enormous scale: 20,000 men were slain at the dedication of the great pyramid at Tenochtitlán. Enervated by the constant warfare required to provide victims, the Aztecs fell early in the sixteenth century to a mere handful of Spanish adventurers led by Hernan Cortés.

When the Spanish had established control over Mexico, they turned their eyes south to Peru, the empire of the Incas, whom they conquered and exploited as they had the Aztecs. The Incas, who carved stone for their cities as if it were butter, never turned their technique to sculpture. Indeed, the South American cultures, with few exceptions, are noted not for their sculpture but for an artistic genius expressed primarily in architecture and in the minor arts of textile, ceramics, and metalwork. The naturalistically modeled pottery of Peru's Moche culture is a lively exception, as are the sculptures produced at Chavín de Huántar in the northern highlands, and the huge monolithic figures

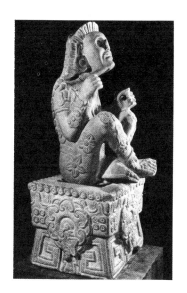

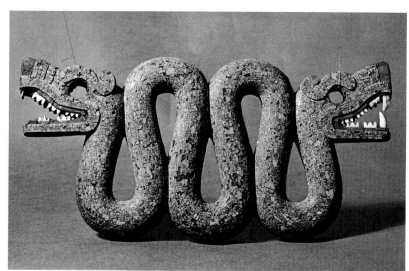

that stand guard over the sacred city of Tianhuanaco in Bolivia.

The Spanish discovery of the New World was entirely fortuitous. Ferdinand and Isabella had subsidized Columbus to seek a trade route to the East Indies, since the overland route through the Middle East had become both dangerous and unprofitable. The demand of the Renaissance world for the spices and silks of the Far East earlier had led the Portuguese to begin their circumnavigation of Africa. Europeans of that time, knowing next to nothing about Africa, were astonished to find major centralized kingdoms along the West African coast.

Early explorers often returned with exotic ivory souvenirs, salt dishes or standing cups carved by local craftsmen to European specifications. These Afro-Portuguese objects enjoyed a brief vogue in the opulent and jaded courts of Europe, but subsequently the arts of Africa were largely ignored until the late nineteenth century, when explorers and missionaries began shipping curious artifacts back to their local natural history museums. Even the impressive bronzes of Benin or the

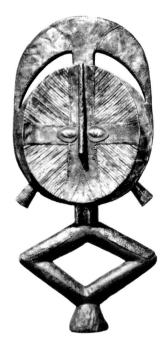

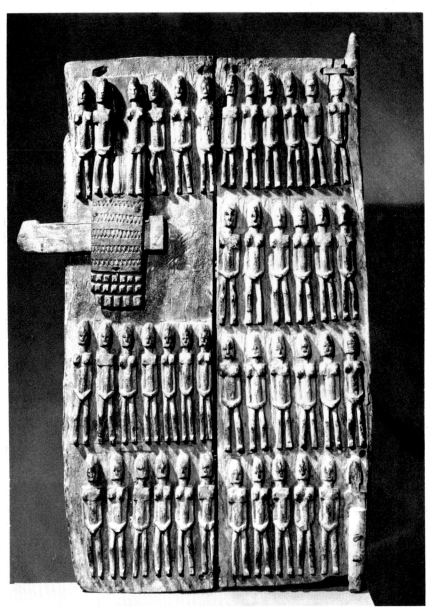

spectacular Ashanti goldwork failed to awaken Europe to the intrinsic beauty of African art.

Europeans finally "discovered" African art in the early years of the twentieth century, when a small group of sophisticated European painters, including Picasso, Matisse, and Derain, acclaimed its aesthetic power. Their acceptance of this art was an outgrowth of their own rebellion against European artistic traditions, but it laid the foundations for a reevaluation of aesthetic standards. Today African art can be appreciated and honored entirely on its own merits.

Sculpture reigns supreme among the arts of black Africa. It is done in relief and in the round, primarily in wood but also in stone, metal, and even ceramic. In most communities the sculptor is regarded as a skilled professional and honored accordingly. African sculpture can be divided roughly into two major categories: traditional tribal art, serv-

Originally considered ethnographic curiosities rather than works of art, the sculptures created by black Africa have only recently received the credit they are due. The Kota guardian figure at left, above, was fashioned of wood, copper, and brass. It shares with the Dogon piece above—once the door of a small granary—a high degree of quite sophisticated stylization.

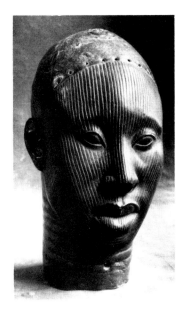

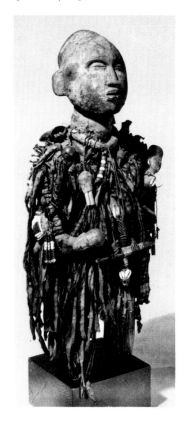

The life-size—and profoundly lifelike—cast bronze head seen above is said to represent one of the kings of Ife in Nigeria. The Kongolese fetish figure below, whose wooden frame is draped in a mantle of nails, cloth, beads, shells, arrows, twine, and nuts, was held to have supernatural powers—for good or evil.

ing the religious and social needs of the village; and court art, dedicated to the service of a king. Both types are essentially religious. African sculpture can be admired on purely aesthetic grounds, but knowledge of the social and religious context is essential for a full appreciation.

African sculptural forms are specific and meaningful. The artist created within the framework of a time-honored iconographic tradition. He intended his work to instruct the young, honor the dead, placate powerful spirits, give form to the gods, illustrate such abstract concepts as justice or the order of the universe, or merely to entertain.

Niger River Africans produce art with a strongly abstract flavor, perhaps the result of association with their Muslim neighbors. The Dogon live in a particularly rocky and inhospitable area and, as if to compensate for the poverty of their material existence, produce ritual objects of surpassing beauty and richness. In a world where malevolent spirits hemmed them in, men and their possessions required protection. The carving on the granary door was not merely decorative; it was meant to ward off evil and to attract the forces of good. Once again sculpture is in the service of sympathetic magic.

In this same region, the tribesmen most famous for their sculpture are the Bambara. Their elegant and decorative *chi wara* masks, representing the sacred antelope who instructed the Bambara in agriculture, are known and loved throughout the world. Bambara masks are worn openly, but their ancestor figures are considerably more sacred. Both male and female ancestors are represented; the figures are normally angular and rigid, severely achitectonic in style. As in most African sculpture, the head is large in proportion to the body. The head was the seat of intelligence, the quality that separated man from the animals, and hence deserved greater emphasis.

The Kota of Gabon apparently no longer produce their famous funerary sculptures. These guardian figures do not represent specific ancestors, but rather their spirits, and were set up over boxes containing bones and other relics. Ancestors, even though deceased, were still considered part of the family, and their advice was sought on important matters concerning their descendants. The guardian figures were cut from slabs of wood, then covered with copper or brass, either in flat sheets or woven strips. Elegant and enigmatic, they are decorative as well as symbolic.

The fetish figures of the Kongo represent an entirely different tradition in African sculpture. They were intended to attract powerful spiritual forces and could be used for either good or evil purposes. Magical substances were usually packed into a cavity in the body; the figure was then hung round with spiritually potent items—horns, metal, beadwork, snakeskins. Often nails were driven into the figure when in use; iron was sacred and would help draw the attention of the spirits.

Royal court art, while deriving from the same general artistic traditions, is quite different from the traditional tribal arts. In general, it is more naturalistic and is often crafted in metal as well as in wood. Its purpose was to enhance the power and prestige of the king, who was regarded as sacred. While the court art tradition is known in all of black Africa, the examples from the Nigerian kingdoms of Ife and

Benin are quite justly the most famous.

The art of bronze casting was introduced in Ife in the thirteenth century, and large bronze heads, portraits of the Oni, are among the most majestic and inspiring works in African art. Highly naturalistic and modeled with sensitivity, their expression is aloof, serene, and noble, as befits a sacred king. The skin may be either smooth or striated, marked with delicate parallel grooves, which may represent scarification marks. These life-sized heads were probably used at secondary funeral ceremonies; attached to a wooden body, they would have been dressed in the king's own robes and regalia.

Smaller heads, about three-quarters life size and capped with crowns, represent both the king and the queen mother. Complete figures are known, but they too are small. All of these bronzes were cast in the lost-wax process, a sophisticated technique probably learned from the ancient Kushites of Meroe. Terra-cotta heads of great beauty were also produced, but these were usually more individualistic and expressive than the bronze portraits.

The art and culture of Benin developed from that of Ife. More is known about Benin and its art, since the kingdom retained its power and independence until the 1860s. Here bronze was a semisacred metal; only the king could order its use. Traditionally only the king and the queen mother could be represented in portrait heads. Benin portraits, less naturalistic and subtle than those of Ife, are highly stylized.

Many other objects were produced for the Bini court—bronze stat-

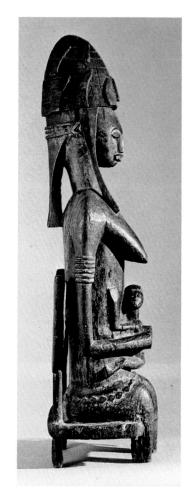

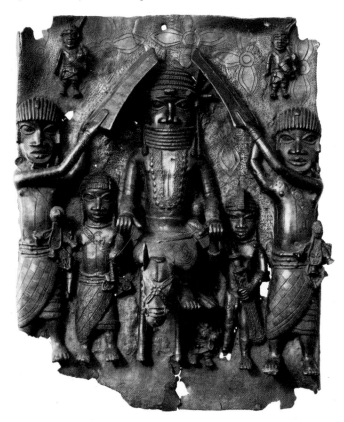

Although infinite in their variety, traditional tribal figures such as the Mali Mother and Child above are overshadowed by the courtly works created by the Bini, cultural inheritors of the Ife tradition. These fifteenth-century artisans, whose metal-working skills are still without rival, covered the walls of their royal palaces with boldly executed bronze plaques like the one at left. They also produced such pensive portrait heads as the one seen at right. Vertical slots in its ivory forehead once held iron plugs perhaps intended to represent traditional tribal scarification markings.

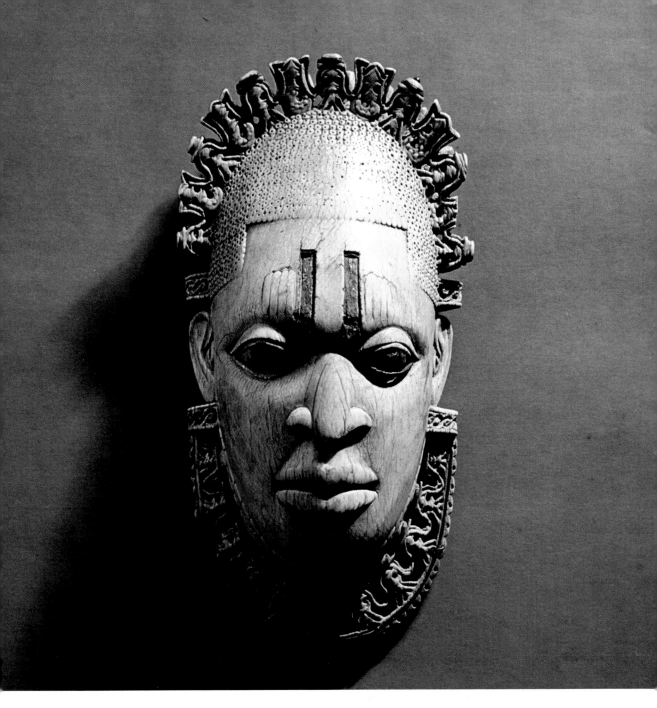

uettes, relief plaques, and exquisite ivory work. The reliefs date to the seventeenth century and were originally nailed on the wooden posts of the palace porch. They represent the activities of the Oba and his retainers. The king is shown enthroned, walking or riding in a royal progress, or performing sacrifices. Courtly ceremony is shown in great detail. Indeed, in the eighteenth century, when the plaques were no longer used as architectural ornaments, they were kept in storage and used as a reference for details of costume and protocol. The ivory carvings from Benin are even more elegant than the bronzes. The pectoral masks are particularly fine, showing a degree of naturalism that the bronzes avoided. The eyes, to add realism, were inlaid with copper as were the slots on the forehead, symbols of high rank. Both crown and

collar are decorated with tiny heads of bearded Europeans, symbolizing the king's power over the upstart foreigners.

African sculpture is astonishingly rich and varied. The styles, both sophisticated and subtle, range from the totally abstract to the mirror of life itself. Expressive, forceful, and sensitive, African sculpture is among the most creative in the history of world art.

The Renaissance search for overseas luxuries had brought the Americas and Africa into the European sphere of influence, first to be exploited, then colonized. The same trend toward imperialism resulted in the eighteenth-century opening up of the South Pacific. This time England and France were the chief protagonists, competing to explore and claim new territories in this area. Captain Cook's three voyages (1768–79) aroused interest in the Pacific, its people, and its culture.

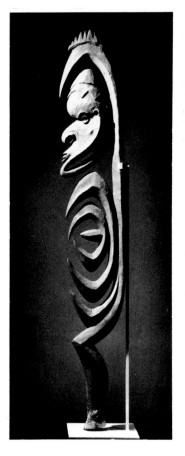

The term Oceania refers generally to the islands of the South Pacific, which are divided into three major ethnolinguistic areas: Melanesia, north and east of Australia; Micronesia, still farther to the north; and Polynesia, to the east. Within this vast watery territory exist a variety of social, religious, and political organizations and a staggering diversity of cultures. As in Africa, the arts of these people serve their religious and social needs. And again, the great art is sculpture.

The Melanesian area, including the large island of New Guinea, is extremely varied in both culture and art. There society was based not on hereditary classes but on individual wealth. Religious life centered on a tribe's ceremonial house and revolved around its primary concerns —ancestor cults and initiation rites. The basic sculptural theme was the human figure, the head being emphasized even more than in Africa. Sculpture was usually painted and often further ornamented with shells, teeth, grasses, and feathers of exotic birds. Masks and ancestor figures were carved, as were elaborate funerary ornaments, ceremonial canoe paddles, and weapons.

New Guinea presents bewildering contrasts. The people of the highland areas have no arts at all; those of the coast and river valleys create a veritable riot of sculpture—masks, ancestor figures, canoe prow ornaments, headrests and bowls, house front decorations, and ancestor poles of astonishing size and complexity. Two figures in particular illustrate the variety of artistic styles within New Guinea. A mother and child from Lake Sentani show a well-developed sense of balance and reflect the shape of the wood from which they were carved. Like most of the sculpture from this region, their forms are rather crude; little attempt has been made to model the limbs or delineate the planes of the face. By contrast, the *Yipwon* ceremonial figures from the Karawari and Krosmeri rivers are fluid, graceful, and abstract, their pierced bodies contrasting with the solid heads. Kept in the men's houses, these figures were supposed to ensure success in hunting and warfare.

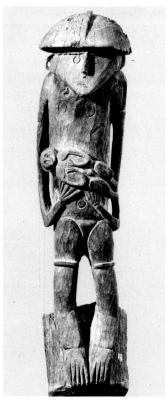

The Polynesian world was the first to become known and exploited by eighteenth-century explorers. Interestingly, the elegantly designed, technically brilliant sculpture of this area touched some buried chord in European consciousness. Polynesian art was admired in Europe long before that of Africa. In London in the 1770s there was actually a small museum devoted to Polynesian art and artifacts. There seems to be no

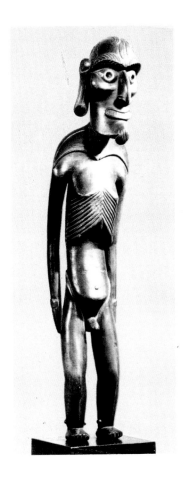

limit to the variety and richness of Polynesian sculpture: household gods from Hawaii, headdresses from the Marquesas, and ancestor figures from Tonga rival house posts, canoe prows, and ceremonial objects from the Maori of New Zealand.

The massive stone images of Easter Island are probably the best known of all Oceanic sculpture, although the problems they present are archaeological rather than stylistic. Carved with stone tools from volcanic tufa, the eyeless watchers stand on the outer slopes of a volcano, staring out to sea. Completed figures measure from three to thirty-eight feet in height; even larger ones were begun but not finished. Some of the long, abstracted, lantern-jawed giants were originally erected on the *ahu*, sacred enclosures used for burial platforms. These were capped with topknots or headdresses of a reddish stone. Today the *ahu* statues have fallen; only those on the slopes of Rano-Raraku still stand, as monuments to struggles for prestige among competing chieftains now long forgotten.

Most of the exotic art forms from the Americas, Africa, and Oceania have been swallowed up in the western tradition. In Oceania only a few untouched areas yet remain where traditional forms are still produced, but there, as in Africa, commercialism has intruded and contributed to aesthetic decline. Yet the great masterpieces remain; herded into museums and divorced from the ceremonies they once glorified, they stand as witnesses to cultures and ways of life now vanished.

RACHEL H. KEMPER

The fragile art of Oceania— much of it carved from extremely soft woods—suggests the cultural variety of the South Pacific. The angularity of the yard-high statue at left, for instance, contrasts dramatically with the integrated curves of the piece directly above it—and yet both were carved by New Guinea sculptors. Easter Island, easternmost outpost of Polynesia, is famous for its bulking sentinel heads (right) carved of tufa, a soft volcanic rock. Less well known are the small wooden figures also carved by the islanders. These include the emaciated but menacing male ancestor figure seen above.

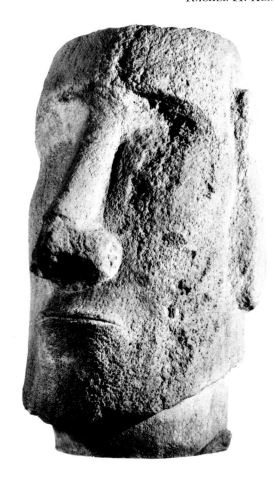

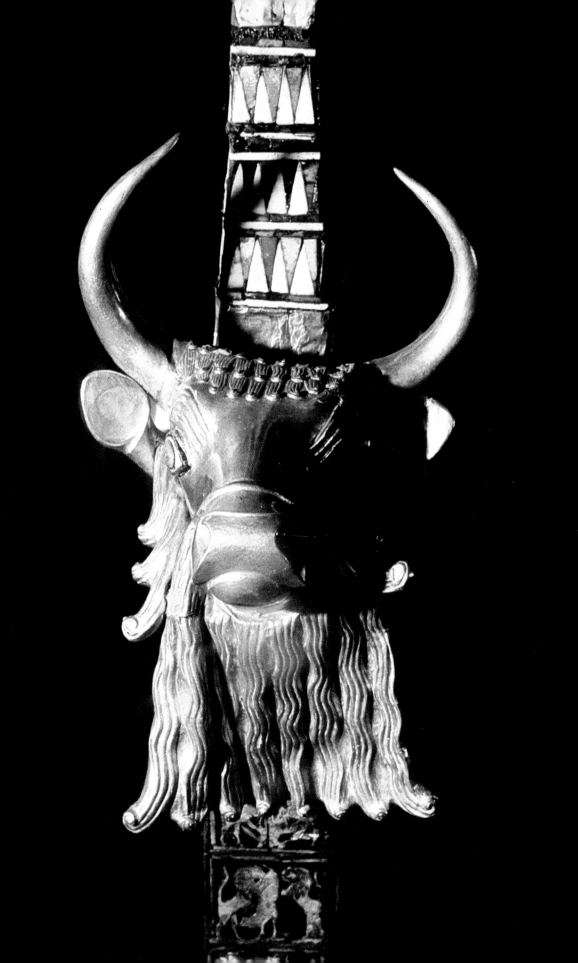

2

Celebrating Kings and Pharaohs

The bountiful valley of the Tigris–Euphrates nourished Mesopotamian civilization from its infancy, allowing for the accumulation of wealth and the fashioning of artworks from precious materials. The golden bull opposite graces an intricately inlaid harp frame that was fabricated around 2550 B.C. as part of the furnishings for a king's tomb. Despite the addition of a fanciful beard, the figure remains emphatically naturalistic.

THE ANCIENT CIVILIZATIONS of the Near East arose in fertile river valleys during the fourth millennium B.C. From the Nile in Egypt, and the Tigris–Euphrates in Mesopotamia, the people drew life-giving water for their crops, assuring themselves of a regular supply of food and the possibility of remaining in settled communities. There followed increases in population, division of labor, and the establishment of political entities capable of conducting foreign trade. With complex economic transactions came the necessity for records and the development of writing. During the latter half of the millennium, the growing maturity of economic and political life allowed for the expression of communal beliefs in monumental architecture and art.

In Mesopotamia, the second half of the fourth millennium B.C. is known as the Protoliterate Period. At Uruk, Eridu, Tell Brak, and other sites, the early Sumerian inhabitants built great temples to the gods of the city-states that served as centers of economic and religious activity. From the ruins of these temples, archaeologists uncovered the civilization's first sculptures, those whose forms and themes continue in the later periods of Mesopotamian art.

The earliest stele, or commemorative stone meant to be seen in an upright position, found in Mesopotamia dates from the Protoliterate Period. Its relief depicts a king hunting a lion. The king or hero as protector of the community against wild animals and the violent forces of nature appears again and again in Mesopotamian art, down to the fall of the Assyrian empire in 612 B.C. The popularity of this theme expresses the real concerns of the people living in the Tigris–Euphrates valley, for whom torrential rains, violent floods, and wild animals were constant dangers to be thwarted by dutiful worship of the appropriate divinity and by the performance of ritualistic acts.

Divine worship involved the offering of all manner of goods to the deity, and this service is depicted on another major work of the early period, a tall alabaster vase from Uruk, the Biblical Erech. Interestingly, the same themes were carved on the small stone cylinder seals first used at this time to indicate ownership on jars containing raw materials, and to attest to the veracity of written records. When rolled on moist clay, the carved seal produced a positive impression of a ritual scene or myth.

The succeeding Early Dynastic Period is marked by changes in

architectural technique, a renewal of cylinder-seal decoration, and the creation of new types of sculpture. Small standing figures of worshipers now become numerous. These three-dimensional sculptures were placed on benches along the walls of sanctuaries to serve as substitutes for their donors, and to offer perpetual prayer on their behalf. In the earliest of these works, organic, naturalistic forms are sublimated to an abstract geometric order. A conical shape dominates the lower half of the body, and even the arms and hands are pressed against the chest so that the basic outlines are not disturbed. Such a geometric scheme is most effective for standing figures. Seated bodies, as we will see later, tend to look unnaturally stunted. Often the faces of worshipers and priests were adorned with inlaid materials—shell, lapis lazuli, or black stone for eyes and brows—whose simple geometric shapes echo those of the body as a whole.

Later, Early Dynastic sculptures in the round show a softening of the geometric forms of the first worshiper statues and a greater naturalism. Contemporaneous metal sculptures are part of the same stylistic trend. Often in the shape of animal heads, they were used as decoration on furniture and on musical instruments. Three gold bulls' heads were found in the Royal Cemetery at Ur. The subtle modeling of the planes of the heads, together with the force of the inlaid colored eyes, creates a vibrant impression despite the fantastic addition of long beards.

Two-dimensional versions of the worshiper figures appear on votive plaques, a new art form of the Early Dynastic Period. These square reliefs with holes in the middle were probably attached to the walls of temples and may have held standards or votive offerings. The most common subject represented on these plaques was the symposium, or ritual feast. In this scene, a seated goddess faces a male of lesser rank. Both figures hold cups and branches, and are waited upon by servants bringing gifts. Musicians and dancers are sometimes in attendance, and often the participants are shown arriving by boat or chariot. In part, the subject is the same as that depicted on the earlier vase from Uruk, the presentation of cult offerings.

An early *ensi*, or king, of Lagash, Eannatum, erected the first Mesopotamian stele with a specific historical subject. Instead of a generalized theme such as the cult offerings, enacted repeatedly in the cycle of Sumerian life, this stele presents a singular moment in the life of one *ensi*, his victory over the neighboring state of Umma. Eannatum's triumph is presented on one side of the stele as the deed of armed men; on the other, it is symbolically interpreted as the result of divine intervention by Ningirsu, god of the city of Lagash.

The votive plaques and stelae of the Early Dynastic Period not only introduce new subjects to Mesopotamian art, they also present a new artistic concept, the independent pictorial surface. Relief no longer functions as decoration added to a three-dimensional object such as a vase, whose space is that of this world; instead it assumes an abstract existence bounded by a frame and internally organized by horizontal lines into a system of superimposed registers. Such votive plaques and stelae are thus conceptually akin to a modern framed painting.

Around 2370 B.C. Sargon, of the Lower Mesopotamian city of

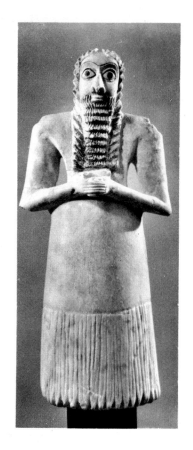

The white gypsum statuette shown above is a classic example of early Sumerian sculpture. Its conical shape and rigid limbs typify works created in Babylon around 2650 B.C. The Plaque of Urnanshe (above right), named for the first king of the Babylonian city-state of Lagash, is executed in a more naturalistic style. In place of the usual scene found on such plaques, it shows the king himself participating in a ritual procession. Gudea, most powerful of the many kings of Lagash, was a great temple-builder. Those edifices are now lost, but the king's likeness is preserved in diorite statues like the one at right.

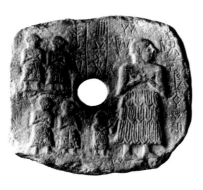

Akkad, revolted against Sumerian rule and established a dynasty that was to govern for more than a century until overthrown by an invading mountain people, the Guti. The art of the Akkadian dynasty shows a gradual liberation from Sumerian models. The early stelae are divided into registers and still employ the symbolic vocabulary of the Eannatum victory stele. But the victory stele of Naram-Sin, Sargon's grandson, is something new and different. The natural, rounded shape of the boulder, modified only slightly, becomes a basic motif of the composition. A unified scene of Naram-Sin leading his armed soldiers into enemy territory replaces the previous division into registers, and the blank background has been transformed into a real landscape with trees, boulders, and a mountain peak. Fallen enemies retreat in the face of the Akkadian advance or plunge headlong to their deaths.

Flowing, curved outlines create figures capable of such organic movement. Gone are the rigid, geometric forms of earlier Mesopotamian art. Even the basic concept of victory has been transformed in accord with the new naturalism. The outcome of battle is no longer effected by gods but by men such as Naram-Sin whose deeds are godlike. Neither completely naturalistic nor totally symbolic, the stele of Naram-Sin allows the viewer to glimpse the larger, eternal significance behind the actual event depicted—and so monumentalizes it.

The invasion of the Guti, which ended Akkadian rule, did not affect all of Mesopotamia equally. The southern cities soon escaped foreign domination, and their rulers initiated a revival of Sumerian political, religious, and artistic forms. This era, known as the Neo-Sumerian Period, was marked by great amounts of building activity. Large ziggurats with their attendant temples and courts arose at Ur, Uruk, Nippur, and Tell Asmar.

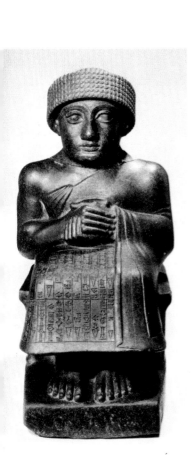

An early leader of this revival was the *ensi* of Lagash, Gudea. Unfortunately, the great temple built by Gudea no longer exists, but this remarkable ruler did leave behind two lengthy poetic compositions describing his temple and the meaning and significance it had for its Neo-Sumerian builders.

Another legacy of Gudea are the several highly polished diorite statues of the *ensi* himself, once dedicated in his great temple. Whether seated or standing, Gudea is clothed in a long garment whose surface is completely smooth, creating a basically cylindrical form that gives no hint of movement by the body beneath. The abrupt placement of the head upon the shoulders, like the rigid clasping of Gudea's hands at the front of his body, complete the impression of a human form as inert as the stone from which it was carved. The seated statues of Gudea show how difficult it was for the Sumerian artist to adapt his basic geometric scheme of a cone or cylinder to a nonstanding pose. Egyptian artists working from a cubic format were far more successful.

In form and function, then, the statues of Gudea echo those of the first Sumerians. The same is true of the reliefs of the period. Their subject matter and organization into registers recalls earlier works.

Neo-Sumerian rule was overthrown by a series of foreign invasions. The next ruler to unite the city-states of Mesopotamia was Hammurabi of Babylon. Few works of sculpture remain from his reign, which

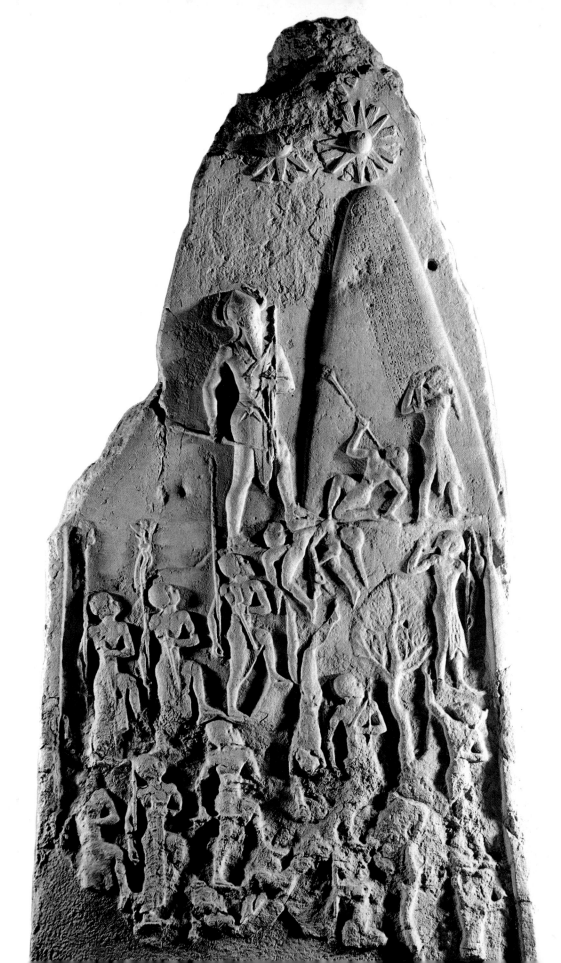

lasted from 1792 to 1750 B.C. Perhaps the most significant is the *Stele of Laws,* bearing the famous judicial code.

Babylonian rule was in turn ended by another group of foreign invaders, the Kassites, who were to dominate political life in southern Mesopotamia from the early sixteenth century B.C. until the end of the second millenium B.C. They produced some new sculptural forms. Large architectural decorations were composed of molded clay bricks that, when arranged on the façades of temples, formed figures of gods and goddesses. The second major type of Kassite sculpture was the *kudurru,* a boundary stone recording a gift of land from the king to a subject or invoking divine protection of the boundary. The pictorial decoration of the *kudurru* is usually highly symbolic, and often difficult to understand.

In northern Mesopotamia, the city-state of Assur gradually emerged as a political force in the fourteenth century B.C. The cylinder seals produced by the Assyrians during the last centuries of the second millennium B.C. express the creativity and vitality of the new state. Babylonian seal designs had been reduced to stereotyped formulas whose very repetition destroyed their effectiveness. The owner of the seal could no longer be associated with a unique design, and long inscriptions were required to identify him.

Assyrian artists created a variety of new themes for their seals, which are rendered in a naturalistic style reminiscent of Akkadian art. Well-modeled figures capable of forceful movement are occasionally placed in landscape settings whose spacious conception belies the miniature size of the seals, which range from one to two inches in length.

The greatest age of Assyrian rule began in the ninth century B.C. Able kings repeatedly expanded the borders of the former city-state until a world empire was created. As an expression of their power, the Assyrians built huge palaces whose organization and decoration were designed to impress subject peoples and foreign envoys with the might of the empire and, conversely, the futility of any revolt against its rule. At the gates of the citadel and the entrance to throne rooms stood stones thirteen feet high carved in the form of *lamassu,* winged human-headed lions. In technique a combination of relief and three-dimensional sculpture, these figures were provided with a fifth leg so that, whether seen from the side or from the front, they appeared complete and powerful. By their size and fantastic character, these protective genii could not fail to impress the visitor to the great Assyrian strongholds.

After he entered the main gate, the visitor would pass through a sequence of courts that diminished in size while the scale of the decora-

Commemorative stelae—upright stone slabs celebrating noteworthy historical events—are among the oldest sculptural forms found in Mesopotamia, with examples dating back to the fourth millennium B.C. The victory stele of Naram-Sin (left) is of particular importance, however, for it is radically unlike any of its predecessors. In fashioning this work the sculptor has abandoned the convention of horizontal registers in order to create a flowing, coherent narrative, set against a real mountain landscape and containing the details of an actual victory. The Assyrians, later rulers of Mesopotamia, were to prove masters of basrelief—on any scale. They revitalized the design of the tiny cylinder seal (above), then applied the same naturalistic style to such ambitious projects as the panoramic Hunt of Ashurbanipal, *seen at lower right.*

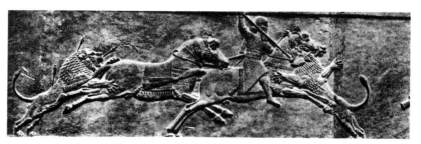

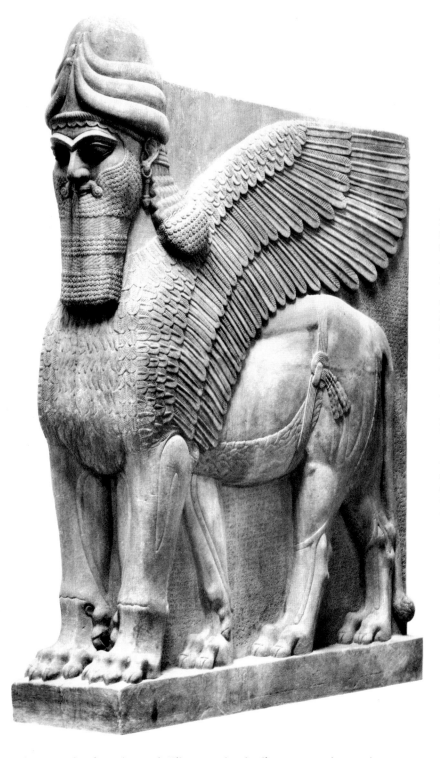

Having conquered a world empire in the first millennium B.C., the Assyrians set about ratifying their achievements in stone. At Assur, Nineveh, and Khorsabad great new palaces were erected. The scale of these structures was awe-inspiring, and so were their furnishings, which included the thirteen-foot-high lamassu, or winged, human-headed lion, seen at left. A two-sided relief (right) commemorates an important event in the early history of the Nile Valley—the unification of Upper and Lower Egypt in 3100 B.C. by Narmer, a southern king. The Egyptians later developed elaborate funerary rites. To assure the deceased a comfortable afterlife, tombs were embellished with low reliefs (lower right) that catalogued the dead man's possessions.

tion remained unchanged. The net visual effect was an increasing sense of the strength of the Assyrian king. Palace decorations consisted for the most part of wall reliefs, whose subjects, though traditional in Mesopotamian art, were now given much more elaborate treatment than heretofore.

Royal lion hunts became grandiose rituals described in minute detail and ending with fields littered with dead and dying animals. Some of the lions in the *Hunt of Ashurbanipal* (669–633 B.C.) from Nineveh are

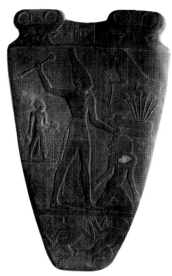

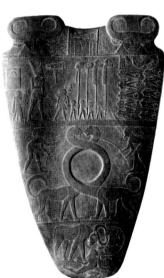

portrayed with great sensitivity, so that the viewer sees the dying beasts as objects of pathos. This same emotion is occasionally evoked by the wall reliefs showing military conquests, particularly in scenes of captive peoples being led away into exile. Generally, however, the Assyrian army is depicted as a cruel, invincible machine, rolling on from victory to victory as the reliefs continue on register after register.

Reliefs of the early Assyrian kings are somewhat generalized depictions of battles, but by the reign of Tiglath-pileser III in the eighth century B.C. these scenes refer to specific campaigns. Impelled by this shift in emphasis, the later Assyrian artists occasionally abandoned the strict register system with its neutral ground in favor of larger compositions with landscape backgrounds that describe the exact locale of a battle and even attempt to show depth and distance. Whatever the subject, however, Assyrian wall decoration remains the same in technique, a very low relief with an emphasis on line.

Archaeologists have long pondered the question of the sources behind the Assyrian system of wall decoration. Though based on previous Mesopotamian themes, these reliefs were inconceivable in southern Mesopotamia, where stone was scarce. Some writers suggest lost wall-paintings as models, citing the stele of Naram-Sin as evidence of a Mesopotamian pictorial tradition whose manifestation in fresco would have been lost due to the fragility of the medium. Others note the thirteenth-century stone wall reliefs executed by the Hittites in their Syrian palaces, which also featured guardian figures akin to the *lamassu*, but whose remaining subjects were primarily mythological. Finally, there may have been some contact between Mesopotamia and Egypt during the second millennium B.C., a period of intense trade and political interchange in the ancient Near East, which would account for the Assyrian reliefs.

The Egyptians had been decorating the walls of their tombs and temples with low reliefs organized into registers since the early third millennium B.C., and by 1480 B.C. the subjects of these reliefs included historical events. If word of the Egyptian model of wall decoration did not reach Assyria by direct contact of trade groups or governmental delegations, then the influence may have been through the intermediary of Palestine–Syria, an object of trade and conquest by both countries.

The exact nature of Egyptian–Mesopotamian relations is a tantalizing question, and one whose roots extend back to the very beginnings

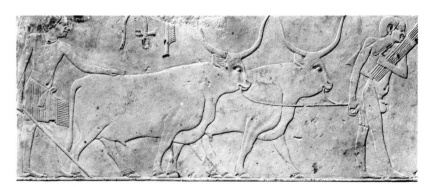

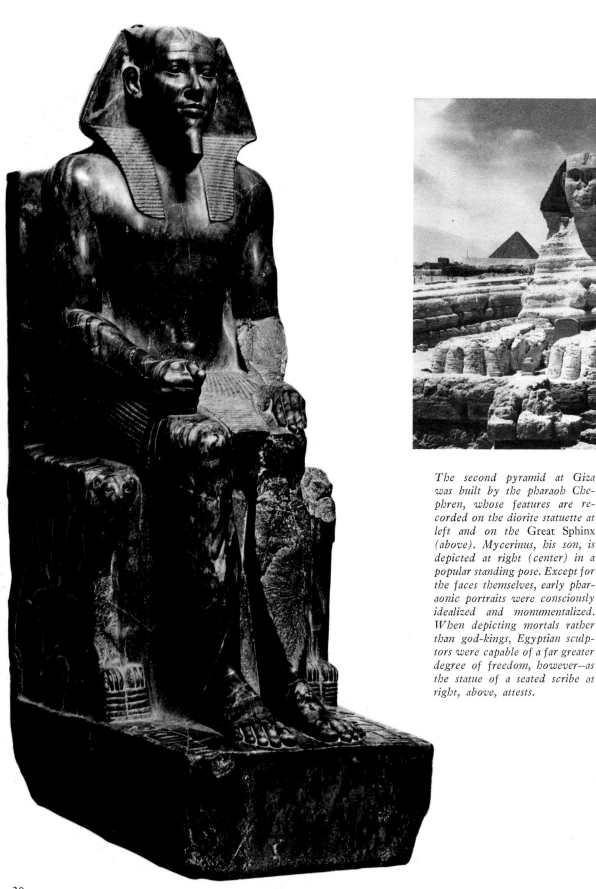

The second pyramid at Giza was built by the pharaoh Chephren, whose features are recorded on the diorite statuette at left and on the Great Sphinx (above). Mycerinus, his son, is depicted at right (center) in a popular standing pose. Except for the faces themselves, early pharaonic portraits were consciously idealized and monumentalized. When depicting mortals rather than god-kings, Egyptian sculptors were capable of a far greater degree of freedom, however—as the statue of a seated scribe at right, above, attests.

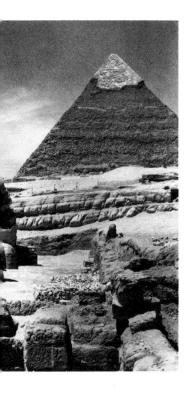

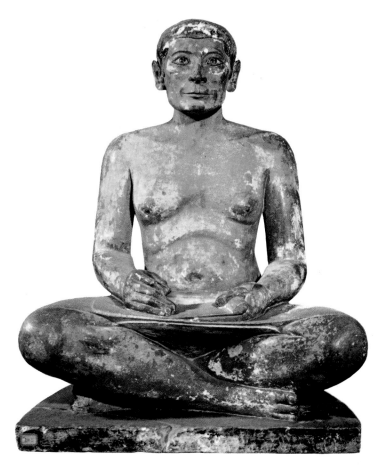

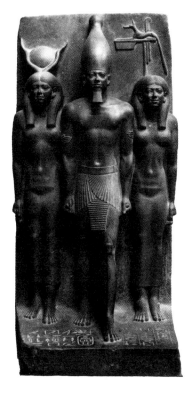

of Egyptian civilization. Contemporary with the Protoliterate Period in Mesopotamia is the Egyptian Pre-Dynastic Era. Archaeological finds from late sites of this period include imported Mesopotamian cylinder seals and pots, plus other evidence of contact with the East. At this time Egypt was divided politically, roughly along geographical lines, into a northern or Lower Kingdom in the Delta, and a southern or Upper Kingdom located along the Nile River valley. The unification of these two regions into one state, around 3100 B.C., concentrated the material resources of the country and the power of its ruler, and allowed for large building projects and their sculptural decoration.

The unification of Egypt, which is so significant from a historical point of view, is celebrated on a two-sided relief known as the *Narmer Palette,* after the name of the Upper Egyptian king who conquered the Delta. This work already announces some of the basic features of Egyptian art. First, the relief is divided into registers with neutral grounds so that space is not actual or scenic but abstract. The character of the figures themselves is suited to such a space. Human figures in Egyptian art are composite forms; while the legs of the king are presented in profile, his upper torso is seen from the front. The same combination of views occurs in the head, with its profile face and frontal eye. The Egyptian artist was unconcerned with visual logic; he was interested in completeness, in depicting forms in their most characteristic shape. The result is a convention for the human body that is not coherent organically, and is therefore incapable of coordinated movement in a real space.

Another convention of Egyptian art that appears on the *Narmer Palette* is the large size of the principal figure. Narmer towers above the kneeling figure of his prisoner, whose hair he holds in a symbolic statement of victory, and he is at least twice the size of the figures walking in procession to inspect the decapitated enemy soldiers. To some extent, this supernatural treatment of the pharaoh reflects his special position in Egyptian life. He was not only an absolute sovereign but also a god, descended from the sun god Ra and the living embodiment of the god Horus, whose falcon appears on the palette.

The reign of Narmer marks the beginning of the First Dynasty of Egyptian history. Dynasties are grouped by Egyptologists into three kingdoms and a later period that ends with the Greek conquest under Alexander the Great in 332 B.C. The Old Kingdom (First-Sixth Dynasties), like the later Middle and New Kingdoms, was a period of strength and political expansion accompanied by artistic creativity. The first monumental stone buildings appear in the Third Dynasty. By the Fourth, they have achieved their canonical form in the great pyramids and temples of Giza, and their standard decoration by means of reliefs and cult statues.

A striking aspect of all these artistic efforts is their funereal purpose. The pyramid housed the tomb of the pharaoh, the temples accommodated his funerary rites and allowed for the presentation of offerings after his death. The same functions were fulfilled by tombs of lesser nobles and court officials but on a smaller scale. All these buildings and their decorations express the Egyptian religious belief in an afterlife that was in some sense a continuation of this one, and which required that a dead man have in his tomb many of his earthly possessions.

Most often, actual objects were buried with the deceased. But where this was impossible because of the nature of the property, low reliefs depicting possessions sufficed. Such reliefs were, in essence, pictorial lists—of estates owned by the deceased, of his servants performing all kinds of tasks, of his cattle and his food. Others portrayed the dead man engaged in the activities he enjoyed in his lifetime, such as boating and hunting. All of these decorations are painted in a limited range of hues to accentuate detail and detach the forms from the neutral background. Human figures are rendered in the same conventional poses found on the *Narmer Palette;* principal figures are always largest.

An essential condition to the achievement of eternal life was the preservation of the dead man's body, considered one of the major aspects of his being. As insurance against the loss of the actual body through decay, a tomb owner provided substitute stone statues in his likeness and had them inscribed with his name and titles.

Statues of pharaohs not only adorned their tombs and mortuary temples but were likewise placed in temples throughout Egypt. The strictest rules governed the carving of these royal sculptures. Their net effect was the creation of an ideal image of the pharaoh, a monumentalized portrait of the living king. The seated statue of Chephren, from his Fourth Dynasty temple at Giza, is perhaps the most perfect realization of this conception. The portrait face identifies the sitter and is the most specific aspect of the sculpture. It is wedded to an idealized,

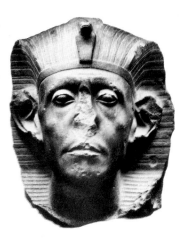

By the beginning of the Middle Kingdom, Egypt's pharaohs were no longer remote gods, a fact reflected in the mutilated bust of Seostris III (above): the Twelfth Dynasty pharaoh is depicted as a careworn and quite mortal monarch. Interestingly enough, the first pharaohs of the New Kingdom were commonly portrayed with the idealism associated with Old Kingdom sculpture, as the statue at right of Thutmose III suggests.

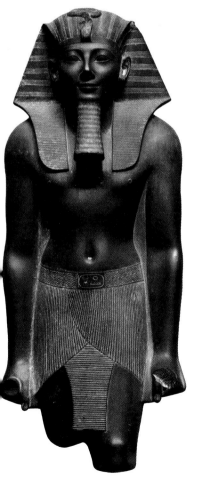

youthful body that expresses the immortal nature of the pharaoh, whose physical appearance is unchanged by time.

A seated figure, which naturally disposes itself in right angles, was best suited to the Egyptian sculptor's mode of working—as it is known from unfinished stone statues excavated at Giza. The sculptor first drew a view on each of the four surfaces of his block and then worked into the stone until his views met, usually in ridgelike lines as on Chephren's right leg and arm. To the Egyptian sculptor, the human form was not something to be seen in the round, but a cubic form, like the block of stone from which it was carved.

Another popular type of pharaonic statue is the standing one, in which the king poses with his left foot forward and his arms tightly clenched at his sides. Here, too, movement is rigidly controlled, and the form remains wedded to the block of stone whose original outlines are indicated by the tall slab remaining at the back. Several such statues of Mycerinus, Chephren's successor, were excavated at the mortuary temple built in association with his pyramid-tomb at Giza.

The enormous effort required by the building projects and sculptural decorations of the Fourth Dynasty pharaohs resulted in the training of a great number of artists. The lesser resources of the succeeding dynasty, coupled with an increase in the power and wealth of the nobility, led to a shift in the direction of sculpture during the latter part of the Old Kingdom.

Artists, now working for dignitaries instead of kings, adapted the seated and standing poses of the pharaonic statues to their new subjects, and even invented other types. A statue of a scribe in the Louvre represents one such invention. Seated cross-legged on the ground, his writing instruments in his hands, the Louvre scribe looks up with an attentive expression. The impression of animation is heightened by the use of paint, a common feature on statues made of poorer quality stone that could not be finished to the high polish of Chephren's seated figure. Here the sculptor has taken greater liberties in the depiction of the scribe's body in accordance with his subject's lesser status. Pectoral muscles sag, and the belly shows a paunch. The tendency, then, at the end of the Old Kingdom, was toward greater naturalism and a sense of the variety of life. Nevertheless, the pharaonic art of the Old Kingdom was considered a norm, an ideal archetype, to which later sculptors and patrons returned again and again.

The unified state of the Old Kingdom collapsed at the end of the Sixth Dynasty, and there followed a period of unrest and foreign invasions known as the First Intermediate Period. By the time the state was reunited at the beginning of the Eleventh Dynasty, under the leadership of nobles from Thebes, the position of the pharaoh had changed considerably. He ceases to be an omnipotent divinity remote from ordinary man; though still possessing divine status, he is now a ruler concerned for the welfare of his people. Faces depicting Seostris III, a pharaoh of the Twelfth Dynasty, express the new cares through downward lines and sagging muscles. The somber-colored stone is typical of sculpture of the Middle Kingdom.

Another Intermediate Period followed the end of the Twelfth

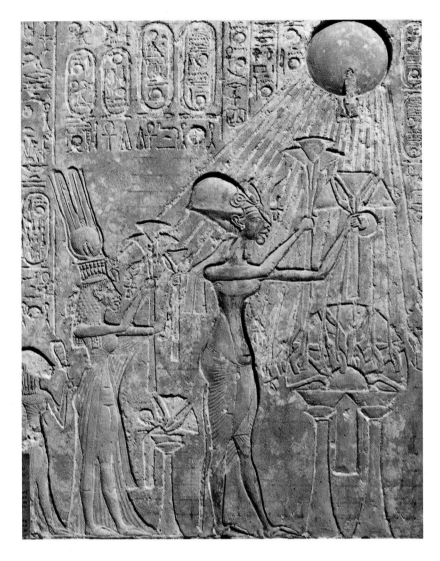

Dynasty, and no large artistic projects were executed until the rise of the New Kingdom under the kings of the Eighteenth Dynasty. This interim era was marked by widespread foreign contact, with Crete, Mycenae, and Western Asia, principally due to the trading activities of the Hyksos, foreigners living in the Delta. The expulsion of the Hyksos in 1580 by Ahmose, first king of the Eighteenth Dynasty, and his subsequent campaigns in Palestine–Syria brought more foreign influences.

When the Egyptians once again began to engage in large-scale artistic projects, some new themes and effects, principally in painting and relief, reflected their widened political horizons. Sculpture in the round remained more conservative, as can be seen in statues of Thutmose III, a pharaoh of the Eighteenth Dynasty. His standing pose, with left foot forward and arms clenched tightly at the sides of the youthful, idealized body, recalls the statues of Mycerinus, as do the pharaonic insignia, the kilt and headdress. A large relief of the same pharaoh, executed for his temple at Karnak, uses the same means to express victory as did the *Narmer Palette*, created 1,700 years before.

Reliefs of later pharaohs are remarkable for their new subjects and treatment. Scenes of the ruler in battle and hunting are portrayed

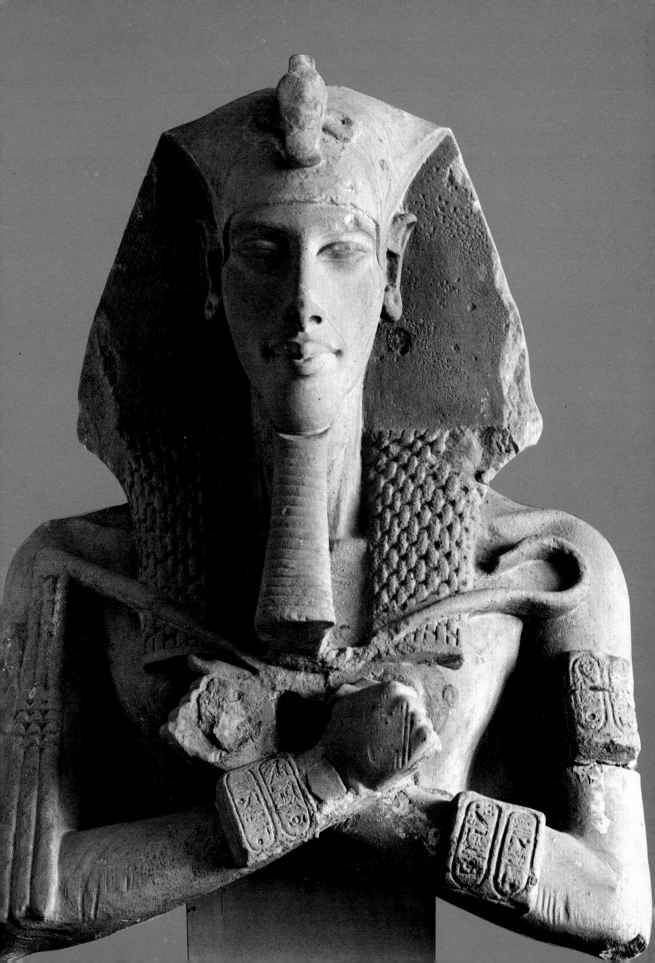

against landscape backgrounds with forms rendered in perspective and capable of convincing movement. To some extent, these innovations were due to an upheaval that took place in Egyptian life during the second half of the Eighteenth Dynasty. Amenhotep IV, probably motivated by a combination of religious and political reasons, attempted to establish monotheism in Egypt. Worship was confined to the sun-disk Aton, whose cult emphasized truth. In order to sever all ties with the previously powerful worship of Amon at Thebes, the king changed his name to Ikhnaten and moved his court to a virgin site, Amarna, whose name is given to this period of Egyptian history.

Since the pharaoh was no longer a god, representations of him were not controlled by the old strictures, the ideal bodily forms and canons of proportion. Instead, the emphasis on truth resulted in the portrayal of all of Ikhnaten's personal characteristics: an elongated face, tilted eyes, a long jaw, loose body, and large hips. In the colossal statues, with their broad treatment of individual forms, these traits are exaggerated to the point of caricature. The same quality pervades the reliefs of the period, which depict Ikhnaten, his wife, and daughters as a loving family, or in their roles as prophets of Aton, whose benevolent rays extend like so many caressing hands toward them.

A new development in the relationship between architecture and sculpture that evolved during the Eighteenth Dynasty led to a preference for large-scale works in the New Kingdom. Instead of being placed inside temples, accessible only to a few dignitaries and priests, statues of pharaohs were now placed on the outside. To harmonize with the size of the architecture, the statues themselves became larger.

At the height of the Egyptian empire under Ramses II, colossal statues were especially numerous. This pharaoh built a great temple to Amon-Re at Abu Simbel whose façade is guarded by figures of the pharaoh that are sixty-five-feet tall. With the reign of the next pharaoh, Egyptian power began to decline, and with it the traditional forms of Egyptian art.

At the time of the Twelfth Dynasty and the Second Intermediate Period, civilization on the island of Crete to the north reached a high point of development known as the Middle Minoan Age. In this period great palaces were built at various sites on the island, primarily centers of administration, trade, and religion. From the largest of these, at Knossos, comes the small figure of a priestess with the insignia of a goddess, an animal headdress, and a snake held in each hand.

The exact nature of Minoan religion is still problematical; yet, from what is known, worship seems to have been concerned with invoking the god's appearance, with epiphany, and with the reality of the moment. Completely absent is the Egyptian emphasis on eternal life. Minoan art expresses its different orientation by its predilection for the depiction of transitory movement.

Similar aesthetic aims are expressed in the relief decoration of a carved steatite vessel, known from its subject matter as the *Harvester Vase*. Around its circumference march a group of men in full stride carrying forked harvesting tools whose long stems rest on their shoulders. The dominant movement of the men from left to right is bal-

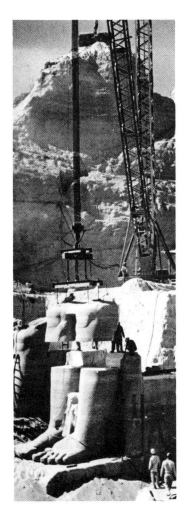

Ikhnaten's successors restored the old pantheon and erected many new temples along the Nile. That at Abu Simbel (below), adorned with colossal statues of Ramses II, was saved from inundation in the 1960s by being moved to a new site high above the waters backed up by the Aswan High Dam.

36

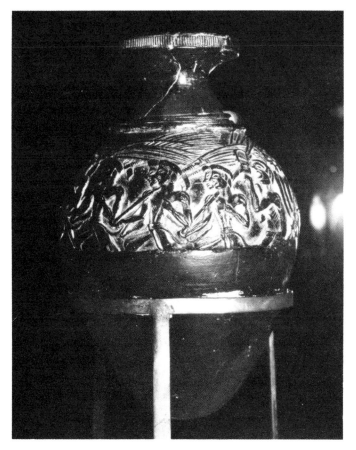

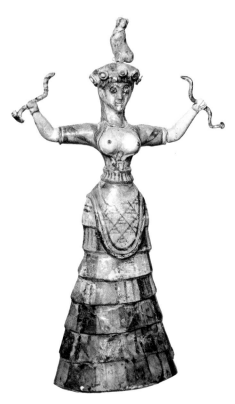

At the time of the Egyptian Middle Kingdom new and vigorous cultures based upon maritime trade arose in the Mediterranean. Foremost among them was the civilization of Minoan Crete, whose artifacts include the terra-cotta Snake Priestess *seen at far right. Her momentary gesture displays a freedom of movement alien to classical Egyptian art. Such freedom is also found on the celebrated* Harvester Vase *(above).*

anced by the long instruments curving from right to left. This play of movement and countermovement is a basic principle of Minoan composition and can also be seen on the frescoes of the great palaces.

Another such principle is the continuous design around the vase, based on a consideration of the shape of the whole. Yet the design is far from monotonous: variations in spacing, in pose, and in the insertion of other figures enliven the composition.

During the last century of their existence, the palaces of Crete were ruled by the Mycenaeans from mainland Greece. Descendants of Greeks who settled in the Argolis around 2000 B.C., the Mycenaeans produced little art for four hundred years. Then, around 1600 B.C., these early Greeks began to construct more elaborate tombs and to furnish them with rich grave goods. In two shaft-shaped tombs within the citadel walls of Mycenae and in one outside, excavators discovered thin gold masks attached to some of the male bodies. All differ in the physiognomy represented so that there was probably some attempt to reproduce the features of the deceased. The whole concept of a death mask is alien to the art of Crete, both for its static quality and for its emphasis on preserving the human form in an eternal afterlife. It may be that the Mycenaeans had contact with Egypt and, therefore, adopted such elaborate burial procedures, but the question of the sources of the new Mycenean practices is far from settled.

Another difficult question in any discussion of Mycenaean art is the source of the other objects found in the tombs. Some appear to be imports from Crete, others are definitely Mycenaean products. Then

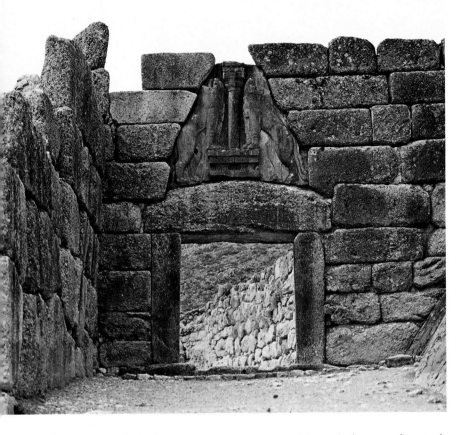

there are works in Minoan style, but executed in techniques and materials without parallel in the art of Crete, such as the two gold cups from a tomb at Vaphio, Greece, decorated with scenes of bull hunting. One cup of the pair is of Minoan workmanship, and the other, illustrated here, was made by a Mycenaean artist who patterned his work on the first cup. Despite the use of numerous Minoan models, the Mycenaean artist reveals himself in several stylistic traits. First, the violence of the scenes on this cup is alien to Minoan art. Second, the cup lacks the continuous decoration encompassing the entire vessel that characterizes the *Harvester Vase*. The narrative is divided into three scenes separated from one another by judiciously placed trees, and also the poses of the falling figures repeat that of the bull. Here, then, one finds none of the countermovement characteristic of Minoan art.

The palaces of Crete were destroyed around 1400 B.C., but Mycenaean civilization flourished for at least two centuries more. In the fourteenth century B.C., the great age of mainland architecture, the Mycenaeans created monumental stone architectural sculpture. Above the massive lintel of the citadel gate at Mycenae stands a relief of two well-modeled lions on their hind legs facing a single column, symbol of the palace and of the goddess who protected it. In its relationship to the architecture, in the conformity of the design to the shape of the frame, defined by the projecting blocks at the sides, the lion relief looks forward to the art of Classical Greece in which temple pediments were filled with statues of heroes thought to have lived in Mycenaean times.

VIVIAN MANN

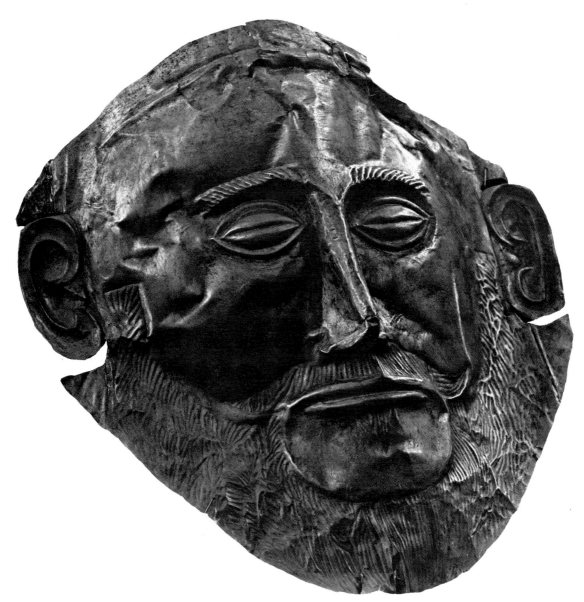

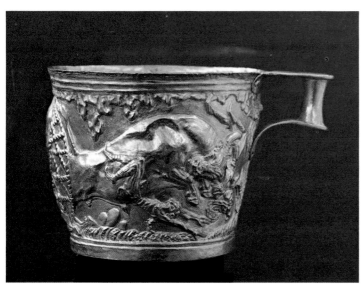

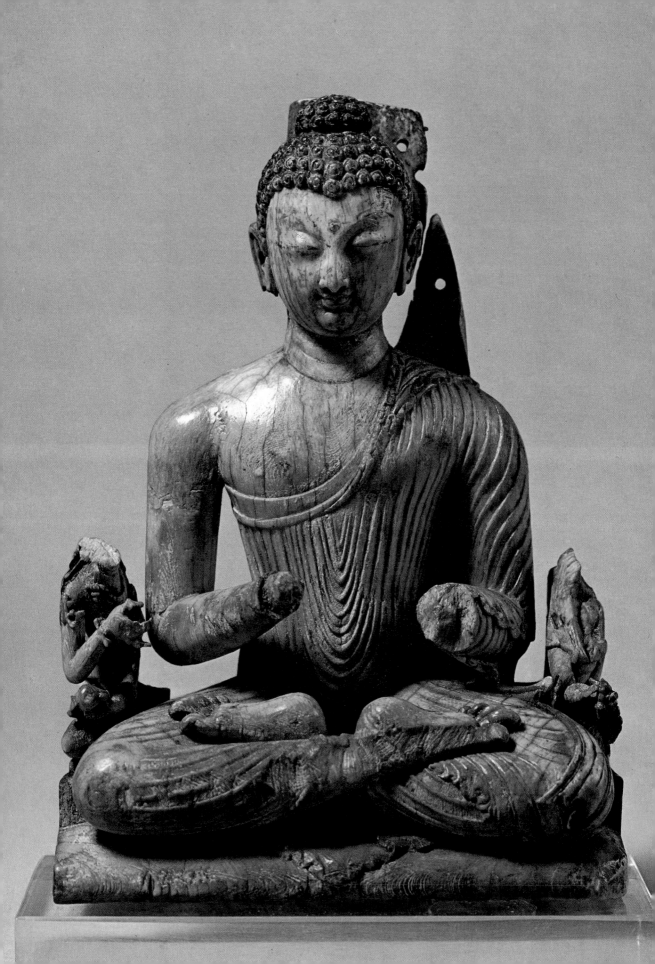

3

The Buddhist Inspiration

The Buddha image originated in India, and the canons governing it were transmitted to every culture that accepted the Buddhist faith. Though created in the eighth century by a sculptor from Kashmir, this small ivory statuette reflects the Indian ideal of proportion and manifests some of the thirty-two physical characteristics associated with the historical Buddha.

To THE EAST AND SOUTH of the Indus River valley lies a vast land mass, heterogeneous in virtually all its aspects yet often conceived of as an amorphous, undifferentiated entity identified simply as "the Orient." In truth, of course, the eastern portion of the Asian continent is in no real sense a unity: its cultures are distinguished by variations in costume and custom, and its peoples belong to disparate ethnolinguistic groups. This diverse collection of cultures has been unified only twice in its history, and then only tenuously—once, briefly, by power, under the thirteenth-century conqueror Genghis Khan; and in a more enduring way by faith, through the widespread acceptance of Buddhism.

The artistic expressions of eastern Asia are understandably as varied and different as the cultures that produced them, with each culture possessing a characteristic inclination toward certain modes of expression. In general it can be said that the genius of the peoples of India and Southeast Asia is basically sculptural, while that of the Chinese and Japanese is fundamentally pictorial. And it is by working on this premise that the broad currents of the history of sculpture east of the Indus become manifest.

By and large, the great sculptural tradition of eastern Asia was fertilized with seeds sown by Indians. Their approach toward the visual arts was always basically sculptural—meaning that sculpture, architecture, and even painting were conceived in terms of palpable volumes. That most rewarding vehicle of the sculptor's art, the human body, was celebrated and affirmed in the substratum of primitive faith that predated both Hinduism and Buddhism, and this attitude was not only manifested but subtly exploited in the art of both later creeds.

In depicting the human body, the Indian sculptor sought not to reproduce nature but to create forms parallel to nature. Greatly influenced by the dance, he interpreted the body as a receptacle filled with breath and pulsating life, and he attempted to render externally its inner sensations as they rose to the surface. For the Indian, the entire body was an organic whole. There was no western-style dichotomy between the head as the seat of the intellect and the body as the vehicle of the senses, since the head was seen as the location of the instruments of the senses and the point at which the body inhaled the sustaining breath upon which its vitality depended. The human body was articulated in sculpture through those canons of proportion that were

41

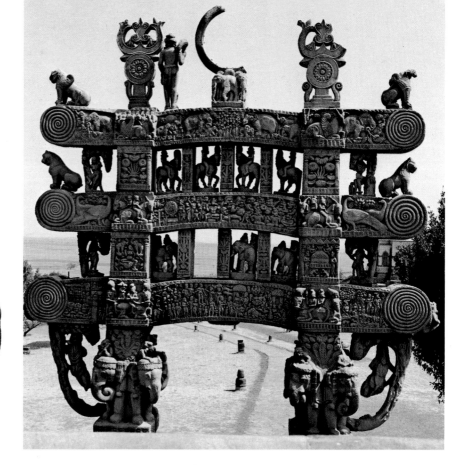

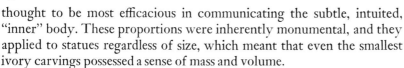

thought to be most efficacious in communicating the subtle, intuited, "inner" body. These proportions were inherently monumental, and they applied to statues regardless of size, which meant that even the smallest ivory carvings possessed a sense of mass and volume.

The assertion that this unique attitude toward sculpture and the human body existed at the dawn of Indian history is verified by statuettes found among the remains of the civilization that flourished in the Indus valley between 2500 and 1500 B.C. From that time until the rise of the Maurya dynasty in 321 B.C., however, there are scant remains of any type of artistic activity. The creative energy of that thousand-year span was dedicated not to the arts but to religion and philosophy, and it was then that the religious systems that were to dominate all of eastern Asia were formulated. The first of these was Hinduism, which developed out of Indo-Aryan worship of the powerful deities of nature.

In the sixth and fifth centuries B.C. two new religious, Jainism and Buddhism, were to develop on the Indian subcontinent. Both avoided the Hindu dependence on priests and sacrifice, and both concentrated their emphasis upon the means by which an individual could escape from the karmic cycle. While the impact of Hinduism was limited to India and Southeast Asia, the adaptability and universality of Buddhism assured its growth and spread elsewhere. Indeed, there was hardly a culture in eastern Asia that remained untouched by this faith of inner and outer peace. Wherever these two Indian creeds were to travel, the

forms, techniques, and iconography of their art also followed, acting as a vital catalyst that invigorated the artistic production of those lands.

The earliest examples of monumental Indian sculpture were produced in the service of Buddhism and inspired by the West. After his conversion to the new faith, the emperor Ashoka, a member of the Maurya dynasty, erected a series of great pillars inscribed with edicts. Representing the official, imperial style of sculpture, these pillars of highly polished sandstone supported depictions of symbolic animals. The Ashokan pillars are frequently compared in style, technique, and conception to the capitals of Persepolis, the slightly earlier seat of Achaemenid rule. The exact nature of the Achaemenid influence is uncertain, but the similarities are indeed striking. The Mauryan period also gave rise to a monumental secular style best exemplified in massive depictions of *yakshas* and *yakshis,* or nature deities, that may have been based on wooden prototypes.

In 185 B.C. the Maurya dynasty gave way to the Shunga, which governed north-central India. The most notable sites of the Shunga period are the *stupa* of Bharhut and the monastery at Bhaja. A *stupa,* or relic mound, is a solid hemispherical structure faced with stone, usually covered with stucco, and topped by umbrellalike appurtenances. This fore-

One of the greatest monuments of early Buddhist art in India is the great stupa *at Sanchi, whose gateways (near left) were ornamented with reliefs and bracket figures of* yakshis, *or fertility deities such as the one seen at far left. At this formative stage the Buddha was represented by symbols alone—and thus his image does not appear on the relief from Amaravati at right.*

runner of the East Asian pagoda was actually a sculptural rather than an architectural conception, for it was not an enclosing edifice but a solid, sculptural mass. Its encircling railings and its four gates, located at the cardinal points of the compass, were usually carved with scenes from the lives of the Buddha, with donor figures, vegetal ornaments, and nature deities pressed into the service of the Buddhist faith.

The greatest monument erected in the central and southern part of India during the ensuing Andhra period is the great *stupa* at Sanchi, built before A.D. 50. At Sanchi, sculptural decoration is concentrated on gateways carved with lively narrative reliefs and adorned by graceful figures of *yakshis*. These female figures were meant to be seen primarily from the front and back, and they appear as if they are composed of two high reliefs set back to back.

The narrative reliefs at both Bharhut and Sanchi depict the Buddha's several incarnations, indicating the presence of the Enlightened One through such symbols as the Wheel of the Law, a set of footprints, or a *stupa*. This approach was called for during the early stage of Buddhism because the abstract quality of his true nature was believed to be indescribable. By the second century A.D., however, anthropomorphic representations of the Buddha did begin to appear, reflecting the ascendancy of the new Mahayana doctrine in which devotion to the Buddha as a supermundane being was encouraged.

The Buddha image itself was developed under a non-Indian dynasty, the Kushan, who were of Tartar origin. The two main Kushana schools of sculpture were centered at Gandhara and Mathura. The former, which flourished from the first through the fifth centuries A.D., is alternatively called Greco-Buddhist, Greco-Scythian, and Romano-Buddhist. The art itself is actually a composite of Indian, Iranian, and Greco-Roman elements. While the Gandharan school developed its style from foreign elements, the Mathura school adapted its style from the indigenous sculptural tradition. In contrast to the Apollo-like quality of Gandharan Buddhas and bodhisattvas, the Mathura Buddhas are reminiscent of native nature deities.

In A.D. 320, following five centuries of division, Chandragupta I was to unite northern India—and in so doing was to inaugurate the classic age of Indian art, an age whose accomplishments have never been rivaled. Lasting for four hundred years, the Gupta period saw the establishment of the canons of beauty that were to regulate the form of the Buddha image ever afterward. The sculptural standards of the Gupta period, the first "international style" of Buddhism, were set at the main workshops in Mathura and Sarnath. The Mathura style is harder, with traces of lingering Kushana influence, while the Sarnath style is softer, more sinuous, and highly refined. Although the Guptas were Hindu, they supported Buddhism, and as a result sculpture was produced during their reign in the service of both religions.

The term Medieval is frequently applied to the art of the Hindu dynasties that ruled after the fall of the Gupta empire. In the field of sculpture, the general tendency that can be discerned is a movement away from the composed, restrained, balanced expression of Gupta art toward a more vigorous and dynamic interpretation of form in space.

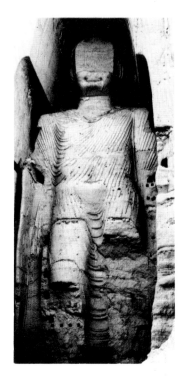

The sculptural style of the Gupta period—which marks the first "international" phase of Buddhist art—was to prove far more durable than the empire itself. Thus long after Gupta rule had ended its artistic legacy flourished throughout Asia—as indicated in the forms of the ninth-century Nepalese bronze at near right and the twelfth-century Cambodian work at far right. The great stupa of Borobudur on Java likewise attests to the pervasiveness of Gupta influence. Its reliefs and Buddha heads (above, right) reflect the Sarnath Gupta style as reinterpreted by the Javanese. Indian artistic canons also traveled to Afghanistan, where monuments such as the polychromed and gilded colossal Buddhas of Bamiyan (above) helped to transmit Indian forms to China.

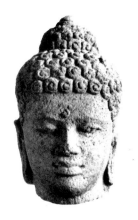

The early Medieval style of the south was dominated by the art of the Pallava kingdom (c. 600–750), which was to influence the sculptural schools in the central and north of India as well as those of Cambodia and Java. The origin of the Pallava style lies in the fleshy and rigorous forms of Amaravati, and the two greatest Pallava monuments, Mamallapuram and the Kailasanatha at Kanchi, bear witness to the fecund imagination and consummate skill of the Pallava sculptor.

In central India, the site of Ellura is unrivaled in its grandeur. The entire complex is carved from solid rock, and in the caves and the Kailasanatha can be traced the development of Medieval Hindu sculpture. The depiction of Shiva as Lord of the Dance in cave number XXI reflects the serenity of the Gupta spirit, but the relief of Vishnu, depicted in his lion avatar in the Das Avatara cave, is more dynamic in conception. Still more electrifying is the scene of Shiva and Parvati above the demon king Ravana in the Kailasanatha, a tableau that communicates a vital surging energy through its animated forms and so exploits space and depth that the division between relief and sculpture in the round is dissolved.

The basic tactile quality of Indian art, its tendency toward three-dimensional form, and its inherent monumentality were to influence profoundly the sculptural development of the cultures that came into contact with the art of India through its religions. The Southeast Asian kingdoms were especially receptive to the influences of their more advanced western neighbor, and the artistic life of these cultures, which had previously produced few objects of any interest, was quickened by the vital impulses experienced through contact with India. Of the Southeast Asian cultures, the Khmer and the Javanese were best able to

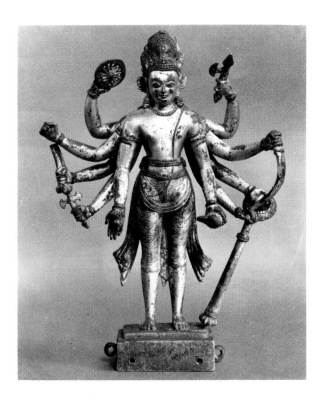

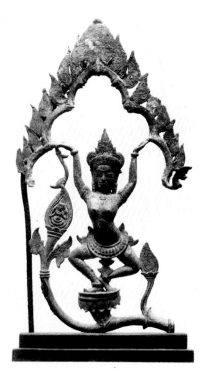

assimilate Indian concepts, forms, and techniques and adapt them to their own needs. The single most significant product of Indian influence on the island of Java is the great *stupa* of Borobudur. Unlike the Indians, who carved away the sides of mountains to create their temples, the Javanese transported stone to the sites of their temples and erected massive monuments to honor their gods. Built at the beginning of the ninth century, Borobudur is a mandalic construction conceived as a statement of the Buddhist faith in stone, covered with narrative reliefs and populated by symbolic Buddha figures.

Both the Javanese and the Khmer cultivated the cult of the god-king, or *devaraja*, but the Khmer were more ambitious in translating this concept into stone. And thus it was that while the Javanese were building Borobudur, these Hindu rulers of Cambodia were creating temple-mountains for the posthumous worship of kings. Initiated in the 800s, this concept did not achieve its ultimate statement until the twelfth century, when Angkor Wat and Angkor Thom were constructed. Both of these temple-mountains were lavished with carved decoration; Angkor Wat alone contains more than a mile of reliefs.

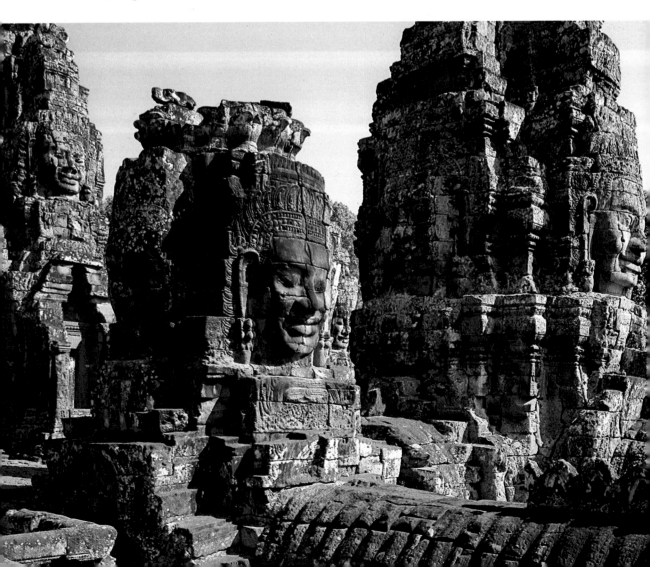

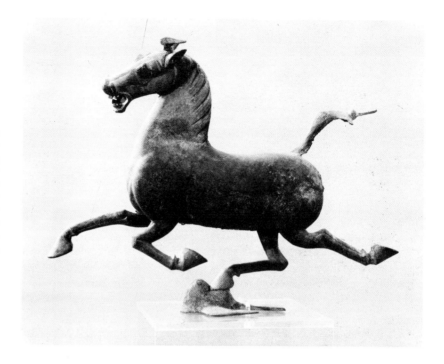

The builder of Angkor Thom, the most ambitious of Cambodia's massive temple complexes, was a fervent Mahayana Buddhist. His personal identification with Lokeshvara, Lord of the Worlds, is manifested in the giant heads that are carved on the towers of the Bayon (opposite). China's sculptural tradition vastly antedates the introduction of Buddhism in the early centuries of the Christian era. Indeed, as early as 1500 B.C. Shang dynasty sculptors were producing bronze ritual vessels like the one below with extraordinary technical precision. The Han dynasty created China's first monumental stone sculpture as well as some of its most striking bronzes, among them the recently excavated Flying Horse, *the animated figure at right.*

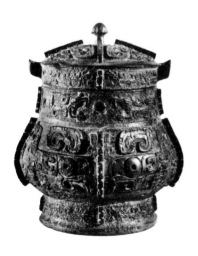

Although both Hinduism and Buddhism served as vehicles to transport the sculptural forms of India to Southeast Asia, Buddhism alone was responsible for the communication of Indian artistic concepts to eastern Asia. The nomads of central Asia, for example, proved highly receptive to Buddhism, and their fortuitous location on the great silk routes that linked China with western Asia and Rome resulted in their playing an instrumental role in introducing the Buddhist faith to China. Indian influence was exerted on Central Asia through Gandhara, and impressive evidence of the strength of this influence can be seen at Bamiyan in present-day Afghanistan, where two colossal Buddhas, one nearly 115 and the other nearly 173 feet in height, still stand.

When Buddhism reached China, it was for the first time faced with a highly developed, sophisticated culture with deeply rooted indigenous philosophical, literary, historical, and artistic traditions. The tortuous process of assimilation that ensued was hardly a Buddhist conquest of China; indeed, it has been suggested that this was more a Chinese conquest of Buddhism. Alien faith that it was, Buddhism managed only to graft itself onto the larger body of Chinese traditions.

China was hardly in need of instruction in the art of sculpture, for the sculptural medium had been admirably exploited by the Chinese since the very inception of their civilization. During the Shang dynasty (1550–1030 B.C.) for instance, bronze ritual vessels were cast by the piecemold process with a technical precision that still defies explanation. The carved jades of the same period, also ritual in function, include pieces shaped into axe-blades, disks, birds, and animals. The following period, the Chou (1030–256 B.C.), saw an initial continuation of the forms of the Shang dynasty in ritual bronzes, but both forms and techniques deteriorated by the middle of the period. By the end of the Chou period, however, a new sensibility was apparent in the bronzes as well as the jades; the bronzes are more rounded in shape and inlaid with intricate designs in precious metals, while the jades are elabo-

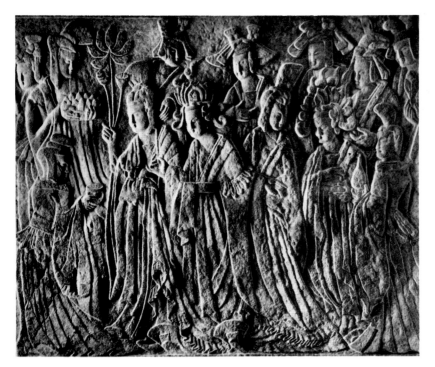

In the turmoil that followed the collapse of the Han dynasty, Buddhism made substantial inroads into China. The earliest independent Buddhist images in China took the form of small gilt bronzes whose linear style is displayed in the expressively attenuated pair of Buddhas below. The imperial procession at left, from the Northern Wei caves at Lung-men, reflects the native Chinese sense of form even more emphatically. The T'ang dynasty, often identified as the Golden Age of Chinese sculpture, was to produce works of great force and imagination (right, below), but many of these were lost in a later wave of anti-Buddhist iconoclasm. It remained for Sung dynasty sculptors to attempt to revitalize Buddhist art through such magnificent statues as the polychromed Kuanyin at far right.

rately carved with sinuous animal forms and are profusely decorated, indicating that they are now more ornamental than ritualistic.

During the Han dynasty (202 B.C.–A.D. 220), the earliest known Chinese monumental stone sculpture appears. The statue of a horse trampling a barbarian archer that stands outside a Shensi tomb is believed to be that of the general Ho Ch'u-ping, who died in 117 B.C. The work itself is heavy and static, with only rudimentary attempts at modeling; it is clear that the sculptors of this work were not adept at carving in the round. Carving in low relief was an art at which the Chinese sculptor excelled, however. Significantly, these reliefs are more pictorial than sculptural in conception and are actually closer to engraving than to relief. Typically depicting Confucian and Taoist themes as well as historical events, each scene pulses with a rhythmic vitality achieved through the subtle juxtaposition of light against dark.

Although the Chinese sculptor did not appear to be particularly sympathetic toward three-dimensional carving, he was nonetheless extremely adept at modeling in the round. The funerary bronzes recently excavated in mainland China—among them the splendid *Flying Horse* from a Western Han tomb in Kansu—reveal a sensitive hand in the creation of the original wax model. On a more folkish level, pottery tomb figurines and animals were also modeled with remarkable expressivity. Thus it was that by the time of the introduction of Buddhism into China in the first centuries A.D., sculptural activity was centered on the production of tomb furnishings. Carving in flat relief had been mastered, but monumental sculpture was limited to works produced under foreign influence.

The ensuing Six Dynasties period (265–581) saw the rapid development of the Buddhist faith under the aegis of the T'o-pa Wei Tartars, who consolidated the north of China under their rule. Like the Kushans in early India, the rulers of this foreign-born dynasty were

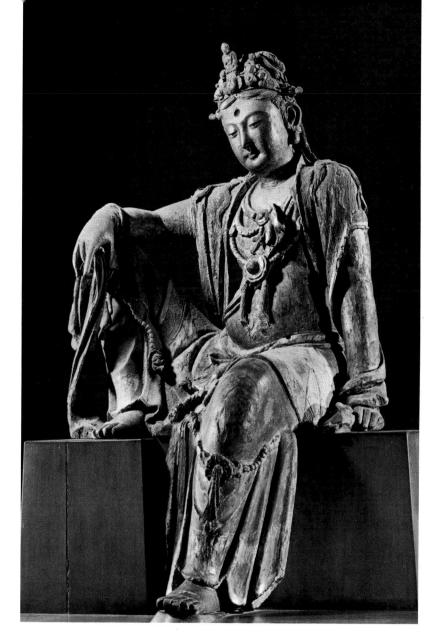

excluded from the traditional cultural and religious systems of the land
they had conquered, and they therefore utilized Buddhism not only as a
vehicle for their religious inclinations but also as a force by which to
unify their subjugated peoples and elicit sympathy for their own rule.

In the year 460 the rulers of the Wei dynasty initiated an ambitious
project that involved the carving of a series of cave temples in the sand-
stone cliffs at Yun-kang, caves that would house colossal Buddhas
meant to symbolize both the power of Buddhism and the greatness of
the royal house itself. And when the Wei capital was moved in 494
from the northwestern capital at Ta-t'ung to Lo-yang in the heartland
of China, a new series of cave temples was initiated at the site of Lung-
men. The finer grained limestone of this site proved a suitable vehicle
for the expression of an increasingly sinified, refined, linear style best
illustrated by such secular reliefs as the slab depicting an empress in
procession that is now preserved in the Nelson Gallery in Kansas City.

After the middle of the sixth century, however, the influx of direct

influence from the Indian subcontinent stimulated a change in style away from the linear, geometricized forms of Northern Wei and back to a more volumetric conception of the human form. Unlike the ossified Indian style that had first been transmitted through Central Asia, these sixth-century influences came directly from the living art of Gupta India, leading the Chinese to attempt for the first time to animate their stone carvings with a sense of breath and to indicate the vital body hidden beneath the garments.

The year 618 marked the founding of the T'ang dynasty and initiated a period of prosperity and glory that would last for the next three hundred years. The capital city of the T'ang, Ch'ang-an, was the greatest city of the seventh- and eighth-century world, and the center of an empire that stretched from Korea to Samarkand. The T'ang period also marked the apogee of Buddhist influence in China, and during this period an insatiable demand for icons absorbed the energies and talents of the greatest painters and sculptors of the time. Toward the end of the T'ang dynasty, however, indigenous Taoist and Confucian factions militated against the enormous influence of the Buddhists, and finally succeeded in having all foreign religions proscribed in 845. During the Buddhist persecution, temples were confiscated and icons destroyed, so that the majority of the great artistic achievements of the high T'ang period are now lost.

The sculptural style manifested in the Buddhist images of the high T'ang period was to become the second "international style" of Buddhist sculpture, transmitted from the Chinese mainland and eagerly adopted by the Koreans and the Japanese. Indeed, certain aspects of T'ang sculpture are better studied today in these countries, the 845 persecutions having destroyed so many of the products of the T'ang genius in China itself. The eighth-century Korean shrine at Sokkuram is an excellent example of the transmission of the high T'ang style to the peninsula. The great Japanese bronzes of the same century, among them those of the Yakushi trinity in Nara, are reminders of now lost works that revealed the skill of the T'ang bronze-caster.

In the centuries that followed the fall of the T'ang empire the Chinese genius was devoted to developing the art of painting. Buddhist sculpture would be revived by the Sung after their accession in 960—and later by the foreign dynasties of Liao, Chin, and Yuan—but it would never again repeat the remarkable attainments of the T'ang period. The most impressive products of Buddhist sculpture of the post-T'ang dynasties are the polychromed and gilded wooden statues of the bodhisattva Kuanyin, whose magnificence and compassion were conveyed through suavely modeled and elaborately caparisoned figures.

The sculpture of Japan is indissolubly linked to the fortunes of Buddhism in that country, for before the advent of Buddhism in the sixth century, sculpture was limited to small clay figurines and cylindrical clay *haniwa*. After that time sculptural activity was centered on the production of statues in the service of the faith. Japanese sculpture is significant in that it is better preserved and better documented than any other of the sculptural traditions of Asia. The respect with which the Japanese regard their ancient traditions has insured the continuous pres-

Before the introduction of Buddhism in the sixth century A.D., Japan's sculptural output had been restricted to the production of haniwa, *or clay funerary figures (above). With the aid of émigré sculptors from China and Korea, however, the first permanent capital of Japan, Nara, was to become a flourishing center of Buddhist art. The city's largest temple, Todai-ji, once housed a representation of the Buddha that is believed to have been the largest bronze ever cast. The statue at right is a seventeenth-century reconstruction of that monumental work.*

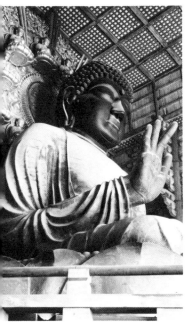

ervation of the masterpieces of the past, and since Japanese sculpture was so deeply affected by the sculptural developments of the Asian mainland, it provides a living museum in which to study the pan-Asian stylistic currents that left their final imprint on the art of Japan.

The traditionally accepted date for the introduction of Buddhism to Japan is A.D. 552, when statuettes and religious texts were presented to the imperial court by the Korean kingdom of Paekche. The seventh and eighth centuries saw a rapid development of sculptural forms and techniques inspired by the continuous importation of new styles from the Chinese mainland. In the first half of the seventh century, for example, the Chinese prototypes of the Northern Wei period were transmitted to Japan by way of the Korean peninsula, but direct contact was made with China by the end of the century and mainland styles were thereafter assimilated with great rapidity.

The Japanese archipelago's earliest sculptors appear to have been naturalized Chinese and Koreans or their descendants. To cite but one instance, the Buddhist sculptor Tori, whose style is practically synonymous with the Asuka period (552–645), was of Chinese descent. Tori was responsible for both the earliest Buddhist image produced in Japan, a bronze statue executed in 606, and the best-known example of Asuka period sculpture, the bronze Shakyamuni Triad, created in 623 for the Golden Hall of Horyu-ji near Nara. Both of these statues are strongly reminiscent of the Northern Wei style of Lung-men.

The Asuka period and the following Hakuho period (645–710) are noted for sculpture in bronze, both monumental and miniature, and for wood carving. The Hakuho period corresponds to the early phase of high T'ang in China, and the range of sculptural styles exhibited reflects the forms of Northern Wei through T'ang. Hakuho period statues are commonly described as "childlike" in their ingenuous rendering of both body and countenance. Superior examples such as the shrine of the Lady Tachibana combine this seeming naïveté of form with highly sophisticated detail executed with unfaltering technique. By the end of the Hakuho period, however, all vestiges of naïveté had been abandoned, and bodies had become full, modeled with increasing naturalism.

The ensuing Tempyo period saw the prestige of Buddhism at its apogee. Buddhist art flourished under imperial patronage, and Japanese sculptors were kept abreast of the latest developments in T'ang China by the official envoys who traveled between the two countries. This period is unsurpassed in the history of Japanese sculpture in the richness of the techniques and materials lavished on the production of images: dry lacquer, clay, tile, bronze, precious metals, and wood. The casting of the Great Buddha of Todai-ji during this period was literally to consume the wealth and energies of the Japanese nation.

In contrast to the sophistication and contained naturalism of the Tempyo period, sculpture of the Early Heian period (794–894) is massive and solid. Often unpainted, it imparts a strong sense of the wood from which it was carved, and it is often forbidding in appearance. This radical reinterpretation of Buddhist sculpture appears to have been effected by the introduction of Esoteric (Tantric) Buddhism, mainland

influences, and the impact of rustic statues carved by ascetics and monks divorced from the official ecclesiatic establishment. The new style is exemplified by the altar of To-ji in Kyoto, which consists of twenty-one deities of the Esoteric pantheon arranged as a mandala.

In the year 894 the practice of sending imperial envoys to China was abandoned, thus marking the beginning of a new, culturally isolated period known as the Late Heian or Fujiwara. Throughout this period, which lasted until 1185, the aristocratic Fujiwara family dominated the political horizon, and the refined tastes of the imperial court dictated the style of the artistic products of the time. Gradually the powerful austerity of Early Heian statuary gave way to grace, elegance, and refinement. The works of the sculptor Jocho, for instance, are a distillation of the essence of Fujiwara sculpture, and his 1053 statue of Amitabha, enshrined in the splendid Phoenix Hall at Uji, near Kyoto, is perhaps the supreme embodiment of the Fujiwara aesthetic.

A number of significant developments in the field of sculpture occurred during the Late Heian period. Cut off from the Chinese mainland, the Japanese began to formulate their own sculptural aesthetic, and for the first time Buddhist sculptors enjoyed improved social positions. During this period the joined wood-block technique was perfected, and distinct provincial styles began to emerge. Headed by the master sculptors of the age, sculptors' guilds were formed, and statues were produced in an assembly-line technique facilitated by the joined wood-block method.

While Fujiwara sculpture was abstract, refined, and ethereal, the sculpture of the following period, the Kamakura (1185–1333), was naturalistic, vigorous, and powerful. The return of a naturalistic tendency in sculpture was instigated by a reacquaintance of sculptors with the forms and techniques of the Tempyo period that occurred during restoration work carried out in the Nara district after the Gempei Wars. Moreover, the newest Buddhist sects — the Pure Land, Nichiren, and Zen—were patronized by the warrior class and the common people, not by the aristocracy, and this created a demand for expressive and readily appealing icons. Communication with the Chinese mainland was also reestablished, admitting new currents of influence.

The sculptors' guilds had by this time become firmly established, and the Kei school, related to Jocho, came to dominate the sculptural production of the entire Kamakura period. Indeed, two great Kei school sculptors, Kaikei and Unkei, produced some of the finest works in the history of Japanese sculpture. Active from 1175 to 1218, Unkei communicates in his work the spirit of Kamakura; his statues are endowed with powerful, massive bodies cloaked in free-flowing, naturalistic drapery and bear expressive countenances. Among his most famous works are the imaginary portraits of Asanga and Vasubandhu in the Kofuku-ji in Nara. In contrast to the vigorous works of Unkei, the statues of Kaikei exhibit stronger Sung Chinese influences, are more lyrical in mood, and more refined in form. The traditions so firmly established by Unkei and Kaikei were continued by successive members of their school, and their respective styles were still very much in evidence in the latter part of the Kamakura period.

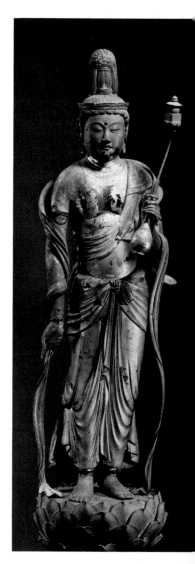

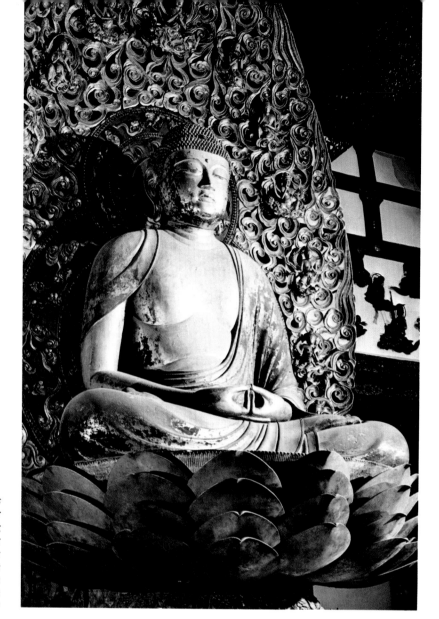

The Kyoto of Prince Genji's time was to produce a sculptor of surpassing talent, a shining prince in his own right. His name was Jocho, and his works —the most famous of which is the sublime statue of Amitabha at right—are an all but perfect fusion of the courtly aesthetic of ancient Japan. The Kei school, the Kamakura-era followers of Jocho, was dominated by two master craftsmen, Unkei and Kaikei. The latter is credited with the lyrical bodhisattva at left, a superb example of the joined wood-block technique.

The Zen sect, which had been growing slowly during the Kamakura period, eschewed the use of religious icons, and for that reason, among others, the demand for Buddhist statuary began to decline. The sect was active in commissioning portrait statues of illustrious monks, however, and this ecclesiastic portraiture proved a more vital area for sculptural activity than the traditional production of icons.

Although both sacred and secular sculpture continued to be produced through the Muromachi, Momoyama, and Edo periods—that is, from the fourteenth well into the nineteenth centuries—it was generally not of high artistic quality. Without the sponsorship of the Buddhist faith, sculpture in Japan could not survive, for it had primarily existed to serve the needs of religion. And although subsidiary genres, such as the carving of Noh masks for the theater and of miniature wood and ivory figures called *netsuke*, did exist, true sculpture was not to be revived until contact with the West once again established it as a significant art form.

WIDAYATI ROESIJADI

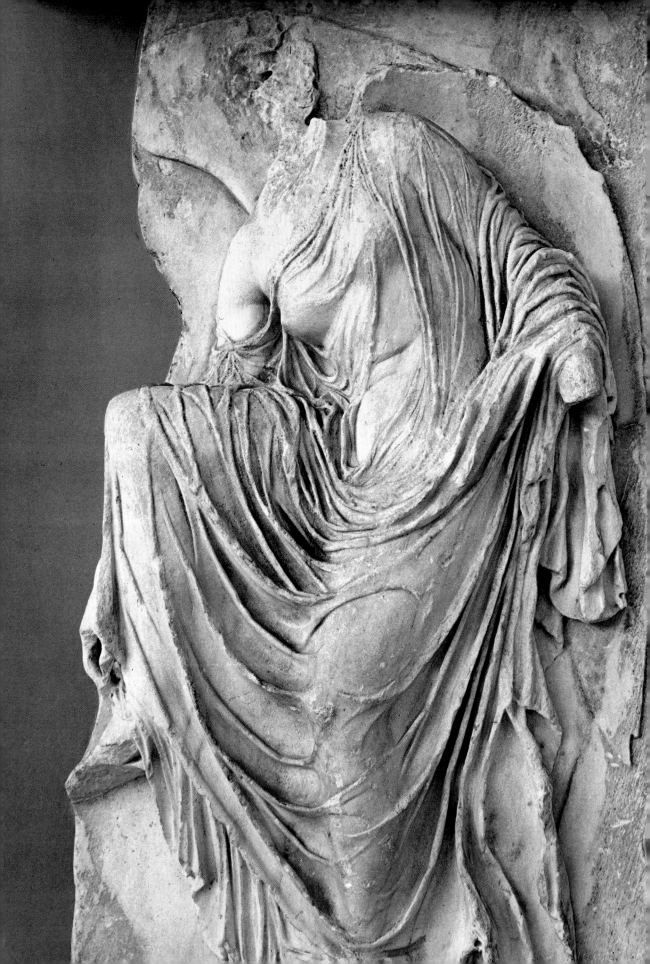

4

The Classic Ideal

AT THE END OF THE BRONZE AGE, invasions and destruction of most sites in Greece brought about several centuries of dire poverty during which the pictorial traditions of the past were lost. The beginning of emerging wealth called for the invention of new forms, forms that were to influence the entire course of Western art. The rebirth of Greek art began with the style called Geometric, a style of essentials, with ornaments and figures limited to a strict discipline of geometric shapes. It is telling that Greek art began with abstraction, for it is clarity of mind that marked Greek sculpture throughout its history.

The first sculptures to appear were small figurines of clay or bronze, which closely resemble the painted figures on contemporary geometric vases. One of these, a bronze horse from the Peloponnesus, has been analyzed into clear geometric components—the torso is a mere rod connecting the flat haunches and forepart. Yet the alert stance, the bulging eyes, and the sharp projections of the ear and leg joints give even this simple figure a living presence.

This liveliness was the quality the Greeks themselves most appreciated in their art. Daedalus, the archetypical great artist, was said to have made figures so lifelike that they could get up and walk away. Because he was credited with the invention of monumental sculpture, the style of the first large-scale figures, which appeared in Greece in the seventh century B.C., is called Daedalic. This century, called the Orientalizing period, saw a great expansion of trade with the Eastern Mediterranean, and foreign products introduced Greek artists to new motifs, materials, and methods of manufacture. The rigorous Geometric style relaxed to allow variety and bold experimentation. Although the resultant works were often strange and clumsy when an artist's mastery fell short of his ambition, they have the excitement of new beginnings. This was the most inventive period of Greek art.

By the beginning of the Archaic period around 600 B.C., intense experimentation had produced what were to become the traditional Greek art forms. The most important of these forms were the Doric temple and the *kouros*, or standing youth. The two have much in common: both are designed to articulate the structure. The Doric temple is essentially a piece of sculpture; all its columns and structural parts were carved on the exterior and meant to be seen and understood from the outside.

The idea of carving temples and figures of stone was inspired by

Ancient Athens reached the apogee of its political and cultural powers during the second half of the fifth century B.C., when the Parthenon, Erechtheum, Propylaea, and the small temple of Athena Nike were constructed. The Victory adjusting her sandal *(opposite), from the Nike temple balustrade, illustrates Classical Greek sculpture at its most sumptuous.*

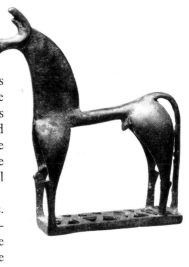

Egypt, and the scheme of the *kouros*, with left foot forward and fists clenched at the thighs, was derived from Egyptian art. So was the method of working, whereby the sculptor applied measured drawings to the original rectangular block of stone, and then patiently carved away layers from the surface. This was a painstaking method but one that allowed complete control, and the earliest *kouroi* preserve the large flat planes and ninety-degree angles that allude to the original block of stone.

Yet the Greek *kouros* is strikingly different from Egyptian figures. The sculptor has cut away all the stone from around the figure, technically a daring practice, and has left the heavy stone mass of the figure supported only by the ankles. Always portrayed nude to reveal the body with total clarity, the Greek *kouros* has been analyzed into parts, with special emphasis on the pelvis, knees, and elbows, the points from which the body moves. The result is a diagram of the human body as a machine for motion, a block of stone transformed into a living being.

The same fundamental desire to achieve vitality in their works led Greek sculptors to seek to improve the *kouros*. They began to substitute more accurate anatomical forms for the simple geometric features of the earlier examples. To accomplish this, they must have studied the youths who trained nude and competed in athletic contests and incorporated these observations into their work. The result was that, by the end of the sixth century, B.C., the male anatomy had been mastered in one of the quickest developments that art had ever seen.

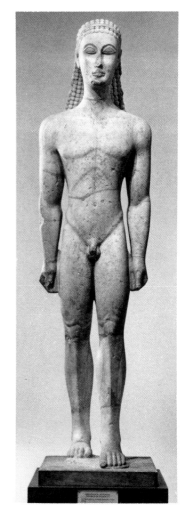

The *Athlete Base* from Athens illustrates these gains. With rather awkward exuberance, the sculptor shows off his new knowledge of the body in figures seen from the front, back, and sides. He has learned how the body changes when figures turn and twist and raise their arms. The clear definition of each muscle, bone bulge, and tendon gives the relief the rich ornamental character of late Archaic art.

Interest in the structural dynamics of the body led ultimately to one of the most important inventions ever made in sculpture, the *contrapposto*, which is simply the position of standing on one leg with the other relaxed. It is, of course, an illusion, for the marble itself is neutral. Yet with this illusion the sculptor can convey the idea of inner dynamics, of tension and relaxation within the body. One of the earliest works to show the *contrapposto* is the *Kritios Boy* from the Athenian Acropolis, made shortly before 480 B.C., when the Acropolis was razed by the invading Persians. The upper body of the piece responds tentatively to the shift in weight: one shoulder is raised a bit and the head is turned slightly to one side. The figure has gained an inner existence, and the obvious Archaic means of showing life are no longer necessary. The walking action changes to rest, the direct gaze moves aside, and the lips begin to turn down with a new seriousness. The figure is on the brink of the Classical period.

During the Classical period, bronze came to be the preferred material for all but architectural sculpture. Some elements of the *Kritios Boy*, such as the inlaid eyes and finely engraved hair, already show the technical influence of this new medium, the use of which liberated the figure increasingly from structural requirements, thus enabling limbs

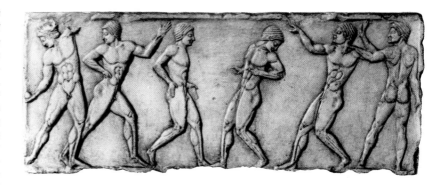

During the earliest phase of Greek sculpture, aptly named the Geometric, small bronzes were produced. In works such as the horse at left anatomy is reduced to its simplest elements. The same clarity of structure characterizes the early kouros *at left, below—a life-size youth in marble. The* Athlete Base *at right reveals the Greek artist's newly gained knowledge of anatomy in motion. This concern finally led to the development of* contrapposto, *seen in the* Kritios Boy *(below), in which inner tension and relaxation are depicted simultaneously.*

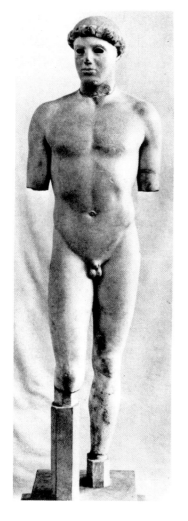

and body to move freely in space. Unfortunately, the best Classical bronzes have not come down to us, for the material was valuable and subject to reuse. Luckily, the Romans had a taste for the Greek Classical works and had many of the bronzes, especially those by famous artists, copied in stone. The copies add tree trunks or other objects at the legs for support and use struts to connect the limbs to the body. Many of the copies were made by mechanical means, and although surface subtlety is lost, we can use them for information about the composition and proportions of the originals.

The *Doryphorus*, or *Spear Bearer*, by Polykleitos, one of the most famous bronze sculptures of the high Classical period and one much copied by the Romans, carries the *contrapposto* idea to its ultimate conclusion. The spear, supported by the taut left arm and shoulder, signals to the viewer that the clear distribution of weight in the legs is reversed in the upper body; this results in a perfect balance that unifies the figure. Ancient literature tells us that the *Spear Bearer* was made to illustrate a treatise written by Polykleitos called "The Canon," which set forth a system of ideal proportions relating each part of the body to the whole, in an attempt to achieve a harmony of parts. This attitude is closely related to that of the Greek philosophers, especially Pythagoras, who believed that the harmony of the universe was based on the principles of number. Because it was so determined by principles, the *Spear Bearer*, more than any other work of art, embodied the ideal attitude of the Greeks.

Greek sculpture was made primarily for religious purposes. *Kouroi* and *korai* (female figures), for example, were dedicated in sanctuaries of the gods to bring honor to the donor, or sometimes stood over graves to commemorate those who died young. Sculpture was also made to decorate the religious buildings themselves.

The carved pediment from the Temple of Artemis at Corfu, one of the earliest of these architectural sculptures, has fortunately been preserved. The running monster at center is the Gorgon, Medusa, whose gaze could turn people to stone. She has just given birth to her children Chrysaor and the winged horse Pegasus, and is shown flanked by two felines. Since architectural sculpture followed the same development as the standing figure, this early pediment was carved in typical low relief: forms are executed in large smooth planes, and details are rendered in geometric patterns. Yet the emphatic projection of the mon-

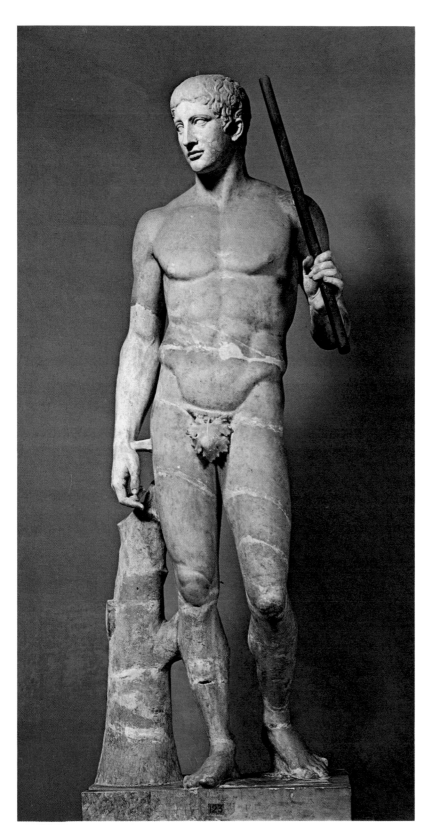

Polykleitos' bronze Spear Bearer *was made to illustrate a treatise on anatomical proportions; his work survives in a heavily damaged Roman copy (opposite). The meaning behind the monstrous forms decorating the earliest Greek temples, such as the Gorgon from the Temple of Artemis at Corfu (right), is often perplexing. Later Archaic art preferred human forms, such as those depicted in the battle of gods and giants that decorated the intricate Siphnian Treasury at Delphi (below).*

strous heads already exhibits the basic feeling for the three-dimensional that Greek artists were to develop.

Greek relief sculpture in the Archaic period evolved rapidly, and the north frieze of the Siphnian Treasury at Delphi already shows its full potential. Dedicated by the people of Siphnos at the height of their prosperity—just before the island was conquered by the Samians in 525 B.C.—the treasury provides a fixed point for dating Archaic sculpture. The frieze, which depicts the battle of gods and giants, illustrates the complexity of Greek relief.

Lying somewhere between Egyptian relief, which is essentially flat and two-dimensional, and Mesopotamian, with its rounded forms, Greek relief was always worked between two planes—an invisible front plane and the solid back wall—within which layers of figures were developed. On the Siphnian frieze, the sculptor has conjured up a space sometimes four figures deep on a very shallow stage. This was done by intricate overlapping, essentially a flat technique, augmented by the rich, rounded carving of actual projecting forms. The frontmost figures are completely carved out from the block in places to enhance the three-dimensional effect.

The artist of the Siphnian frieze was exploring the same pictorial means being developed by contemporary vase painters in Athens, where the red-figure technique had just been invented. He learned to vary the figures and unite them by compositional means. The use of flying garments to enhance the movement of a giant seen fleeing his attacker, for example, was an innovation that was to have far-reaching consequences for Greek art. The giant's body twists around, but the artist had not yet learned to make the transition between the profile legs and frontal torso that was to be mastered by the sculptor of the *Athlete Base* some fifteen years later.

During the early Classical period, the richness of late Archaic art

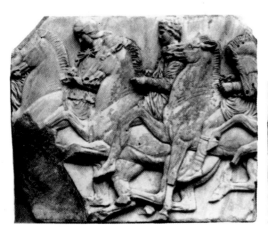
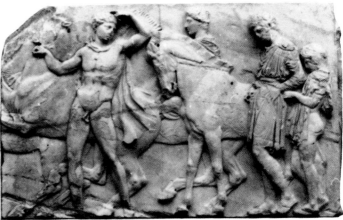

gave way to a new deliberate simplicity. In relief sculpture, as in the *kouros*, obvious action was replaced by quieter moments, before or after the action, when the inner thoughts of the figures were emphasized. This style, termed the Severe, required a more subtle understanding on the part of the viewer. It is best exemplified by the sculpture of the Temple of Zeus at Olympia, where even in action scenes the human figures show a quiet restraint.

The Severe style developed into the high Classical in the short period between 447 and 433 B.C. when the Parthenon was decorated. The buildings on the Acropolis in Athens had lain in ruins since the Persian destruction. Then, in the mid-fifth century B.C., under the leadership of Pericles, an extensive rebuilding project was undertaken, designed to glorify the city and enrich the citizens. The overseer was Phidias, who himself constructed the colossal gold and ivory statue of Athena that stood inside the temple. He must have organized large numbers of sculptors from all over Greece to complete the ambitious project in such a short time.

Although some of the metopes of the temple, which were completed first, still show traces of the simplicity of the Severe style, the sculptured frieze that ran around the entire building inside the colonnade represents the mature Classical style. Its subject is the Panathenaic procession in honor of Athena, and a portion of it is devoted to youths riding horses. This motif juxtaposes the humans with the more spirited animals and emphasizes human control, a major Classical theme. The frieze uses the spatial techniques of overlapping combined with rich modeling seen in the Siphnian frieze, but the figures are compressed into an unusually low relief. Yet there is no constraint. They move with consummate ease upon their shallow stage. The youths and horses are generalized, following a pattern that gives order to the work. The pattern is never rigidly repeated but always varied, however, so that each figure has an individuality and freedom.

The pedimental sculptures of the Parthenon were completed last, and the most advanced figures, such as the *Three Goddesses* that filled the corner of the East pediment, already have the overfull volumes and sumptuous "wet drapery" clinging to the body that characterize the

rich style of the end of the fifth century. The building program on the Acropolis continued, despite the interruptions of the Peloponnesian War (431–404 B.C.), to include the Propylaea, the Erectheum, and the Temple of Athena Nike. The balustrade once surrounding the parapet on which the Nike temple stood was carved in the rich style with a relief of Nikes, or Victories. The *Victory* bending over to fix her sandal is a tour de force of marble carving. The lavish drapery, seemingly transparent, partly clings to and reveals her body and partly cascades around it in deep folds.

The *Victory*'s unbalanced stance and fancy display of drapery for its own sake foreshadow the developments of the Hellenistic period. The Classical achievements of structural clarity and balance no longer challenged artists, so they began to turn their attention to the exploration of surfaces and to structural and spatial complexity. More and more, sculpture was designed to appeal directly to the physical senses

The supreme example of Greek relief carving is the frieze depicting the Panathenaic procession that once encircled the Parthenon. It was the only temple decoration to portray ordinary men rather than mythological heroes (two fragments at left). The caryatids (right) supporting the roof of the Erechtheum porch show the same clarity and balance as the Spear Bearer. *The cascading lines of their graceful garments suggest the underlying forms of the women's bodies.*

61

and feelings of the viewer. Subject matter also changed from the general to the specific, and sculptors learned to render children, old people, and exotic ethnic types as well as transient states of sleeping, drunkenness, and excitement. Yet the clear understanding of the human form in general continued to underlie all these developments.

After the conquests of Alexander the Great, and the subsequent divisions of his empire among the Hellenistic kings following his death in 323 B.C., the center of power shifted to the new capitals, especially to those in the East. The kingdom of Pergamum on the coast of Asia Minor became an important center for the arts. The most elaborate Pergamene monument is the great Altar of Zeus, decorated with an enormous frieze depicting the battle of gods and giants. The frieze is placed below the columns and carved in unusually high relief to bring it closer to the viewer. Instead of the repetition of patterns found in the Parthenon frieze, every one of these hundreds of figures is inventively varied. Writhing figures are choreographed into exaggerated gestures,

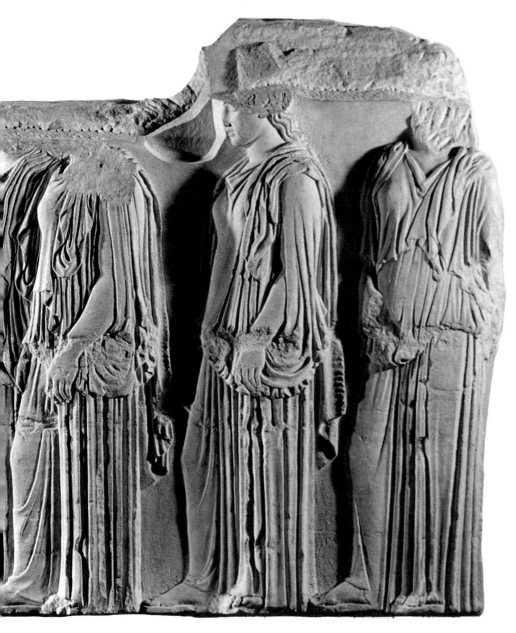

The maidens from the Panathenaic procession on the Parthenon frieze (above) are based on an orderly pattern, echoing that of the caryatids from the Erechtheum porch. In Hellenistic works such as the Altar of Zeus at Pergamum (right), theatrical effects, rich variety, and dynamic tension have replaced the restraint and clarity that characterizes Classical works.

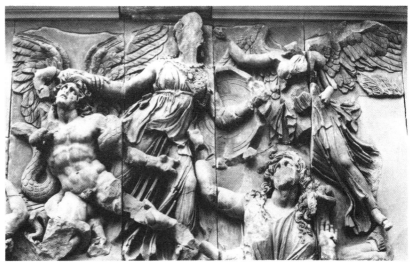

with faces contorted in pain. This is sensationalism. The sculptors presented the viewer with what he could never see with his own eyes and presented it larger than life and with all the emotions magnified.

The same dramatic style characterizes the *Victory of Samothrace*, a work that has been attributed to a Rhodian artist. The *Victory* was seen just alighting on a ship's prow, without the present intervening block, to commemorate a victorious naval battle. Originally the monument was part of a fountain that incorporated the natural setting and spilled real water over sculptured waves to heighten the immediacy of the huge apparition. No other figure in ancient art has so much movement: her back is arched, her shoulders and hips move each with a different torsion, and the flying drapery enhances her forward thrust and evokes the gusts of wind around her.

During the Hellenistic period, the Romans expanded their power to become the major force in the Mediterranean. As the Romans gained hegemony over the Hellenistic world, they came under the influence of Greek art, bringing much of it back to Rome as booty. The Romans also owed much to the art of the Etruscans, a mysterious non-Indo-European people who ruled central Italy in the Orientalizing and Archaic periods until they came under Rome's domination in the Classical period. Etruscan art was heavily influenced by Greek art, but it had its own character. The Etruscan artists were less intellectual and more direct, sometimes even brutal, in their approach. Since there was little usable stone in Etruria, sculptors worked mostly in clay or bronze, media that did not require so much planning as stone and that encouraged direct working.

A row of Gorgons once masked the roof tiles on the Temple of Apollo at Veii. The Gorgon, with its wide grin emphasized by harsh strain lines, surpasses the Greek version in its shock value. The Veii artist was not inhibited by the problems of organizing relief planes or rendering anatomy that concerned the Greek artist. The sharp clay details (including a row of snake heads that once surrounded the figure) were more spontaneously formed and make a quicker, more immediate appeal to the senses.

Tuscany was rich in metal ores, and the Etruscans were well known in antiquity for their bronzes. Solid-cast figures were made for parts of furniture or as votive dedications. One such dedication is the *Chimaera of Arezzo*: the monster has just been wounded and bristles back in pain, with its hairlocks all raised in spikey projections. The anatomy indicates that it was made in the Classical period, but the patterns of hair and muzzle are more repetitive than a Greek artist of the period would have made them. Such subtlety, however, would have interfered with the direct expression.

The Romans acknowledged that they were not an artistic people; as Virgil states in the *Aeneid*, their fine art was the art of ruling. Throughout their history, the Romans commissioned others—first the Etruscans and then the Greeks—to produce their sculpture. Their attitude was practical and down to earth, which is why architecture was their greatest art. In sculpture, the major Roman achievements are the portrait and the historical relief, both rooted in the here and now.

Never in all history has neutral stone exuded such life: wings half-folded and windblown robes aflutter, the winged Victory of Samothrace alights on a bowsprit, her descent momentarily arrested. Created in the second century B.C., this figure is a magnificent example of the Hellenistic "baroque" style.

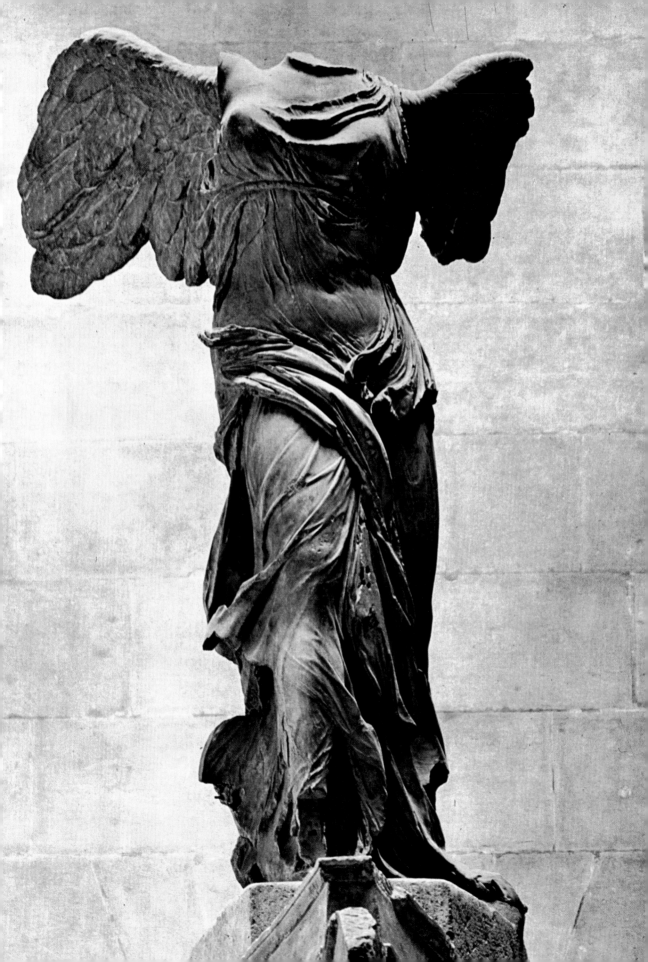

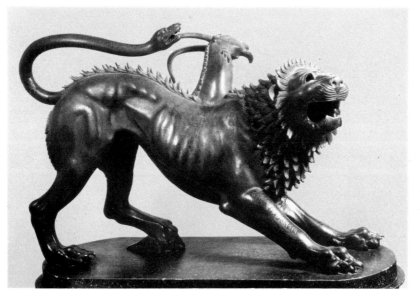

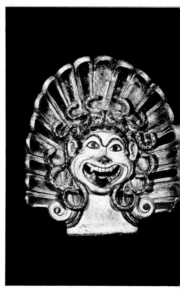

The earliest Roman portraits that survive were made at the end of the Republican period under Greek inspiration. But the Roman concept of the image was formed by an older ritual practice, that of making wax masks of their ancestors. (These masks were kept in household shrines to be worn by the living at funerals.) The emphasis was, therefore, on the specific traits that connected a Roman with his family, and on old age, when the individual character is most visible. The result is a concern with facial particulars that is diametrically opposed to that of the Greek artist, who was concerned with the general or ideal human form. Although Republican portraits reveal no basic understanding of the human anatomy, they show each wrinkle and furrow of the face with obsessive honesty.

When Octavian became the first Roman emperor in 27 B.C. and took the title Augustus, he needed an official image that was appropriate to his new office, one that would transcend the individual person. He wanted also to evoke the authority of the past. For his portrait, he borrowed forms from the Classical age of Greece, as he did for other works he commissioned. This was the first of many periods of classicizing in the history of art, when borrowings from works of the Classical past became part of the meaning as well as the style of the later work. It is no accident, for example, that the legs of Augustus' portrait from Prima Porta repeat those of the *Spear Bearer* of Polykleitos. Augustus' features are generalized, also in imitation of Greek works, and although the portrait from Prima Porta was made after his death in A.D. 14, it shows no signs of age. The total effect of the portrait, however, is not Greek but Roman. The upper body, with the commanding gesture and straightforward gaze, does not complete the balance of the lower body. Instead, it leads out toward the spectator with the power and directness of the Romans.

Inherent in Roman art from the beginning is a penchant for symbols. Elements are not present for their own sake but to be "read" in

Etruscan art—which is, like the Etruscan tongue, a tradition apart—includes such diverse and remarkable creations as the bronze Chimaera *of Arezzo (above, at left), its hackles raised against an unseen foe. The archaic* Gorgon *(above), an equally appalling mythic creature, has the same brutal power. The terra-cotta* Apollo *at right, above, decorated the roof of the sixth-century temple at Veii.*

66

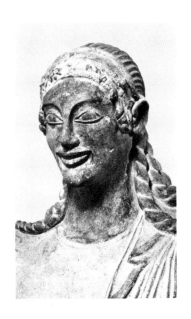

terms outside the work. A small figure of Amor at Augustus' foot refers to his supposed descent from the goddess Venus. On his armor, a scene showing the recovery of the standards of the Roman army from the Parthians is surrounded by the Sun, Dawn, Heaven, Earth, Apollo, and Diana. This sets the historical achievement in a cosmic framework alluding to the divine blessings of the *Pax Romana*.

Augustus' classicizing style was imitated by his Julio-Claudian successors, and influenced the entire course of official Roman art even beyond their reign. The *Gemma Augustae*, an elaborate cameo, uses the same mixture of history and allegory as the Prima Porta statue. On its bottom register, Roman soldiers raise a trophy over defeated prisoners; above, allegorical figures and mortals attend Augustus, who sits enthroned with Roma while waiting to receive a triumphant general. Although the exact identification of the general is uncertain, the rhetoric of a Roman victory glorified with symbols is clear.

Like portraiture, historical relief sculpture was derived from an older Roman ritual practice, in this case the triumph. Since Republican times, paintings of military battles had been carried in triumphal pro-

A typical Roman Republican portrait (below) shows the sculptor's concern with honest portrayal rather than with the idealized forms that concerned his Greek predecessors. These Greek forms were deliberately revived and applied to the portrait of Augustus from Prima Porta (right), whose commanding gesture and outward gaze nevertheless create an imposing Roman presence.

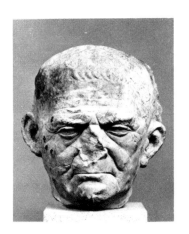

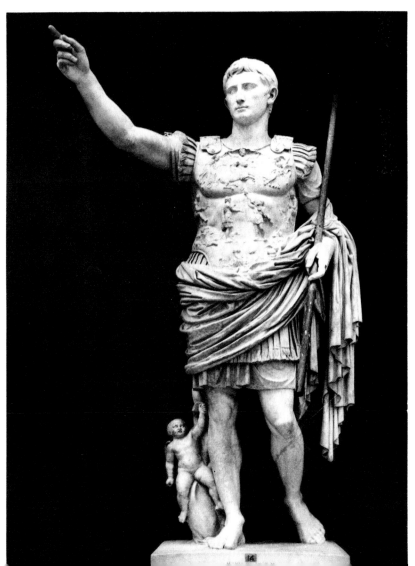

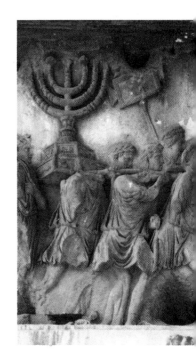

cessions and set up in the city, a practice that accustomed the Romans to depict specific events. The relief from the passageway of the Arch of Titus shows the actual triumphal procession that celebrated the victory over Palestine in A.D. 70. The figures depicted in it are not arranged regularly but are thronged to simulate the actual surge of a crowd passing through a triumphal arch. The depth of carving ranges from fully carved figures in the foreground to very shallow figures behind, who merge into the background. The artist has treated the stone as if it were air. Originally, paint, with colors fading into the background, contributed to the atmospheric effect. These techniques give the spectator the sense of actually being present at the triumph; this "illusionism" is a particularly Roman quality with counterparts in architecture and painting.

At the beginning of the second century A.D., Trajan expanded the Roman Empire to its greatest limits. It was to commemorate this that he erected the first triumphal column ever to be constructed, one hundred feet high and entwined with a winding scroll of carved reliefs depicting his campaigns against the Dacians. More than 2,500 figures record the events of those campaigns with such accuracy that antiquarians can actually reconstruct details of Roman history from them. In order to present a complete picture, Trajan and his army are repeated again and again in a succession of scenes, a technique called continuous narration. The triumphal column is perhaps the most characteristically Roman monument. The ancient equivalent of the documentary, it aimed to preserve historical fact with a minimum of distortion for artistic considerations.

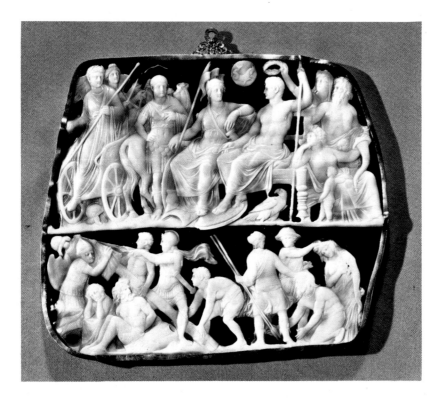

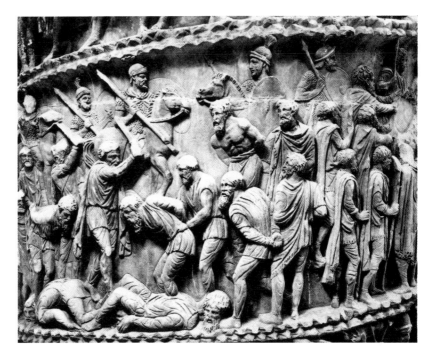

The enthusiasm for linking Class-ical themes and contemporary events in a single piece of sculp-ture was to persist throughout Roman art. In the Gemma Au-gustae *(opposite) an actual his-torical scene (bottom register) is juxtaposed with an elaborate al-legorical tableau. Over the cen-turies Roman sculptors com-memorated dozens of their con-quests in stone. The relief on the famed Arch of Titus (detail above) records the sack of Jeru-salem in* A.D. *70. The detail from the victory column of Marcus Aurelius above, at right, shows the decapitation of defeated Germanic tribesmen in the cam-paigns ending in* A.D. *180.*

Trajan's successor, Hadrian (A.D. 117–38), was a philhellene with a deep enthusiasm for Greek civilization. He inaugurated another period of classicizing in Roman art; yet, at the same time, Hadrianic sculpture is characterized by a definite sensuousness. The statues of Hadrian's beloved page Antinuoüs, whose cult was established after his strange suicide, are characteristic of the period. The figures imitate classical prototypes but are colored by romanticism and nostalgia. Emphasis is on the surface, with velvety or sometimes smooth-polished flesh to contrast with the rougher texture of hair.

The period of Hadrian through Commodus (A.D. 180–92) was marked by great material prosperity but also by the emergence of anti-materialistic tendencies that contributed to the transformation of Roman civilization in the Late Antique period. Under these Antonine emperors the provinces gained in importance, and lessened Rome's influence as the center of power. The Roman state religion had become mere display, and Romans searched with anxiety for more sat-isfying and personal beliefs. Hadrian, and after him Marcus Aurelius, embraced the Stoic philosophy, with its emphasis on the inward state as a refuge from the uncontrollable elements without. This looking inward has a direct analogy in late Antonine portrait sculpture, where the irises and pupils of the eyes are modeled three-dimensionally and shown partly rolled up behind the lid. The effect is an emphasis on the inner life and a suggestion of otherworldliness. From this point on, spirit begins to be divorced from the body.

The portrait of Commodus illustrates this removal. Commodus, whose disastrous reign ended the Antonine era, was unequal to the task he had inherited. As if to compensate, it was his conceit to be repre-sented as Hercules. Yet the toy club and puny apples of immortality in his hands are unconvincing trappings, and the openwork support for the bust mocks its subtantiality.

The increasing emphasis on the spiritual was marked by a great di-

versification of religious and philosophical thought. Relief carvings on sarcophagi, elaborate stone coffins that came into use in the time of Hadrian, reflect the many different ideas about the meaning of afterlife. The sumptuous Badminton sarcophagus in the Metropolitan Museum (from c. A.D. 220) illustrates a conflation of popular types. Dionysus and his retinue appear in the center surrounded by the four seasons, who are personified as youths carrying appropriate products, with Earth and Ocean carved on the two ends. This relief is completely different from the one on the Arch of Titus with its convincing immediacy. The figures depicted here are present only to refer to abstract concepts on another plane, to conjure up the hope for a bountiful afterlife through the Dionysiac mysteries.

The triumphal column of Marcus Aurelius is often considered a turning point in the transformation to Late Antique. The column commemorating Marcus's campaigns on the Danube was plainly made in imitation of Trajan's column, but with significant changes. For the first time in Roman art, miraculous events are illustrated amidst the historical scenes, and the heads of the figures are emphasized at the expense of the bodies to show a new emotionalism.

An important technical device that contributed to the change to Late Antique was the increased use of the running drill, which substituted for the older and more laborious technique of chiseling. The running drill produced channels like wormholes in the stone, encouraging sculptors to sketch more superficially on the surface, to drill out lines or frothy perforations. These produced a sharp black and white contrast on the stone that replaced the subtle gradations of earlier sculpture. The result was the breakdown of solid form.

The over-life-size portrait of Trebonianus Gallus, whose short rule (A.D. 251–253) is characteristic of the age, illustrates yet a further step in the disintegration of form. Though represented in heroic nudity in the Classical tradition, the head is much too small for the ungainly body. The middle-aged features are reduced to linear details that play tentatively over the unquiet surface. The repetitive hatchings of hair and beard no longer convey texture but are abstractions that have overwhelmed the face.

Constantine was the first Roman emperor to embrace Christianity as the official religion. His act of moving the capital eastward to Byzan-

tium in A.D. 323 marks the end of the Roman era. The triumphal arch built to commemorate his victory over Maxentius in A.D. 312 may be seen as the last Roman monument. Its colossal size and rich array of reliefs were gained, however, at the expense of organic coherence, for the parts were not designed for the whole, and most of the decoration consists of pieces reused from past monuments. The columns are Flavian, the standing barbarians and friezes in the center passageway Trajanic, the roundels Hadrianic, and the relief panels decorating the attic story date from the time of Marcus Aurelius. Of the friezes, only those over the side arches are Constantinian.

Constantine's monument recapitulates the entire history of Roman sculpture, from the full-bodied images of the barbarians to the flat panels symbolically focused on the emperor. Its coherence lies not in the physical substance but in the symbolic meaning. Each scene takes its place in an elaborate program to glorify the emperor who used the monuments of the past to affirm the traditions behind him and to establish the basis for his new departure.

ELLEN DAVIS

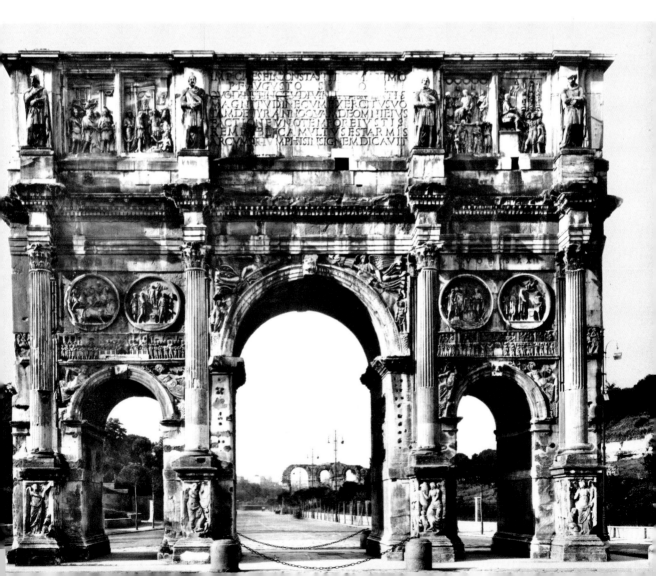

5

An Age of Faith

THE TERM MEDIEVAL literally means the period in between; it covers the time between the art of classical antiquity in Greece and Rome and the revival of that art in the Renaissance. Because it rejected the classical canons of natural proportion, the medieval period was long seen as a bizarre interlude—its creations bewildering, if not plainly ugly. But in fact the period was a rich one for all facets of art, including sculpture. The subject matter was almost exclusively Christian, and the style was uniquely suited to this end.

The earliest beginnings of Christian art had already appeared in the closing centuries of the Roman Empire. By necessity, the first Christians were humble members of an underground sect, and their art stayed with them—tucked away in the catacombs where they had sought refuge. But amid the secrecy and the evident groping for their own artistic expression, certain Christian artists from as early as the second century created works of quality every bit as high as those of the Greco-Roman world surrounding them. This is particularly true of those artists, especially the sculptors, who most directly depended on contemporary pagan works as inspiration for their figures and scenes depicting the Christian stories. Early figures, whether as decoration for a sarcophagus or isolated as small freestanding statues, share the same plastic modeling and careful detail as their Roman models.

What is important to realize, however, is that, despite the similarity to Greco-Roman works, Christian art from the outset reflects a total change in artistic intention. The Christian artist was proclaiming a spiritual message not at all of this world, one whose dominant theme was hope for an afterlife. The Good Shepherd was a particular favorite with early Christian artists. Although most probably based on a motif long popular in bucolic art, it was transformed into an allegory of the theme of the Good Shepherd so prevalent in the scriptures.

Christian sculpture continues in a rather diminutive scale even after the status of the fledgling sect was profoundly altered by the momentous conversion of the Emperor Constantine in a vision before his battle with Maxentius at the Milvian Bridge in the year 312. Christianity was able to profit from the stability of an alliance with the empire and yet still maintain its eastern essence of mystery. As emperor, Constantine cast himself in the role of deputy of Christ, the True King enthroned in Heaven. To assert this image he concentrated mainly on a number of

The story of the Good Shepherd was one of the most popular themes in early Christian art. It is frequently seen in wall paintings, as decorative reliefs on sarcophagi, or in freestanding statues. The small ivory representation at left was carved in the second century.

architectural endeavors both in Rome and in the East. These remain as his monuments, even though the sacking of Rome in 410 by Alaric, leader of the barbaric Visigoths, put a decisive end to the political power of Rome and forced the dissolution of its vast holdings throughout the western world. Christianity survived in the West, but only in the sanctuary of scattered monasteries, mainly in Italy and Ireland.

Brief attempts to revive at least an echo of former glory all folded sooner rather than later under the relentless waves of rival tribes no longer contained by the firm hand of Roman generals. The most shining example of such efforts was sixth-century Ravenna under Theodoric, converted ruler of the Ostrogoths. With Rome gone as an anchor, he turned his allegiance to Byzantium with its imperial capital at Constantinople, where he had been educated. Before he in turn was submerged by the Longobards, Theodoric established a lavish court at Ravenna and built a number of churches whose awesome mosaics convey the mysterious, ethereal flavor of eastern Christianity.

Sculpture, too, shared in the flowering, enjoying a fresh burst of creativity under the inspiration of artists—often Greek or Greek-trained—who came to work at Ravenna. Its high quality may be seen in the exquisite lacework of the capitals of the Church of San Vitale and in the rich and carefully executed carvings on the cathedra, or official throne, of Maximian, Archbishop of Ravenna from 540 to 546. The

The richness and variety of medieval sculpture is seen in the wealth of small objects, both religious and secular, the period produced. Some fine examples of this abundant legacy are the Longobard clothing ornament seen above, at left; the ivory altarpiece commemorating the reign of Romanos II and Eudoxia (above); and the ivory cross (far right) presented by King Ferdinand of Spain to the Church of St. Isidoro in Leon. Sculpture on a more substantial scale is seen in the decoration created for the chair of Maximian, Archbishop of Ravenna (near right).

compelling mixture of figure, scene, symbol, and design in the reliefs that cover the chair confirms the direction in which Early Christian art had already begun to move in fourth-century Rome—toward a relaxation of its early dependency on classical models in favor of a spaceless realm where physical reality declined and a wealth of symbolic language increased. Even without the pronounced eastern accent in the Ravennate carvings, such a shift was inevitable for the artist who aimed to stress the spiritual thrust of the Christian message.

Even in the more stable Byzantine realm of the East, the course of Christian art was not completely smooth. Sculpture, particularly, was to encounter a problem potentially far more thorny than the external threat of invasions in the West. For within the Church itself a bitter controversy raged on the question of Iconoclasm, erupting in Leo III's

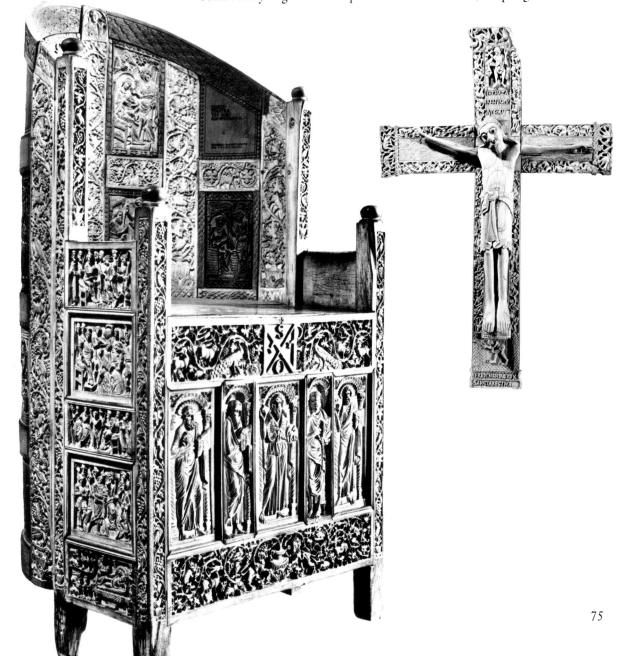

imperial edict of 726 that prohibited religious images altogether. Sculpture suddenly faced the possibility of its near extinction.

The danger finally passed with the reversal of the edict in 843; sculpture flourished once more, mainly in the form of miniature portable ivory altarpieces. These little masterpieces of Byzantine art have an enormous range of themes, both new and traditional. One, which shows Christ crowning Emperor Romanos II and his wife Eudoxia around 950, is clear proof that the concept of the earthly ruler as Christ's designate survived intact. It also epitomizes the hieratic abstraction of the classical figure, with a smooth grace and elegant refinement that remains fixed in the Constantinopolitan court style for many centuries.

If there is a dark spot in the medieval period it falls in the hazy void in the West between the fall of Rome in the fifth century and the rise of Charlemagne three hundred years later. But the label Dark Ages is denied even here by the vibrant energy and inventiveness of the treasures left behind by those vigorous, vandalistic, warring tribes who swept through Europe. The form their art took was in keeping with their vagrant life-style. Some larger pieces have been found, especially in the impressive Viking ship-burials—when a king and his belongings, ship and all, were buried on a hill overlooking the sea. But for the most part the objects that have been preserved are portable and small, many of them buckles and brooches to be worn on clothing.

The bold vitality of barbarian art transcends all regional differences. Theirs is an anticlassical style that defies all natural reference. Human figures and animals, when they appear, are treated with the same abstraction as the rest of the designs that enliven every portion of an object's surface.

The dynamic melange of abstract motifs of beast and interlace in barbarian art was eagerly seized by Celtic artists of the seventh and eighth centuries; they saw its possibilities for expressing Christianity's mystical message, particularly when the elements were compressed within the confines of a geometric order. In fact, this fascinating heritage had a staying power that endured through the whole medieval period. The barbarian aesthetic formed the framework of western art for centuries; its accent is still unmistakable in the wild grotesques of Romanesque capitals and the fantastic gargoyles that embellish the waterspouts of Gothic cathedrals.

By the middle of the eighth century the anticlassical bias of barbarian art had all but banished any trace of the Greco-Roman tradition in the western world. But the tables were turned by the emergence of Charlemagne, who in one bold stroke in the year 800 unified the fragmented kingdoms of Europe and had himself crowned Holy Roman Emperor. To fortify his image he deliberately drew on the forms of imperial Rome and imported great scholars from the English monasteries to create important centers of learning on the Continent; there classical art and literature could be studied and emulated.

No more telling testimony to Charlemagne's grand design can be found than a small but imposing equestrian statue that may be seen today in the Louvre. Whether or not it is of Charlemagne, or his son Louis the Pious, or his grandson Charles the Bald—genuine portraiture

Although it stands only eleven inches high, the style of the equestrian statue at left, thought to be of Charlemagne, is an attempt on the part of Carolingian sculptors to recreate the artistic grandeur of imperial Rome. More typical subjects for medieval sculptors were biblical stories, retold in countless artworks. The expulsion of Adam and Eve from Paradise is seen in the top register of the panel at right from the doors of the Church of St. Michael at Hildesheim.

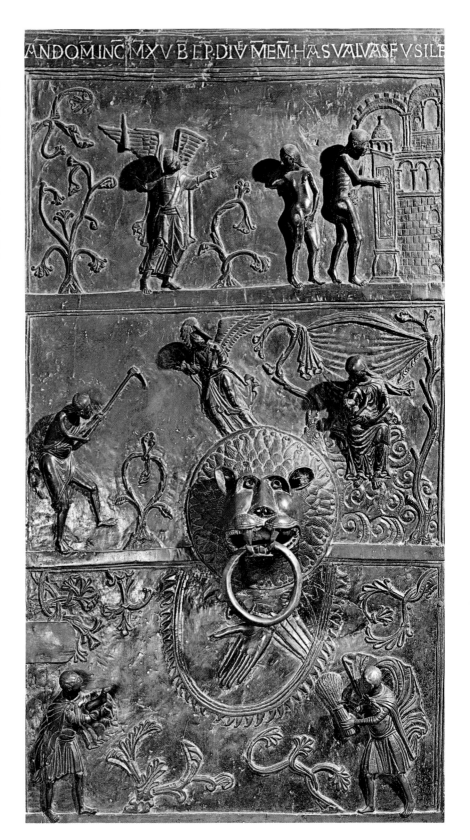

is not a mark of this period—the statue boldly proclaims the extent to which the Carolingian ruler fashioned even his own image on imperial formulas. Just as in the much-admired equestrian portrait of Marcus Aurelius, he saw himself loftily elevated above his subjects by virtue of his mounted pose. This little freestanding statue is exceptional in the medieval period, for religious art steadfastly maintained an antipathy to images rooted in the strictures of the second commandment. But it nevertheless shows in its smooth simplification of contour that the Carolingian Renaissance was not a mere imitation of its model but rather a return to classical inspiration as a springboard to fresh innovation.

Between the Carolingian and Romanesque periods, the most important developments in sculpture took place in the first half of the eleventh century under the reign of a succession of German kings. From Otto I, crowned Holy Roman Emperor in 962, comes the label frequently applied to works crafted during this interval—Ottonian art. While sculpture still thrived in its traditional forms elsewhere, in Saxony under the patronage of the powerful Bishop Bernward of Hildesheim it was to branch out in a more monumental direction with the establishment of great workshops for bronze casting.

A visit to Rome is thought to have inspired Bernward's two major commissions in bronze for his Church of St. Michael at Hildesheim: the Easter column based on Trajan's famous monument, and the renowned doors modeled on those of the Church of St. Sabina. Both works are enormous. The column is twelve feet high and shows twenty-four scenes of Christ's life. The doors, dated 1015 and now installed in the Cathedral at Hildesheim, are even larger. Fifteen feet tall, they are made up of sixteen rectangular panels showing scenes from the Old and New Testaments thematically interlocked.

The prodigious creativity of the Ottonian craftsmen, especially in these monumental works, provides a vital link to the small-scale art of the Carolingian period while at the same time preparing the way for the great Romanesque stone sculptures to come. This link can also be seen in the varying styles that appear even within a single relief on the great bronze doors. The pictorial conception of the expulsion from Paradise of Adam and Eve, for example, relates it to the illusionistic style of Carolingian miniatures—in smooth-flowing contours enlivened by quick movement and expressive gesture. But the greater angularity of the figure of the angel and the ordering of each part of his anatomy in a separate zone points to the style that was only fully to emerge in Romanesque art.

Such a transition was taking place elsewhere in Europe during the eleventh century. In Spain a splendid ivory cross, the gift of King Ferdinand and his wife Sancha to the Church of St. Isidoro in Leon in 1054, is a prime example of the minor arts that were flourishing everywhere under the important patronage of kings and clergy. Although a small-scale object, the cross already shows important links to France, where the great stone sculpture was to be developed. In its tendency to harden contours and to translate even its figures to the abstract terms of a spaceless surface design, it shares characteristics that were later to blossom in the sculpture of the churches that lined the roads leading

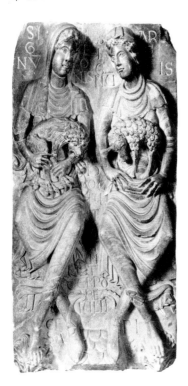

The small reliquary statue of St. Foy Enthroned (left) was discovered in the treasury of the Church of St. Foy in Conques, an isolated village in the Auvergne region of France. Dating to the late tenth century, it was built on a wooden base covered in gold and encrusted with semiprecious and precious stones. To avoid idolatry three-dimensional figures had to take the form of such reliquaries. The twelfth-century relief below, from the Church of Saint Sernin, celebrates the legendary birth to two women in Toulouse of a lion and a lamb—at approximately the time of Christ's birth.

down through France to the pilgrim's prized goal of Santiago da Compostela in northwestern Spain.

The link is made in theme as well. Any gift to the church—whether a small cross such as this one, or larger ones in wood, or other liturgical objects such as Gospel books and reliquaries—carried with it the donor's hope of a favorable decision at the Last Judgment. The concept of the Last Judgment, which reflects a shift from the sure confidence of the early Christian, was a source of increasing concern to the medieval believer. Although the idea behind the gift was rarely expressed in the art of the earlier period, it is spelled out quite clearly on Ferdinand's cross. The whole surface of the cross is an intricate tangle of figures and scrolls. Only on the upper part of the shaft do the souls of the blessed break free as they near the welcoming hand of the Archangel Michael, seen just below the figure of the ascending Christ. On the Romanesque churches of the pilgrimage roads, whole tympanums are devoted to this theme.

The pilgrimage route—*la grande cheminée de France*—was a preeminently French conception. It released a burst of religious fervor that drew vast numbers of worshipers to its churches—their efforts rewarded by uncounted miracles and spectacular cures as a result of an encounter with a saint or exposure to a treasured relic, their faith unfolded before them by the great works of sculpture that filled the capitals and portals of every church.

One of the main creative sources for this abundant church sculpture may be found in southwestern France, best known from the carvings at St. Sernin at Toulouse and their brilliant variant in the Cluniac church of St. Pierre at Moissac, somewhat to the north. The earliest figures still show the kind of dispassionate immobility of the Christ from the Leon cross, only in more massive size and more rounded contours. But in short order they emerge in the classic Romanesque style: proportions are flattened and elongated; forms are enlivened by unlooked-for twists of the body; drapery, neatly described in crisp folds, seems to be stirred by an inexplicable breeze. Suddenly relief sculptures appear in every scale from larger-than-life to diminutive, often within the same composition, contained and controlled in all their variety by the abstract geometric ordering that ties them to their architectural frame.

Just as suddenly, in this early-twelfth-century period, there seems to be no end to the variety of subjects these new figures can convey. Legend, allegory, and biblical theme are set forth in spellbinding profusion. Among the unusual representations to be found is a relief now in the museum at Toulouse. It depicts the legendary birth to two women of Toulouse, at the time Christ was born, of a lion and a lamb. These two creatures symbolize Christ's dual nature: the lion of Judah, the king of beasts, standing for his divine nature; and the paschal lamb, representing his gentler, human side. Most important of all at this time is the idea expressed in the tympanum at Moissac through a representation of the Second Coming of Christ. The Last Judgment is the dominant theme of the Romanesque portal whether it appears in the form of the Christ in Majesty or the Ascension, or in the more graphic depiction of the weighing of souls, as at Autun Cathedral.

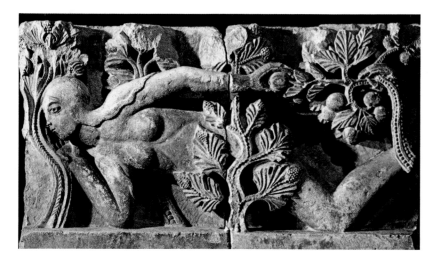

Many of the finest achievements of Romanesque art were executed in stone. Among the most beautiful nudes of all time is the remarkable Eve—shown reaching for an apple from the Tree of Knowledge (left)—that originally graced the doorway of the Autun Cathedral. Below, the Old Testament figure of David is used to represent the third musical tone in a choir capital executed for the abbey church at Cluny. The apex of Romanesque sculpture is the tympanum, seen to stunning advantage in the narthex portal of the Church of St. Madeleine at Vézelay (right).

The fate of the damned is more readily dramatized than is the joy of the blessed. Romanesque art often tends to encourage the virtuous life by terrifying the viewer with vivid representations of the torture awaiting those who follow the alternative course—with tormented souls consumed by monsters and in every imaginable unenviable pose. Nowhere were its seductions more eloquently depicted than in the Temptation from the lintel of the north doorway at Autun of about 1130. Even though the figures of Adam and Satan are now gone, the full power of the scene remains in the languid Eve, who rests on one elbow as she whispers irresistibly to Adam. This was the work of Gislebertus, one of the first medieval sculptors whose name is recorded.

Autun is in Burgundy, a region no less important than Languedoc for the development of stone sculpture in this period. The artistic center was Cluny, the famous abbey church that is now, unfortunately, almost totally destroyed. The delicate modeling of the capitals rescued from the choir, however, makes it clear that the Burgundian version of the Romanesque style is freshly creative from the start. The fine contour and soft movement of the personification of the third musical tone suggest a connection with Ottonian art. The sophistication of the carving is matched by that of the program of these capitals when taken as a group. In place, they presented no less than an image of the City of Heaven in a complex interweaving of Old and New Testament themes with the concordance of musical harmonies that were actually heard in the choir.

Of all the works to come out of this creative surge in France in the first third of the twelfth century, none is more spectacular than the narthex portal of the Burgundian church of the Magdalen at Vézelay. In majestic simplicity it sets forth a rich complexity of theme. The central pillar—the *trumeau*—features a damaged figure of John the Baptist holding a disk with the lamb to suggest that the sacrifice of Christ is the hope and salvation of all who enter the church. The tympanum that the *trumeau* supports shows not the Last Judgment but the imposing image of Christ as he appeared to the apostles with his commandment that they spread the Gospel throughout the world. The theme of mis-

aspect reflects an unmistakable desire to show the joining of body and soul—a profound new philosophical idea inconceivable in earlier medieval thought.

The fundamental reversal of approach in the direction of naturalism seen in each of the Chartres figures indicates a new rationalism in sculptural programs. Gone are the vast apocalyptic visions of the Romanesque. The message now is one that encompasses every aspect of life on earth as a relevant reflection of the heavenly realm. The shift in emphasis opens up a virtually encyclopedic range of subject matter along with greater space in which to develop it. Now there is a place for an expanded variety of narrative scenes from the lives of the saints. Kings take their place with the prophets and apostles that decorate not only the doorways but the entire outside of the church and interior walls as well. The particular skills of the burgeoning guilds are honored along with the theological virtues and the labors of the months. New realms of knowledge, expanded by the creation of universities at this time, are set forth in their wide range of subjects. Even a taste of the daily life of the student—the classrooms and the carousing—are included in the decoration of Notre Dame. Everywhere the vitality of earthly life only confirms the reality of the life in heaven to which it is linked.

Something of the naturalism of Gothic sculpture may be seen to have developed from the French Romanesque art of Languedoc and Burgundy. The seductive Eve from Autun is often cited in particular as a promising source. But much of the incentive for the new style is due to the small-scale works of twelfth-century goldsmiths from the valley of the Meuse—a region between France and Germany that had long been artistically fertile. The works of a succession of gifted artists specializing in liturgical objects in enamel and metalwork culminate in the masterpieces of Nicholas of Verdun, whose craft and creativity brought Romanesque art to the very brink of the Gothic. The smooth fluidity of the drapery that envelops the tiny Mosan figures reasserts the idea of the body beneath that had been deliberately denied in most Romanesque art. The majestic Daniel sitting in a niche on the Shrine of the Three Kings previews in miniature the monumental figures who would come to life on the great Gothic portals of the first half of the thirteenth century.

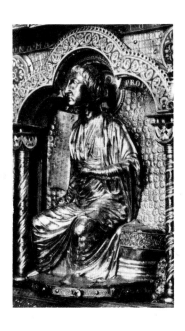

The exuberant movement characteristic of Nicholas's style was a potent catalyst for the transition from the considerable stiffness of the figures on the Royal Portal at Chartres to the axiality to be seen in such works as the Strasbourg *Synagogue* figure and the *Annunciation* and *Visitation* groups at Reims. No longer so tightly bound to their architectural base, the figures stand believably with real weight on one leg, the body slightly turned. The decisive sense of reality also comes from the way the drapery acts to define the form and hangs with a new response to the pull of gravity. The distinct echo of classical models in the Virgin and Elizabeth of the *Visitation* group is but one instance of the versatility of the Gothic sculptors in their efforts to imbue their forms with expressive animation in a variety of ways.

The expressiveness achieved through pose and drapery extended to the expression of inner feelings as well. The famous Reims smile on the

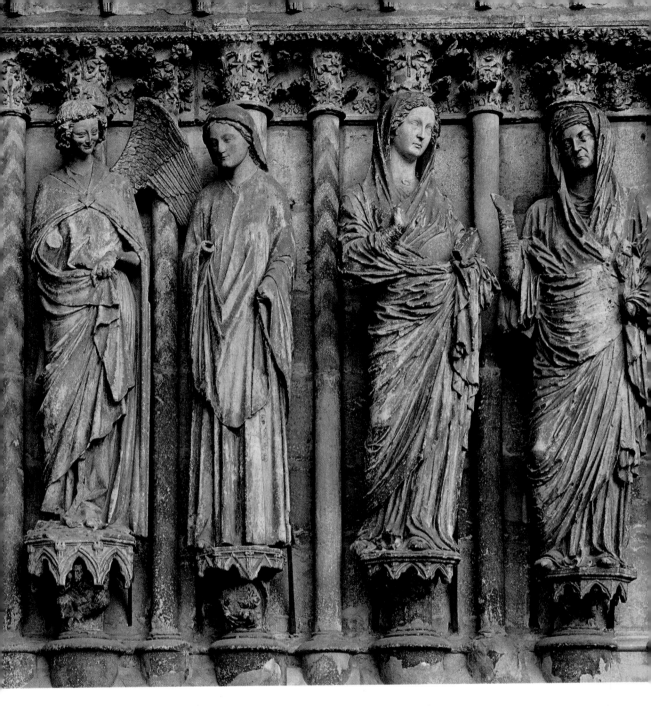

Annunciation angel, winning as it is, may be somewhat equivocal since many other figures have it too. But it is a sure sign of the impulse to confirm feeling as well as life within the figure. The effect of true emotion is more fully achieved in the sculptures of Strasbourg Cathedral, which share the date of about 1230 with the figures from Reims (except for the angel, who was executed about twenty-five years later). A touching vulnerability permeates the personification of the defeated *Synagogue*; her body bends in a low, slow curve that subtly mirrors the inner sadness of her downcast head.

Paris, of course, was the birthplace of the Gothic and, throughout the period, remained the center for its purest expression. The style quickly spread throughout Europe, however, picking up the regional

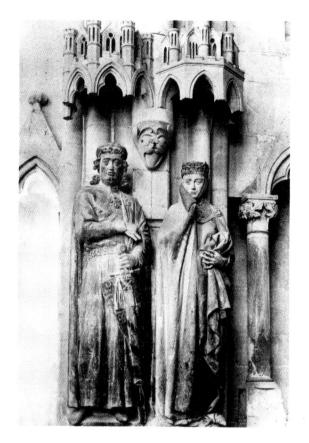

It was in Gothic sculpture that stone figures truly began to "come to life." The dynamic possibilities of this vitality are brilliantly realized in the An-nunciation and Visitation groups gracing Reims Cathedral (left). The artists who contributed to the Strasbourg cathedral also in-fused their works with strong emotions, as shown in the Syn-agogue figure (below). In Germany the purity and restraint of French Gothic sculpture gave way to a more earthy and dra-matic tendency, as seen in the choir statues of Ekkehard and Uta at Naumburg (right).

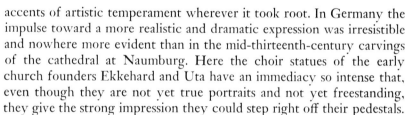

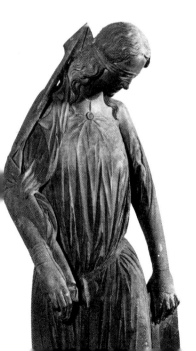

accents of artistic temperament wherever it took root. In Germany the impulse toward a more realistic and dramatic expression was irresistible and nowhere more evident than in the mid-thirteenth-century carvings of the cathedral at Naumburg. Here the choir statues of the early church founders Ekkehard and Uta have an immediacy so intense that, even though they are not yet true portraits and not yet freestanding, they give the strong impression they could step right off their pedestals.

A full grasp of the quality of the Gothic style in Italy requires a return to the native art of the period from which it evolved—the Ital-ian Romanesque. Among the most gifted exponents of this earlier style was Benedetto Antelami, who in 1178 carved a large relief of the Descent from the Cross for the choirscreen of the cathedral at Parma. The stiff, sturdy quality of the many figures that fill this scene is typi-cal of contemporary Italian sculpture. Nothing in drapery or form gives the slightest hint of the rich new vocabulary rapidly developing farther north at this time. What is unusual in this relief is the emotional force it manages to convey almost because of the rigid suppression of any overt expression. The subject of the Descent remained popular in Italy throughout the first half of the thirteenth century, during which time a number of life-sized groups were carved in wood, directly reflecting Antelami's own style.

In fact, Italian sculpture remained conservative and formalistic in style and theme well into the second half of the thirteenth century. The situation changed radically around 1260, however, when Nicola Pisano undertook a commission for the Pisa Baptistry pulpit, the first of a series to be made by him and his son Giovanni. The richly decorated

pulpit had long been an important church furnishing in Italy, but in the hands of the Pisani it was raised to the aspect of a miniature cathedral. Nothing in Italian portal sculpture, either Romanesque or Gothic, approaches the organic unity achieved in these marble monuments.

So sudden was the emergence of a real feeling for form and life in his figures that one is tempted to think that Nicola Pisano must have studied and worked from the sculpture of the great French cathedrals. Whether or not he did, or simply heard about them, has never been proved. What is more certain, however, was his turning to the monuments of ancient Rome, as artists—especially Italian ones—were apt to do when the stylistic expression of their own time allowed them to utilize their native heritage for particular artistic ends.

For Nicola Pisano, then, the vigorous naturalism of classical art was the medium by which he was able to transform Italian Romanesque sculpture into the Gothic style. In many instances the return to a classical source can only be sensed. But with the majestic Madonna from the relief of the *Adoration of the Magi* on the Pisa Baptistry pulpit, it can be established that the specific model is the figure of Phaedra from a second-century sarcophagus found in Pisa.

Italian Gothic sculpture came to rapid fruition in the vibrant art of Giovanni Pisano. The carvings of his pulpit for the cathedral at Pisa teem with a characteristic passion and energy of forms freshly released from all the prolonged confines of Romanesque art as it lingered in Italy. Every figure modeled by Giovanni's hand pulses with life, in the vigorous turn of the body, the tilt of the head. Each one testifies in sculptural terms to the high point of artistic creativity that was being matched in contemporary Italian painting by Duccio and Giotto.

In Giovanni's art, the influence of the French Gothic is very pronounced, even though proof of his travels and of the specific models

Leading Italian Romanesque sculptor Benedetto Antelami's marble relief of the Descent from the Cross *(left) is one of several pieces that originally decorated the choirscreen of Parma Cathedral. Despite the rigid posture of his figures, Antelami's scene conveys a remarkably strong emotional force. Church furniture—pulpits and tombs—was the chief medium for Italian Gothic sculpture. The pulpit at far right was designed by Nicola Pisano for the Pisa Baptistry; above is a relief of the* Adoration of the Magi, *one panel of the pulpit's decoration. A sculptor at work is portrayed in the relief at near right by Andrea Pisano (no relation to Nicola), an early-fourteenth-century Florentine sculptor.*

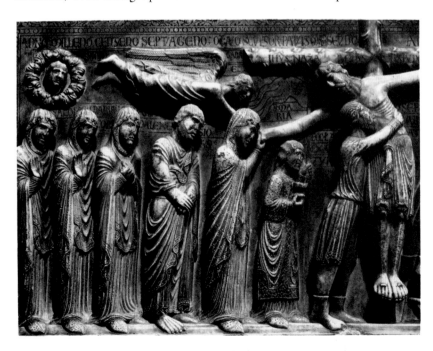

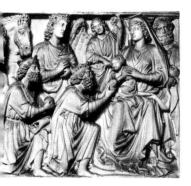

from which he drew is elusive. He most certainly learned the style first-hand, if only from small portable ivory carvings that came to Italy from Paris at this time. The favorite Gothic theme of the Madonna and Child was one that Giovanni portrayed in a number of versions, one in ivory as part of a larger group of figures commissioned for the High Altar of the Pisa Cathedral in 1299. The emphatic sway of her body, the elegant fall of the drapery folds, owe much to contemporary French sculpture, in which a marked deflation of form came to replace the greater massiveness of French figures carved in the first half of the century. But Giovanni's own style has a new sense of intimacy established both by glance and by gesture between the two figures.

The vigorous energy of Giovanni's style settles down in the hands of his successors in the early fourteenth century. This change is clear in Andrea Pisano's smooth reliefs for the doors of the baptistry of Flor-

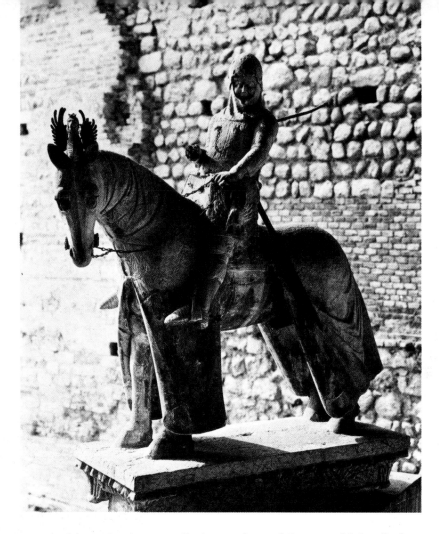

Nicola Pisano's son, Giovanni, was an outstanding sculptor in his own right. The style of his ivory Madonna and Child (near right) shows an unmistakable debt to French Gothic sculpture. Can Grande della Scala, Lord of Verona, left to posterity a dashing and confident portrait of himself in the equestrian statue at left, made for his tomb. The final flowering of medieval sculpture came with the elegant and courtly International Gothic style. Its founder, Claus Sluter, at times created figures—such as his Moses (far right)—that displayed a power and realism far exceeding the work of his late medieval contemporaries.

ence and even in the more lively carvings of Lorenzo Maitani's *Last Judgment* for the façade of Orvieto Cathedral.

An unexpected departure from the rather diminutive scale of individual figures erupts just once in the colorful statue of Can Grande della Scala, Lord of Verona, designed in 1330 as part of his elaborate tomb. He presents himself with great flair as a dashing soldier, sword in hand, astride an elegant mount. For all of its essentially pictorial character, this work marks an interesting point in the development of sculpture. Its revival of the equestrian statue, a form that had virtually disappeared since antiquity, forms a bridge to the Renaissance and the monumental works of Donatello and Verrocchio.

The closing years of the fourteenth century brought the final flowering of medieval art as the creative forces north and south combined to form the International Gothic style. For sculpture, the transformation was based on a renewed interest in the weight and volume of forms, a quality that had increasingly diminished in the period that followed the great sculptures at Reims. But the retrieved monumentality was proclaimed with a vigorous new sense of tangible reality that emerged almost single-handedly in the art of the sculptor Claus Sluter, when he, along with other artists, was called to Dijon from his native Holland to work at the stimulating court of the Duke of Burgundy.

Among the most famous of the monuments Sluter produced at this time is the fountain for the Chartreuse of Champmol made between

1395 and 1406. It has come to be known as *The Moses Well* because of the commanding presence of this majestic figure who stands on one of its sides. The compelling reality of each of the figures on *The Moses Well* was originally enhanced by the fact that they were painted.

The art of Claus Sluter is so powerful that he has at times been seen as the Michelangelo of northern art. Certainly the figure of Moses confirms such a view. The bold volume of the form reaches out into space by every means—the ample folds of the robe, the fullness of the beard, the outward curve of the long scroll. The full three-dimensionality to which this figure expands essentially frees it from its nominal tie to the architectural frame. This accomplishment is a most crucial one for freestanding sculpture of the future, and one that is achieved with a power unmatched until the works of the High Renaissance.

ELIZABETH PARKER

6

A Glorious Rebirth

The first panel of Lorenzo Ghiberti's The Gates of Paradise, *shown at left, depicts the story of the Creation from the formation of the world, seen in the upper third of the relief, to the expulsion from Paradise in the extreme right foreground.*

THE RENAISSANCE IN ITALY was a distinct historical movement that ultimately affected the entire cultural and intellectual landscape. It did so, in large part, because its leaders consciously chose to act in opposition to the concepts and values of the Middle Ages. Indeed the very word Renaissance, coined by the sixteenth-century historian and painter Giorgio Vasari, signifies rebirth. More specifically, it implies a revival of the humanist culture of classical antiquity and of classic forms and motifs in art. Renaissance men felt that they were rebuilding an entire society based on the glorious achievements of ancient Greece and Rome—and in this respect the Italians had an advantage not shared by the rest of Europe, for the physical remains of ancient Rome stood before their very eyes.

Individualism and secularism, hallmarks of the Renaissance tradition, emerged in conscious contrast to the moral and social values of the Middle Ages. Renaissance man remained Christian, but he concentrated on the glories of this world rather than on those of the next. Naturalism in the arts, particularly the scientific naturalism observable in the Renaissance artist's concern with perspective and anatomy, derived directly from this emphasis on secularism. So too did Renaissance individualism, which contrasted sharply with the humble anonymity of the medieval artist. The Renaissance glorified the talented, versatile man who could attain excellence in many fields. Especially admired was *virtu*, that combination of extraordinary ability and personal energy that led to success and fame.

The crowning glory of Renaissance thought was Humanism. Primarily literary in origin, it at first referred to the study of the literature and philosophy of pre-Christian Greece and Rome. Later, this description was broadened to include the study of the nature of man and his place in the universe. Like individualism and secularism, this concept originated early in Italy and came to full flower in fifteenth-century Florence, encouraged and subsidized by that city's great banking families, particularly the Medici, who were Florence's benevolent dictators, in fact if not in name.

The new era began dramatically in 1401, the year the Wool Merchants' Guild announced a competition to design new bronze doors for the Florence Baptistry. The results would set new standards of artistic excellence affecting the entire western world. The subject set for the

Threatened with invasion by the army of Milan, Florence was miraculously saved when an outbreak of plague killed most of the Milanese soldiers. As an offering of thanks for this "divine intervention," the city commissioned Ghiberti to create The Gates of Paradise (right) for the Florence Baptistry. The panel above relates the story of Joseph, while the figure shown at far right is Miriam, the sister of Moses and Aaron.

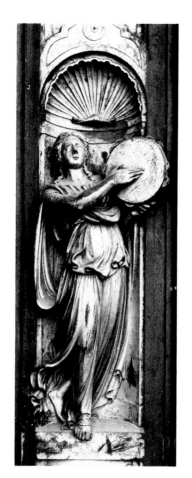

contestants was the Sacrifice of Isaac, a theme requiring both draped and nude figures, a variety of human types, animals, and landscape details. The disappointed runner-up in the competition, Brunelleschi, promptly left in disgust for Rome, where he studied the architectural remains of the classical past. (Eventually he returned to Florence to become the most outstanding architect of the century, his early defeat erased by his later triumphs.) The winner was a twenty-three-year-old goldsmith who had as yet achieved no great success, Lorenzo Ghiberti.

Ghiberti's victory in the competition provided him with a lifetime job. The north doors, which occupied him until 1424, were deliberately planned to match a set of doors executed by Andrea Pisano in the previous century. Pisano's doors illustrated the life of John the Baptist; Ghiberti's program, drawn up by the canons of the cathedral, called for scenes from the life of Christ. The schematic restrictions of this program, which required Ghiberti to compose within small quatrefoil panels, somewhat cramped his genius. The influence of the International Gothic style is still evident in his work, but much more prominent are the new ideals of the Renaissance, the cult of classical antiquity, and the new emphasis on secularism and individualism.

The success of these doors was such that, upon their completion, Ghiberti was rewarded with another commission for a final set of baptistry doors, those that came to be called the *Gates of Paradise*. This time there was no contest; no other artist was even considered. In executing this last commission Ghiberti departed from the format of his earlier doors in various ways. For one thing, the new doors were composed of ten large rectangular panels ornamented on the border with portrait heads and full-length figures. Moreover, the subject matter was drawn from the Old Testament, beginning with the Creation and ending with the story of King Solomon and the Queen of Sheba. Finally, while the panels of the north doors had been episodic in nature, these presented a continuous narrative; several related episodes are included in one frame and set against a unified background. The pictorial organization, the individual figures, the portrait heads and architectural details—all reveal the influence of Roman art. Ghiberti had visited Rome while working on the north doors, and from then on classical elements were increasingly to dominate his work.

The Creation scene admirably illustrates the complexity and beauty of these panels. In the upper background, in extremely fine relief, the figure of God the Father accompanied by angels indicates the Creation of the World. In the lower left foreground, high relief is used in the Creation of Adam, parts of the figures being totally detached from the background. Hovering angels separate this scene from the following episode, the Creation of Eve, which is located in the central middle ground. Adam lies asleep, merging physically with the rocky ground, while a bemused Eve floats up in response to the Creator. Again, a circle of angels is used to separate and focus the scene. The action then moves to the left background, the site of the Temptation and Fall. Here the classically posed nudes under the trees have a dreamlike air, and the delicacy of the relief suggests the remote past, the innocent beginnings of mankind. The final episode, the Expulsion, is in the lower

right foreground, where the size of the figures and the prominence of their modeling imply a more immediate event. The gently modeled Eve looks back at the gate and the avenging angel separating her from Paradise, while Adam strides resolutely into the future.

Ghiberti was a master of atmospheric perspective, and his panels suggest a recession into space that is far in advance of his period. He was also a master of linear perspective, which is seen to its best advantage in scenes featuring elaborate architectural settings. The discovery and mastery of perspective was a major preoccupation of Renaissance artists, as was their interest in the precise depiction of anatomy. This resulted from their concern with scientific naturalism, a visual outgrowth of the concept of secularism, as artists strove to show man in visually correct relation to the world around him. In the panel depicting the Story of Joseph, for instance, a large crowd participates in the action around and within a circular building that dominates the background, architecture serving here as a means of organization, imposing order, logic, and rationality on a complex scene.

One can scarcely overestimate the influence of Ghiberti's genius on the course of Renaissance art. Between 1401, when the competition was announced, and 1452, when he completed the *Gates of Paradise*, Ghiberti was involved in virtually every important artistic enterprise of his time. And during this time a steady stream of apprentices and assistants flowed through his workshop and went on to become established artists. Ghiberti's genius was broad, rather than deep and analytical. He was a public, almost a political, figure in the field of art.

One of the major artistic programs of fifteenth-century Florence was the decoration of the Church of Or San Michele. Each of the city's most influential guilds was assigned an exterior niche in which to commemorate its patron saints, and Ghiberti was given several of these commissions. Another artist who shared in the project was Nanni di Banco, who executed three commissions before his early death in 1421. The most outstanding of his works is the *Quattro Coronati*, or the *Four Saints*, produced for the sculptor's own Stone and Woodcutters' Guild. Even more than Ghiberti's early work, the *Four Saints* shows Renaissance interest in classic art. These nearly life-sized marble figures possess a monumentality that far exceeds even the best of medieval sculpture. Two heads in particular, those of the saints in the rear, show the direct influence of Roman sculpture.

Jacopo della Quercia, a strangely isolated figure in early Renaissance sculpture, was born in Siena and spent most of his life there, but he seems to have been unaffected by the Gothic elegance of Duccio and Simone Martini, whose influence still dominated the Sienese school. Like Brunelleschi and Ghiberti, della Quercia was a competitor in the contest of 1401; unfortunately, his trial piece was not preserved as were those of the other two. It is thought, however, that his Abraham panel in Bologna may reflect the trial piece submitted to the Florentine Signory a quarter of a century earlier. Della Quercia's work for the Church of San Petronio, where ten marble reliefs on pilasters flanking the portal present a series of scenes from Genesis, was undoubtedly the most important commission of his career. The Sacrifice of Isaac, while

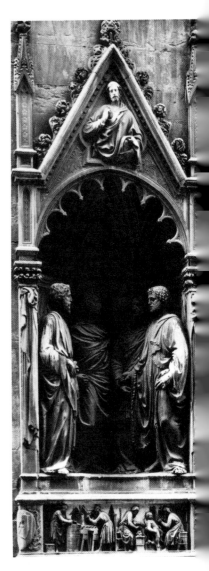

In Nanni di Banco's Four Saints *(above), four Christians martyred during the reign of Diocletian stand atop a deeply cut relief portraying the activities of stonemasons and sculptors. Differences in style and temperament are immediately apparent in comparing the final trial presentations made by Brunelleschi (right, above) and Ghiberti (right, below) for the Florentine competition of 1401; both interpret the Sacrifice of Isaac. Jacopo della Quercia also submitted an entry, now lost; at far right is the version he created for a Bolognese church.*

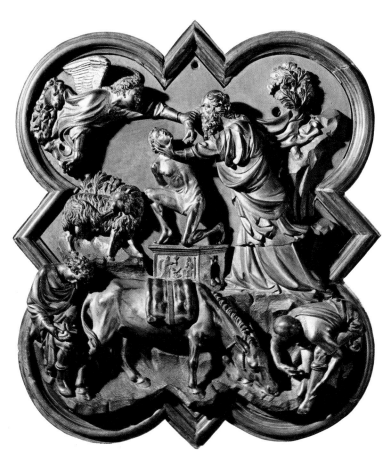

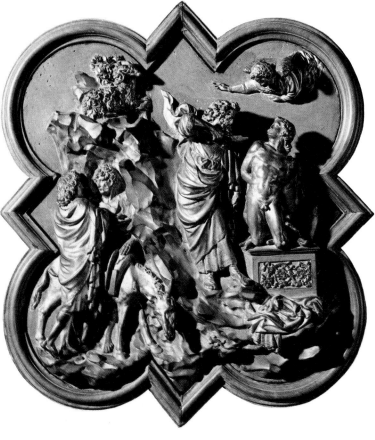

not the most famous of these scenes, is an intriguing and rewarding subject for contrast and comparison with the bronze trial pieces of Brunelleschi and Ghiberti.

Each artist approached the familiar scene of Isaac's sacrifice in a different way. Brunelleschi's panel is extremely cluttered, for example, and his figures strain at the confinement of their frame. The composition is organized along a central, horizontal plane, and the dramatic action is underscored by the emphatic angularity of the figure of Isaac, the agitated swirls of the drapery, and the whirlwind approach of the Angel of Mercy. Ghiberti, on the other hand, strove for a tension balanced by poise and serenity. His figures converge on the center of interest, the carefully counterpoised heads of Abraham, Isaac, and the angel. The composition is divided diagonally, with sharply projecting rocks throwing deep shadows that separate the protagonists from the onlookers. The nude body of Isaac has an almost Praxitelean quality. Ghiberti in fact claimed that he had modeled the figure after a classical statue recently discovered near Florence.

By deciding in Ghiberti's favor, the Florentine judges elected to follow the new aesthetic standards of the Renaissance. Ghiberti's naturalism and secularism can be seen in the firm relation of man to nature; antiquity is present, not only in the derivation of the nude, but also in the atmosphere of classic control dominating the tension of the subject. Ghiberti's technical expertise must also have impressed the judges. Brunelleschi's relief was cast in separate sections, then mounted on the background; Ghiberti's was cast in a single mold.

If della Quercia's trial piece in any way resembles his relief for San Petronio, one understands why, in the aesthetic ferment of the beginning of the century, his work was rejected. Brunelleschi's failing was that he clung too firmly to the Gothic style; della Quercia's, that he ignored it completely. The world of 1401 was not yet ready for his forceful, monumental nudes, which captured both the inner and outer qualities of classical antiquity. Della Quercia was unconcerned with many of the secularizing trends of the Early Renaissance. There is little or no pictorial depth, no atmospheric recession into space; background detail is held to a minimum; relief is low, and naked human forms are modeled simply in broad, flat planes. The figures swell to fill the space, which seems too small to contain them. No other sculptor was to appreciate the understated severity of della Quercia's style until the end of the century—when they were discovered by the young Michelangelo, who was to build much of his career on the foundations laid by this enigmatic figure.

The most authoritative figure in fifteenth-century sculpture was Donatello, whose statue of St. George, designed for Or San Michele in 1415-17, was a pivotal work in his career. Commissioned by the Armorers' Guild, it was placed in a shallow niche from which it seems to emerge with great force. The body stands in *contrapposto*, the weight on the left leg. The spiral shifting of the torso lends tension to the pose, a tension reflected in the face, which is almost Hellenistic in its expression of alert wakefulness, suggesting an impending emotional and physical crisis. The energy of the figure is latent and highly controlled.

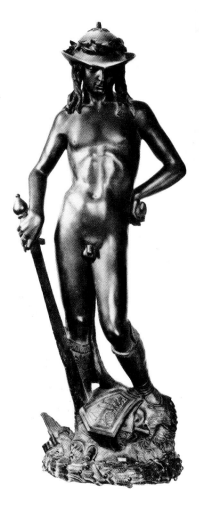

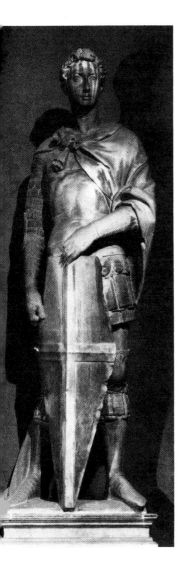

Saint George established Donatello's reputation, and the next decade brought him many commissions, including a series of prophets for the Campanile of the Duomo, that show his grasp not only of the vocabulary but also of the principles of antique art. Here the *contrapposto* of the figures is extremely bold, the heads displaying the unflinching realism of Roman portraiture. The unusual directness of these figures was determined by the technical problems imposed by their original location, high above street level. This necessarily meant an extremely steep angle of vision, a problem that Donatello solved by emphasizing the folds of drapery through deep undercutting, while enlarging details such as hands, feet, and heads. Displayed today at eye level in a museum, the physical and emotional impact of these stern figures is overwhelming.

By contrast, Donatello's magnificent bronze *David* creates a serene, almost lyrical impression. This work, probably commissioned by the Medici, is of supreme importance in the development of European sculpture. The first life-sized, totally freestanding nude to be created since antiquity, it sensitively blends naturalism and classicism. The relaxed pose recalls Praxiteles, as does the sensuously modeled adoles-

*The scope and intensity of Donatello's accomplishments can be seen in a survey of some of his finest works—*St. George *(above), executed in 1417 at the beginning of his career;* David *(left), completed fifteen years later; and* Mary Magdalene *(right), a wooden statue carved in 1454.*

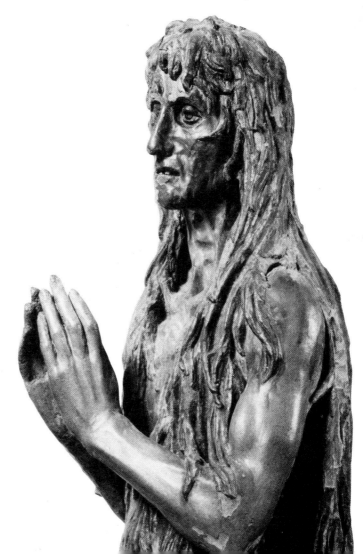

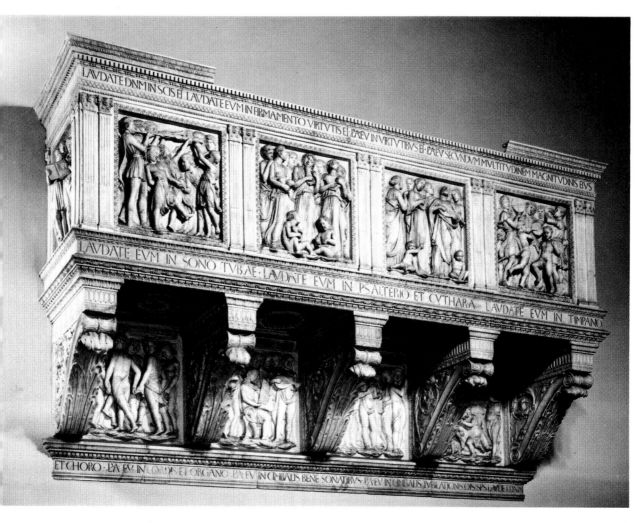

Within the image, the inscriptions read:

LAVDATE DNM IN SCIS ET LAVDATE EVM IN FIRMAMENTO VIRTVTIS EI EAEV IN VIRTVTIBVS EI EAEV SECVNDVM MVLTITVDINEM MAGNITVDINIS EIVS

LAVDATE EVM IN SONO TVBAE · LAVDATE EVM IN PS ALTERIO ET CVTHARA · LAVDATE EVM IN TIMPANO

ET CHORO · PA EV IN CORDIS ET ORGANO EAEV IN CIMBALIS BENE SONATIBVS EAEV IN CIMBALIS IVBILATIONIS OIS SPS LAVDET DNM

cent form. The body speaks more directly to the viewer than does the face, which—by Donatello's standards—is unusually lacking in expression, gazing reflectively out of the shadow cast by a shepherd's hat with its leafy garlands.

Unlike his contemporaries, who were limited to their own specialities, Donatello was a master of every technique, expression, and style. He could present ideals of youth and beauty, of strength and force, or of Christian repentance and asceticism. These latter ideals are dramatically illustrated in his *Mary Magdalene*, carved in wood for the Florence Baptistry in 1454, toward the end of his career. There is profound irony in the way the emaciated, almost cadaverous figure is posed in a classical *contrapposto* curve. Both appearance and mood deny physical beauty, yet a shadow of beauty remains in the exquisite bone structure of the haggard face. Seen by many critics as a reversion to medievalism, the figure more accurately illustrates Donatello's great versatility and individualism.

No artist of the period could equal Donatello's intensity. Indeed, Luca della Robbia, who was active throughout the middle third of the century, was almost his opposite. Della Robbia's style was unfailingly serene, classical, and rather conservative. He is best remembered today for having developed a method of casting terra-cotta reliefs that could

A revealing contrast in artistic temperament is apparent in the two Cantorias *designed by Luca della Robbia and Donatello for the Florence Cathedral. Della Robbia's elegant and restrained interpretation of Psalm 150 is seen above. Donatello's more dramatic* Cantoria *(above, right) emanates a palpable spirit and immense vitality.*

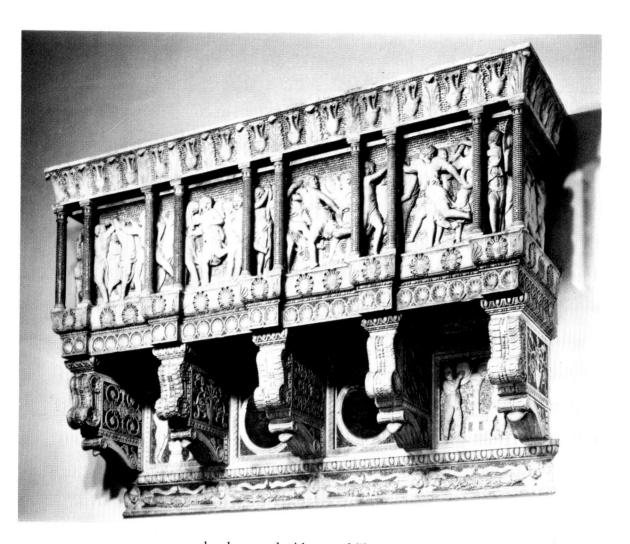

then be coated with enamel-like glazes. The new medium was attractive and far less expensive than marble, a factor that accounts in part for its popularity. Della Robbia began his career as a sculptor in stone, his first major commission being a decorated choir loft for the Duomo. His *Cantoria* featured two rows of marble panels, with two additional panels on the sides of the upper row. The theme of this work is a literal illustration of Psalm 150, which urges the faithful to praise the Lord with singing, dancing, and music played on various instruments. Della Robbia's interpretation is delicate and refined: the central panels are quiet and formally balanced, while the end panels, with their groups of dancing children, reveal the sculptor's knowledge of the traditions of Roman art.

Della Robbia's *Cantoria* was highly successful, and it greatly influenced the development of the mid-century Florentine style. Unfortunately, for both the artist and his work, della Robbia's choir loft had to measure up to a second *Cantoria* on the opposite wall, this one by Donatello. Although expected to follow the same schema in composing his panels, Donatello instead substituted a more individual and dramatic solution. He carved in deep relief a long row of dancing children, or *putti*, set against a background of gold mosaic partially screened by groups of paired columns also covered with gold tesserae. In striking

contrast to the serenity of della Robbia's work, Donatello's gallery is immensely active, with the little dancers racing along in Dionysian abandon, and the gold mosaic accents intensifying that vitality with gleams of reflected light. The freestanding columns and the restrained poses of the young boys at either end control the excess motion and turn the action back on itself.

It is not known why della Robbia abandoned marble, but with his decision to concentrate on ceramic reliefs—coupled as it was with Donatello's departure for Padua to execute, among other projects, the equestrian monument of Gattamelata—Florence abruptly yielded its place as the sculptural nexus of the Renaissance. This setback was slowly remedied by such young men as Bernardo and Antonio Rossellino, Desiderio da Settignano, Mino da Fiesole, Benedetto da Maiano and others, who turned their hands to every commission available. In general they appear to have been awed by the legacy of Donatello's genius, and their styles indicate a cautious return to the delicate and less demanding forms of Ghiberti.

In the latter third of the fifteenth century, young and vital talents began to appear. Antonio Pollaiuolo, perhaps better known as a painter than as a sculptor, specialized in bronze reliefs and statuettes. A scientific naturalist, his greatest interest lay in the study of anatomy and the depiction of the human body in violent action. (His engraving *The Battle of the Naked Men*, for instance, was clearly intended as an anatomical text.) Pollaiuolo was devoted to the study of classical antiquity. His small bronze, *Hercules and Antaeus*, monumental in all respects save actual size, shows two figures engaged in furious struggle, interlocked in a complex composition designed to be best appreciated in the round. The action seems to shift with each variation in the point of view, but despite the agitated pose the group is balanced, a strong central axis controlling the abandon of the outflung limbs. The careful delineation of the muscles shows Pollaiuolo's preoccupation with anat-

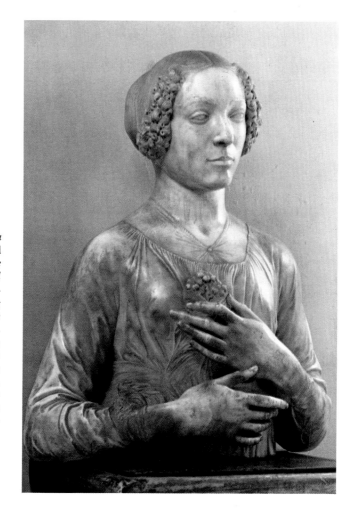

As his enameled terra-cotta sculptures, such as Madonna and Angels *(below, left)* grew more popular, della Robbia abandoned carving in marble and concentrated his energies on directing a flourishing workshop. The realistic detail of Antonio Pollaiuolo's small bronze group Hercules and Antaeus *(left)* ably demonstrates this sculptor's profound grasp of human anatomy, which far exceeded that of his contemporaries. Andrea del Verrocchio's life-size bust, Lady with a Primrose *(right)*, is a sensitive portrait distinguished by the subject's full and sensuous form, direct countenance, and extremely expressive hands.

omy, and has led some art historians to speculate that he may have been the first artist of his time to practice dissection of the human cadaver. The bulging muscles and straining tendons indicate a more than superficial knowledge of the structure and function of the human machine.

With few exceptions, the artists of mid-century, working in the shadow of Donatello, followed a safe and conservative path. There emerged many artists of considerable talent, charm, and elegance, but none approached true genius. Andrea del Verrocchio, active from the mid-1460s until his death in 1488, was the first artist whose vision and ability equaled those of his great predecessor. His talents extended to many areas, and his studio provided training for such young apprentices as Ghirlandaio, Perugino, and Leonardo da Vinci. He himself executed the most important sculptural pieces of his time, but he must have been aware that his triumphs were inevitably measured against those of Donatello.

Perhaps Verrocchio's most endearing work is the *Putto with Dolphin*, commissioned for a Medici villa near Florence. It depicts a plump, naked, winged boy balancing on a round base adorned with the heads of lions. The little wings and the streaming curly hair seem to be in motion; the shadow of a mischievous smile flits across his features. He clutches a squirming dolphin, which originally spouted a stream of water from its mouth as if in response to the child's excessive affection.

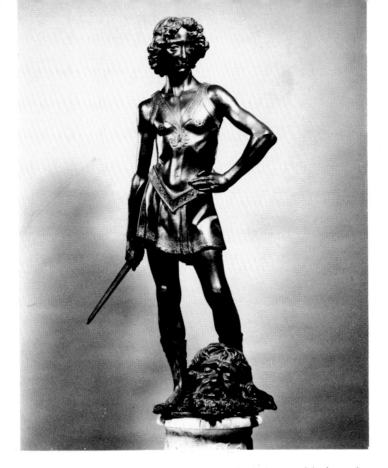

The motif and general design recall the Hellenistic world, but the warm human naturalism is the gift of the Renaissance.

Significantly, Verrocchio's crowning masterpieces curiously echo those of Donatello. Around 1465 the Medici commissioned Verrocchio to do a bronze David. The resulting work inevitably—even deliberately—recalls Donatello's David, but with distinct differences in psychological interpretation. Verrocchio's stands in the same *contrapposto* pose, the left hand on the hip, the right arm holding the sword—all just as before. But there the similarity ends. Donatello had created an introspective naked youth, still unaware of the spiritual consequences of his heroic deed, a personification of the Renaissance contemplative ideal. Verrocchio's young hero is clothed in tight-fitting and rather theatrical armor; the body is wiry, almost scrawny through the arms and torso. The sword does not droop languidly but is held firmly in his hand, in a state of readiness. His head is lifted to meet the viewer's gaze; a triumphant smile underscores the self-confidence shown in the attitude of the entire figure, thus personifying another aspect of the Renaissance ideal—the man of action. Even the head of Goliath restates this theme: in Donatello's work, Goliath's severed head is almost hidden under an ornately decorated helmet; at first glance it appears to be nothing more than some anonymous wreckage from the battlefield. But in Verrocchio's piece the grisly trophy is thrust forward aggressively, the weary resignation of the dead features contrasting with the alertness of the victor's. Donatello's David will contend sooner or later with the moral implications of his action, the spiritual burden consequent upon the taking of human life. Verrocchio's David will never recognize that such burdens exist.

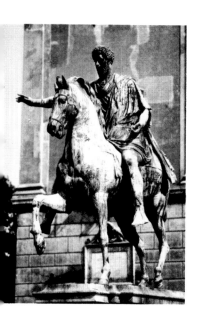

Much the same qualities of contrast exist in the two great equestrian monuments of the era. When Verrocchio was called to Venice in 1483 to do a portrait on horseback of the army commander Bartolommeo Colleoni, he was surely haunted by Donatello's *Gattamelata*, certainly the most significant equestrian monument executed since antiquity. The subject was a professional captain of mercenaries, Erasmo da Narni, one of the most successful soldiers of fortune of the Renaissance. The work had been inspired by the Roman equestrian statue of Marcus Aurelius that Donatello had seen in Rome. Gattamelata's horse moves calmly in a plane parallel to the viewer. One foot rests on a globe, the symbol of worldly supremacy, an image taken from Roman coins. The charger is the typical massive war-horse of its time, but it is completely dominated by its master. Gattamelata, in ornate parade armor decorated with classical motifs, sits in balanced calm on the huge animal, controlling it through his sheer authority. Brute, animal strength is symbolically dominated by the force of character and intellect. Donatello's statue is thus a psychological rather than a true portrait, one in which the sculptor suggests a combination of determination and shrewdness, shadowed by qualities of bitterness and disillusionment.

Verrocchio, following the psychological approach already developed in his *David*, challenged this concept. His *Colleoni* is somewhat larger than the *Gattamelata* and more advanced technically; the horse raises one foot off the ground, a device that Donatello had not attempted. Colleoni's horse is almost too small for the rider, and it moves forcefully into space. The twist of its head and neck reinforce

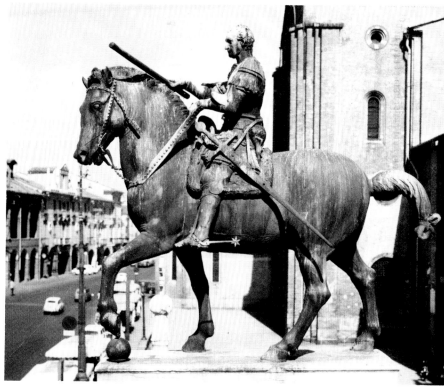

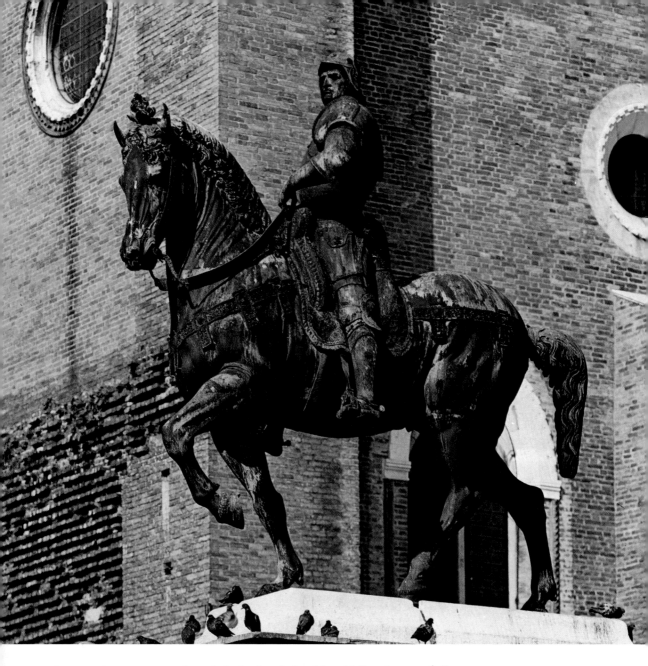

the complementary torsion of the body of the rider. Colleoni wears full field armor, heavy and professional, and he grasps his marshal's baton like a weapon. The figure thrusts forward aggressively; the harsh, frowning face is totally lacking in the subtle introspection found in the *Gattamelata*. Like Verrocchio's *David*, this monument is inspired by and dedicated to the Renaissance ideal of the man of action.

The Early Renaissance, born in Florence in 1401, had received its greatest encouragement from the Medici. And when, toward the end of the fifteenth century and the beginning of the sixteenth, members of that family began to obtain high ecclesiastical posts in Rome, they naturally encouraged Florentine artists to move there to participate in the extensive artistic programs, initiated by Pope Julius II, that gave rise to the High Renaissance.

More than a change of scene is implied in the term High Renaissance, of course, for it was during this era that the tendencies of the

earlier period were carried to their logical conclusion. The cult of individualism was particularly strong, crystallizing around such figures as Leonardo, Raphael, and Michelangelo. Each had in his style much that derived from the artistic traditions of Florence, but each transcended this common heritage through his individual mode of expression.

The attitude toward Humanism had also changed. Artists now turned to the principles rather than to the mere externals of antiquity. The art of the High Renaissance, therefore, is rigorously intellectual, emphasizing formalism rather than naturalism. By then the scientific trends of the fifteenth century were taken for granted. Perspective, anatomy, the vocabulary of ancient art, all were well known and thus no longer exciting. The problems had all been solved. The stage was set for the struggle of the giants.

The clash between the horse's forward movement and the rider's restraining grip infuses Verrocchio's monument to Bartolommeo Colleoni (left) with an extraordinary power and tension. The raised hoof marks a technical advance over Donatello's Gattamelata.

If Donatello and, to a lesser extent, Verrocchio, dominate the fifteenth century, then Michelangelo, supreme in all fields—architecture, painting and sculpture—positively overwhelms the sixteenth. His early career illustrates the continuity of Florentine traditions: he was, for a brief time, taught by a minor sculptor named Bertoldo di Giovanni, who had once been a pupil of Donatello. Subsidized by the Medici, Michelangelo was forced to flee the city when they fell from power in 1494. In Bologna, his next stop, he discovered the panels of Jacopo della Quercia, which profoundly influenced his development—so much so that many of their themes and motifs are "quoted" in Michelangelo's later work. Then, in 1496, Michelangelo went to Rome, where he spent the next four years in almost monastic seclusion, working on three major figures. Among them was the Vatican *Pietà*, a work commissioned by a French cardinal attached to the See—hence the northern, almost Gothic qualities of the iconographic type.

The theme of the *Pietà* poses serious compositional problems for any artist. He must somehow arrange the body of a full-grown male across the lap of a seated female, who must nonetheless appear delicate and fragile. To solve this problem Michelangelo devised a pyramidal composition based on the Virgin's voluminous robes, which both define her limbs and conceal their actual proportions. The body of Christ, bent sharply at the waist, seems almost without weight. It is the body of a slender athlete, its naked vulnerability underscored by the surrounding heavy draperies of the Virgin's mantle and gown. More of the complex drapery is folded around the upper body of Mary, literally cloaking the massive proportions of her shoulders. Her veil shrouds her face, accentuating its delicacy. Michelangelo not only met the compositional challenge of the theme; he devised a solution remarkable in its ingenuity. It would be a mistake to consider this work merely as a magnificent tour de force; with its muted emotional appeal, its overtones of resignation, contemplative sorrow, and sustained mysticism, it is also one of the most outstanding and moving of testaments to the power of Christian faith.

By 1501 the artist was again in Florence, where he received the commission for a marble David. This theme had already been handled by Donatello and Verrocchio, but Michelangelo's interpretation was to prove entirely different from theirs. For one thing, the moment of

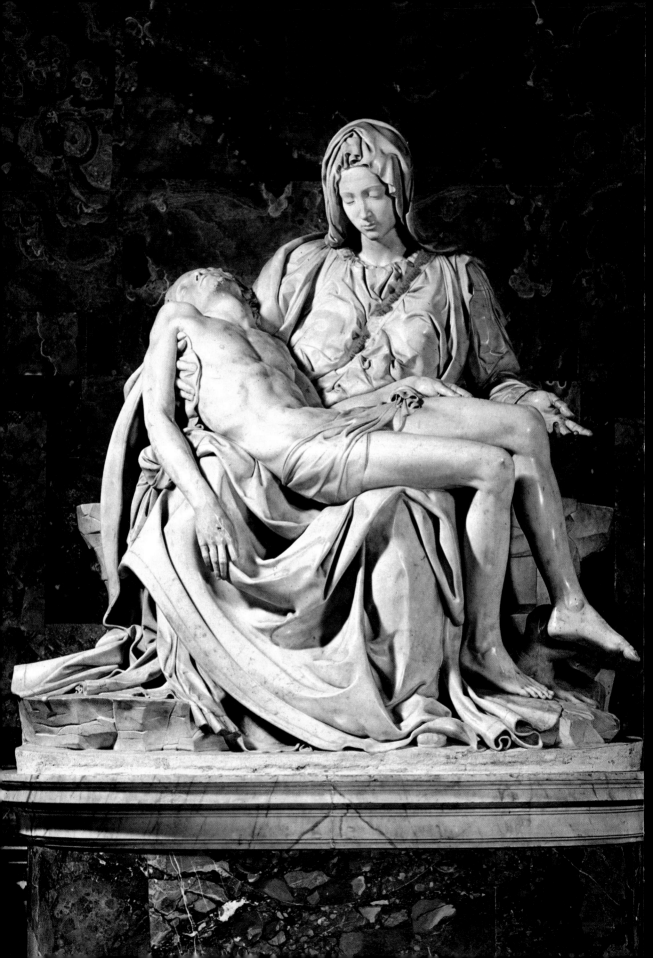

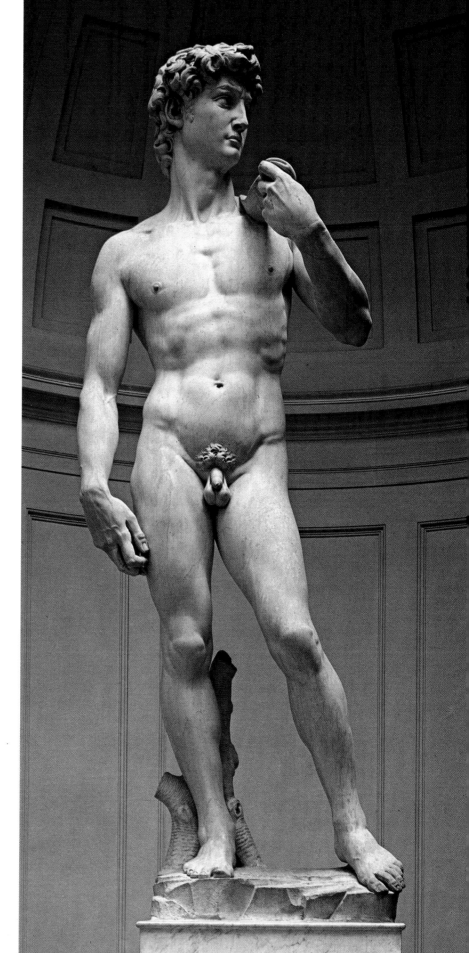

One of the supreme embodiments of the Christian ideals of love and compassion, Michelangelo's Pietà (left) is a unique and inspiring work. Two years after its completion, in 1501, Michelangelo began carving his statue of David (right). This figure is a milestone in Michelangelo's development as a sculptor because it brings together those qualities of overwhelming force, dynamic tension, and explosive energy that distinguish all of his later works.

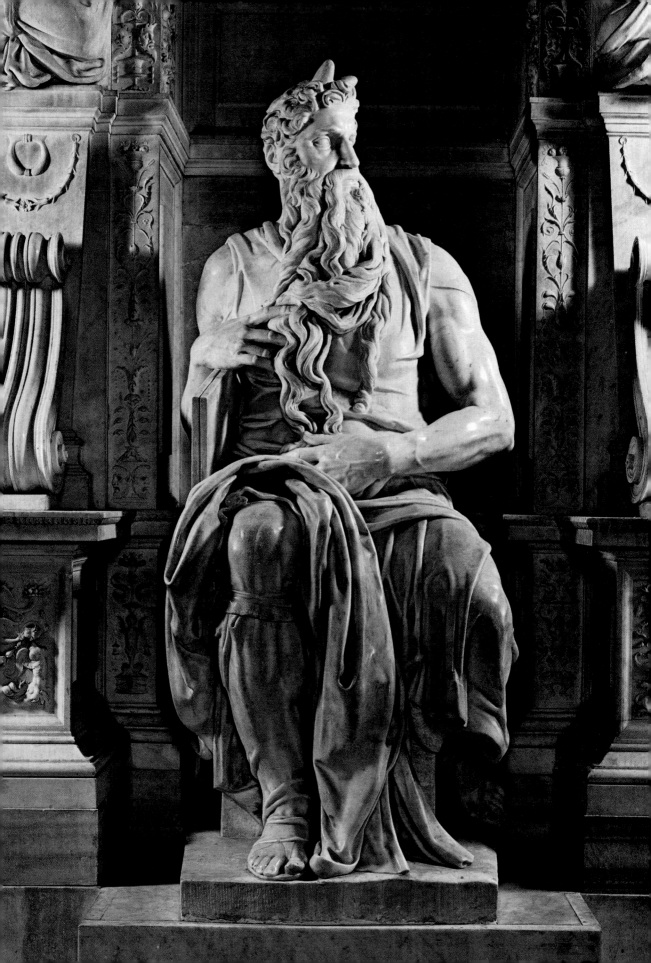

The unfinished Boboli Captives *(above) and the completed figure of* Moses *(left) were key elements of Michelangelo's design for the never-to-be-completed tomb of Pope Julius II.*

action itself is different: a well-muscled young man stands proudly erect, sling in one hand and stone in the other, searching the horizon for the enemy. Bold and defiant, his great internal energy is barely contained by the calm watchfulness of the pose—a combination that makes this one of the most attractive and overpowering male nudes in the history of Western art.

In 1505 Michelangelo returned to Rome, where he became involved in numerous projects, including the frescoes of the Sistine ceiling, and in the nightmarish frustration of Julius's tomb. This particular commission—postponed, modified, nearly abandoned—dragged on until 1545. It was never completed as planned, but the statutes designed for it—*Moses*, *The Bound Slave* and *The Dying Slave* (now in the Louvre), and the four unfinished slaves known as the *Boboli Captives*—are among Michelangelo's most powerful works.

The *Moses*, the only one of the figures incorporated in the tomb as it now stands, is often held to be the greatest of Michelangelo's sculptural creations. The powerful body, seated but not relaxed, seems the very embodiment of barely controlled Olympian rage, the calm before a devastating storm. The agitated beard, the deeply cut drapery, the engorged veins and tense musculature—all contribute to an atmosphere of suppressed fury. Moses is more than the great lawgiver of the Old Testament; here he personifies the elemental force of Nature.

The four unfinished *Captives*, originally intended as symbolic allegories for the tomb, are designed on the same monumental scale as the *Moses* but have a less universal and more direct application to the personal philosophy of the artist. Michelangelo was a Christian, but he was a Neo-Platonist as well. This philosophy had been in vogue for some time at the Medici court, where it was much discussed and refined by the brilliant circle of Humanists who gathered there. In Neo-Platonist thought, the soul of man is said to be locked within the prison of the flesh, from which it seeks to escape to the realm of pure spirit from whence it came; but it is an escape possible only through death. Michelangelo saw the sculptor's role as that of a divine genius who liberates his artistic conceptions from the imprisoning stone, and thus his unfinished captives struggle within the massive blocks that seem to be trying to draw their human spirit back into a state of formless chaos.

Between 1520 and 1534 Michelangelo was intermittently occupied with the Medici tombs in the Church of San Lorenzo, Florence. This was the last major sculptural program of his career. From then on, his time would be spent in Rome, devoted to architecture and fresco painting. The tomb honored the memory of Giuliano, Duke of Nemours, and Lorenzo, Duke of Urbino, son and grandson, respectively, of Lorenzo il Magnifico. Michelangelo made no attempt to render portrait likenesses; instead the program was organized around a typical humanist theme, the contrast between the Active and the Contemplative Life. The Active Life is personified in the tomb of Giuliano, where the young hero, clad in elaborate classical armor and loosely grasping a baton, assumes a posture of alert tension. The details of the costume are sharply linear, and a flicker of movement seems to play across the entire figure. The head tilts forward to catch the light. Below him, the

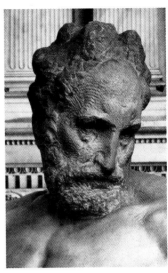

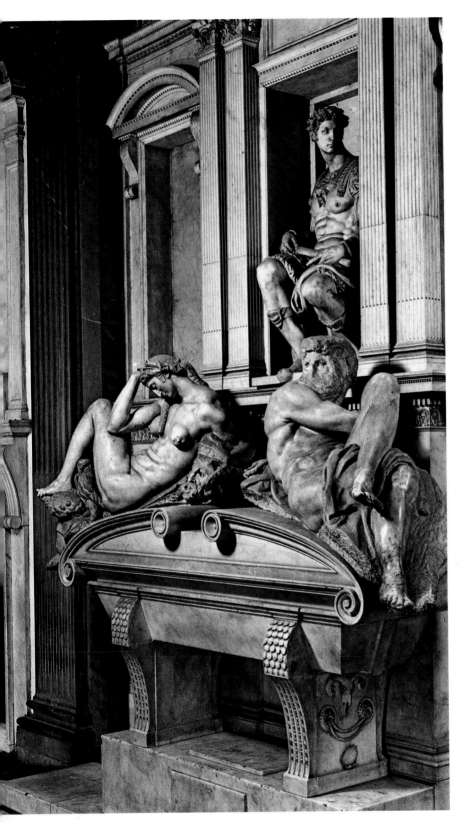

Michelangelo's final major sculptural commission was the design of burial crypts in the Medici chapel. The tomb of Giuliano de' Medici (left) is decorated with a male and a female figure respectively representing Night and Day. On an opposite wall is the tomb of Lorenzo de' Medici, for which Michelangelo chose to fashion figures symbolizing Dusk (detail above) and a reluctantly awakening Dawn (right).

figures of Day and Night, derived from antique river gods, recline on the symbolic sarcophagus. The deliberately unfinished head of Day glowers over his shoulders like the sun rising behind a hill. Night is sunk in narcotized slumber with the poppies of oblivion at her feet.

On the opposite wall the Contemplative Life sits cloaked in shadows that flow smoothly and evenly across the figure. The quiet hero personifies the withdrawn introspective life of meditation. The figures of Dawn and Dusk, shadowy, indeterminate times of day, recline at his feet. The sagging muscles of Dusk sink into lethargy, the quiet aging face steeped in quiet reflection. His companion, Dawn, struggles to awake from heavy sleep. There is no joy in the awakening, only an agony of body and spirit. The body is young and superbly developed, yet it seems incapable of decisive action.

This monument marks a turning point in Michelangelo's career and in the course of Renaissance art and culture as well. A new style has evolved that differs markedly from the balanced clarity of his earlier sculpture. The unrest, the tension, the bitter resignation of the allegorical figures—all reflect the disillusionment that filled sixteenth-century Italy. Rome had been brutally sacked in 1527 by the undisciplined troops of Charles V, and many Italian states had become virtual fiefs of the Holy Roman Empire. The composed, logical, rational view of life

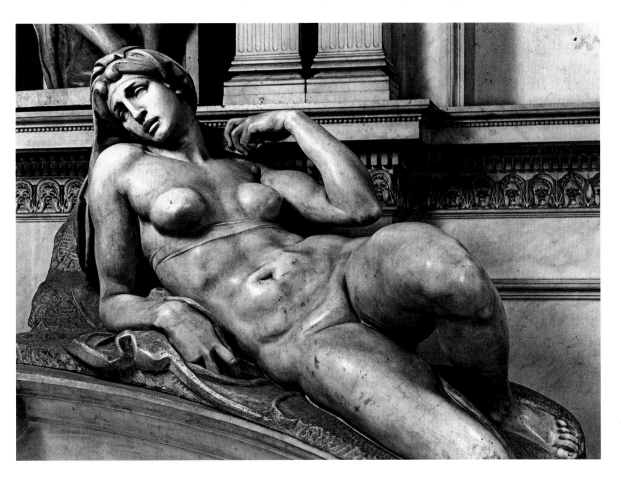

that had been the supreme contribution of humanist philosophy was now totally discredited. The Golden Age was over.

In the arts, the rising generation of young sculptors and painters sank into a like mood of resignation and despair in the face of the matchless accomplishments of their predecessors. Out of this atmosphere of disorder and discontent arose a movement called Mannerism. As a style, it falls generally between the late 1520s and the early 1590s. As a label, it describes works of art executed "in the manner of" the High Renaissance masters.

In the hands of an inept sculptor, Mannerism becomes merely a vulgarization of Michelangelo's inventions. Under a greater artist, a Benvenuto Cellini or a Giovanni da Bologna, the style becomes capable of great virtuosity and refinement. Cellini was the earliest and perhaps the most famous exponent of Mannerism in sculpture. Brash, conceited, intensely ambitious, he was nevertheless an artist of sensitivity and ingenuity. The extraordinary gold saltcellar that he designed for Francis I of France in the early 1540s is his only major work in precious metal to escape destruction. Earth, a female figure of great elegance, presides over a tiny triumphal arch that disguises the pepper mill, while the bearded figure of Neptune watches over the boat-shaped salt dish. These major figures, like the host of minor ones that embellish this elaborate confection, are borrowed almost directly from the Medici tombs. But the eccentricities of form, barely hinted at by Michelangelo, are here carried much further. The bodies are excessively slim and elongated; the twists of torso, head, and legs more pronounced; the use of the classical theme is almost playful, devoid of seriousness.

During his career, Bartolommeo Ammanati received much encour-

With a sculptural style derived almost equally from ancient Hellenistic masters and Michelangelo, Giovanni da Bologna's The Rape of the Sabine Women (right) is an impressive study of violent action. The nymph seen below, far right, is one of many figures completed by Bartolommeo Ammanati and his assistants for the Neptune Fountain in Florence. In the representations of Neptune and Earth carved on a saltcellar (left) designed for Francis I, Benvenuto Cellini captured the air of courtly refinement so characteristic of High Renaissance life.

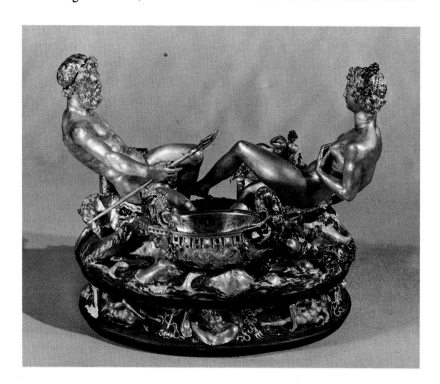

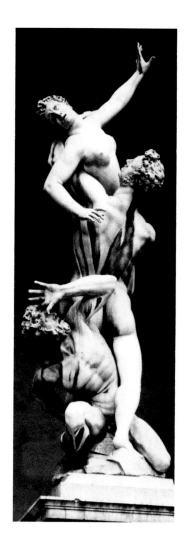

agement from Michelangelo, who successfully recommended him for the commission for the Neptune Fountain in the Piazza della Signoria in Florence. The central figure of Neptune is a disappointment, but the smaller bronze nymphs, satyrs, and sea gods that ornament the rim are totally delightful. They too are children of the Medici tombs, rendered elegant and sensual through the magic mirror of Mannerism.

Perhaps the greatest sculptor of the Mannerist era was Giovanni da Bologna, whose style goes beyond pure Mannerism to touch upon the Baroque. For all its subsequent fame, his *Rape of the Sabines* was designed primarily as an attempt to solve a technical problem, the organization of three nude figures in a common action. Such groups had previously been done as miniature bronzes, but no sculptor had yet attempted one in marble. Designed to be viewed from any angle, the figures interwine in a precise balance of action as succeeding gestures and movements lead the eye upward in an ascending spiral. Thus, in its compositional complexity and dynamic organization, this work prefigures the great sculptural groupings of the Baroque era.

The Mannerist movement, overall, does not mark the beginning of a new style so much as the end of an old one. The elegance and courtly refinement that distinguish this period are the dying echos of the titanic struggles of the High Renaissance, when naturalism and individualism warred with classicism, and Neo-Platonist Humanism promised the glorification of man in the flesh as well as in the spirit. These ideals were now in disfavor, the great creative geniuses were gone. The new century was to belong to the rediscovered realism and elemental religious vitality of the Baroque.

RACHEL H. KEMPER

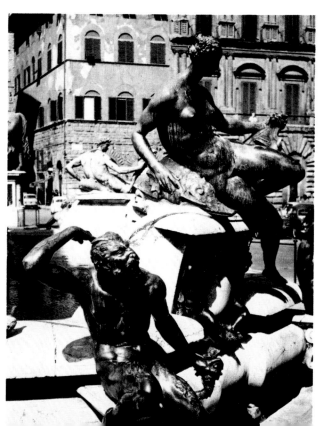

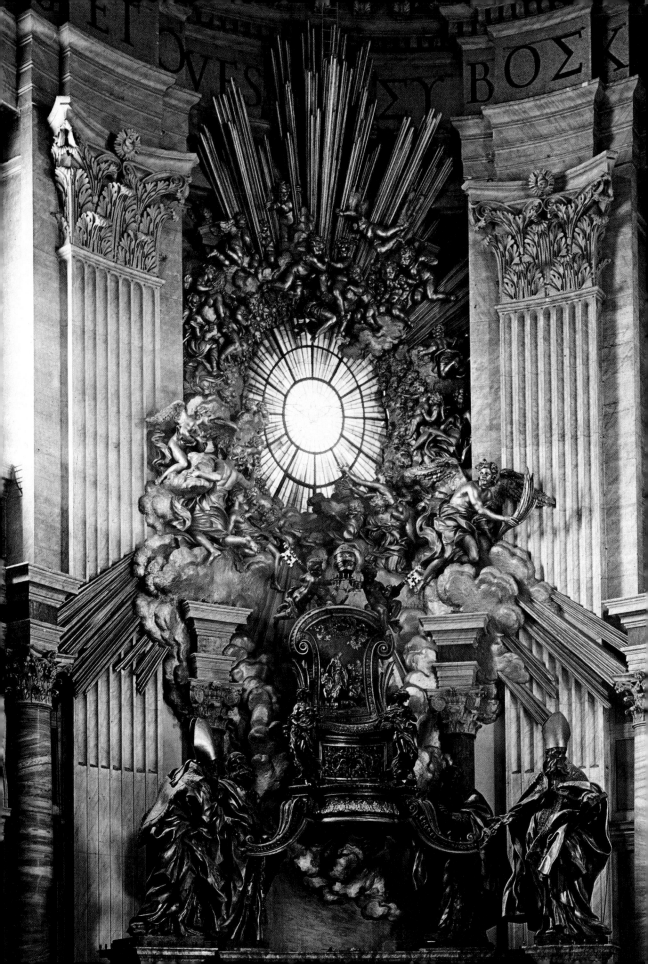

7

The Elegant Baroque

Serving as both a resting place for one of the important relics of the Catholic Church—the ancient throne of St. Peter—as well as a decoration for the apse of St. Peter's Basilica, Bernini's Cathedra Petri *is a beautifully realized monument to Christian faith in God.*

SCULPTURE OF SUPERB QUALITY in considerable quantity was produced in the seventeenth and eighteenth centuries. But the conditions under which it was created differ greatly from those of today. Most forms of art, including sculpture, remained institutionalized, as they had been in the Renaissance. Almost all the great works of sculpture served Church or State; they had, therefore, a propagandistic as well as an aesthetic function. Most works were executed on commission, and documents give plentiful evidence of designs being changed after criticism by a patron. Rarely did an artist work independently, hoping to sell his sculpture to a discerning connoisseur-collector.

One circumstance affecting Baroque and Rococo sculpture that cannot be underestimated is the experience of Rome. Almost all sculptors visited there, lived there, studied there, or worked there. For much of the seventeenth century, the popes and clergy were the major patrons of art, summoning sculptors, painters, and architects to build and decorate churches, palaces, and squares. One of the period's greatest challenges was the completion of St. Peter's Basilica, Roman Catholicism's chief monument. Even when real leadership in the art of sculpture shifted to France in the late seventeenth century, Rome remained a magnet for the aspiring artist. Nowhere else were the riches of antiquity, the Renaissance, and earlier Baroque art so abundantly available.

Sculpture of the Baroque and Rococo era is seldom blocklike and self-contained; it was designed to interact with the light and air around it, with the spectator before it, and with the architecture framing it. These characteristics are largely due to the example and influence of one brilliant innovator.

Gian Lorenzo Bernini—sculptor, architect, painter, stage designer, and playwright—was born in Naples in 1598. His father, a sculptor, moved the family to Rome early in the seventeenth century. Recognized as a prodigy in his youth, Gian Lorenzo proved to be a genius. Throughout a long life—he lived until 1680—and a long career, primarily as a sculptor, Bernini was always original in his art, whether treating familiar subjects in new ways or having to cope with and rise to the challenges of the unprecedented. Except for a trip to France, Bernini never left Rome, and much of his art served the Church there.

One of several large sculptural groups Bernini carved for his first important patron, Cardinal Scipione Borghese, for his villa in Rome, is

the *Apollo and Daphne*. Executed in 1622–25, it is a work of astonishing virtuosity in choice of subject, composition, and technique. The god Apollo has fallen in love at first sight with Daphne, a wood nymph who shuns love, the daughter of a river god. Pursuing her through the forests, he is about to catch her when she realizes that her river-father is nearby. She cries to him to "change and destroy this beauty by which I pleased too well"; he hears her and transforms her into a laurel tree.

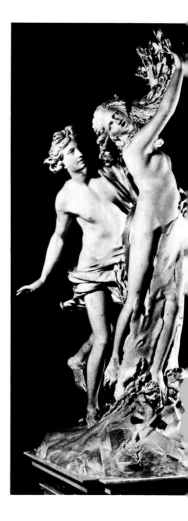

Bernini depicts this very instant of transformation: the running Apollo has grasped Daphne; she calls in desperate terror to her father; and, even as she does so, her metamorphosis begins. The sculptor's utter confidence and skill in the handling of marble is evident in the different textures—hair, leaves, drapery, skin, bark—and the broken outline of the group; at the left, Apollo's arm, windblown drapery, and left leg extend, unsupported, in space.

Maffeo Barberini became pope, as Urban VIII, in 1623. Recognizing Bernini as the major artist in his domain, he promptly began commissioning major works of architecture and sculpture, including, at St. Peter's, the Baldacchino and the St. Longinus, and at the Church of Sta. Bibiana, a new façade and a figure of the saint. One of the most prestigious commissions in Rome, for any sculptor for centuries, was the tomb of a pope. Urban's tomb was first planned in the late 1620s; Bernini completed it in 1647, three years after the pope's death.

Set in a niche in St. Peter's, to the right of the high altar, the monument is organized as a tall pyramid. At its apex, the bronze and gilt-bronze seated figure of Urban VIII, in full papal regalia, makes the gesture of benediction toward the spectator before him. Occupying the lower tier of the monument is the bronze and dark marble sarcophagus, flanked by white marble allegorical figures of Charity and Justice. Between the volutes of the sarcophagus emerges the skeletal figure of Death, who is writing Urban's obituary inscription on a plaque—Bernini has transformed the usual death's head motif into an active personification. (In Bernini's later papal tomb in St. Peter's for Alexander VII, executed in 1671–78, Death brandishes his hourglass while lifting up the jasper marble shroud covering the tomb chamber.) Bernini's tomb of Urban VIII was a novel and influential design; not until Canova's tomb for Clement XIII of about 1790 was the pattern radically broken.

After the death of Urban VIII, Bernini received few papal commissions for several years. As a result, he was able to work for several private patrons. One of them was the Venetian Cardinal Federigo Cornaro, who in 1645 commissioned the decoration of a chapel in Sta. Maria della Vittoria, Rome, as a burial place for himself and his family.

In the Cornaro Chapel, familiar aspects of Bernini's art are developed and combined into a total ensemble. The capture of a crucial moment, so that the work of art seems a vision suddenly appearing before the viewer (as in the *Apollo and Daphne*), is transmuted into a climatic scene of religious ecstasy. Richness of materials, as in Urban VIII's tomb, is elaborated into an architectural and sculptural complex of many-colored marbles, gilding, painting, and stuccowork; even the natural light falling into the chapel is used for expressive purpose.

St. Teresa of Avila, an important reformer of the Carmelite order, was also a mystic. Bernini has depicted a famous visionary experience recalled in detail in Teresa's autobiography: an angel had appeared to her and repeatedly plunged an arrow into her heart, she wrote,

> The pain was so severe that it made me utter several moans. The sweetness caused by this intense pain is so extreme that one cannot possibly wish it to cease, nor is one's soul then content with anything but God. This is not a physical, but a spiritual pain, though the body has some share in it. . . .

The white marble figures of St. Teresa, consumed by this rapture, and her cherubic visitor are the focal point of the chapel. Set on white marble clouds, which have an appropriate foggy texture, they seem to hover in air. The golden rays behind them appear to emanate from the dove of the Holy Spirit above in the vault of the chapel, paralleling the fall of light from the window above. Around the dove descend painted, celebrating angels and stucco clouds, both overlapping actual architectural elements of the vault.

Somewhat unexpectedly, Bernini's plan for the Four Rivers Fountain in the Piazza Navona was selected by Pope Innocent X (Giambattista Pamphili). Innocent usually preferred the work of other artists but could not resist Bernini's revolutionary design, which fused animals, plants, figures, rustic rockwork, gushing waters, and an obelisk in a manner hitherto found in gardens, not in city squares. Although Bernini designed the fountain and supervised its construction in the years 1648–52, most of the carving actually had to be delegated to assistants. The Four Rivers Fountain's most famous descendant is the Trevi fountain of 1732–62 by Nicola Salvi and others.

Alexander VII (Fabio Chigi), elected pope in 1655, followed Urban VIII's pattern in choosing Bernini as his chief sculptor and architect. Among his works for Alexander were the Scala Regia with the *Emperor Constantine* at its entrance and the *Cathedra Petri* in the basilica of St. Peter's.

Originating as a project of 1654 for a niche in St. Peter's, the equestrian statue of the Emperor Constantine was worked out between 1662 and 1670. Devices employed by Bernini recall the St. Teresa group: the placement of white marble figures against a colored ground, here a painted stucco drapery, and the use of natural light, flooding from above, to correspond with the source of the miraculous light. Recalling as well the *Apollo and Daphne* is Bernini's choice of a transitory moment as a subject. Constantine's rearing horse derives from Leonardo da Vinci's designs for the Sforza monument in Milan and was rather unusual in executed sculpture. While Pietro Tacca had earlier employed the pose for the horse in his equestrian monument to Philip IV in Madrid, it was Bernini's *Constantine* that made this dramatic treatment famous. In Bernini's later equestrian monument to Louis XIV, in which Louis was depicted as Hercules climbing the rocky mount of Virtue, the horse's pose contributed to the French king's air of "majesty and command."

Bernini's most truly glorious contribution to the great basilica of St.

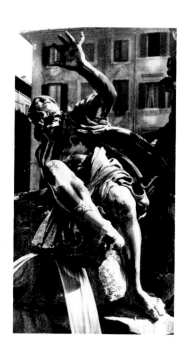

Enhancing the dramatic impact of Bernini's Apollo and Daphne *(left) is the upward thrust of the group, which was originally designed to be seen at an angle and against a wall, not in the round as we see it today. The success of Bernini's scheme for the tomb of Pope Urban VIII set a pattern for such commissions that lasted more than a hundred years. A larger-than-life-size portrait of the pope (below, left) was placed above the sarcophagus, on which the figures of* Death *and* Justice *are seen. In the detail below of Bernini's* Four Rivers Fountain, *the personified symbol of the Americas, the Rio de la Plata, looks upward at the obelisk that stands at the center of this picturesque monument in the heart of Rome.*

Peter's is the *Cathedra Petri*, an immense work combining sculpture, architecture, relief, painting, and, again, natural light. The materials are rich: colored marble, bronze, gilt bronze, and gilt stucco; even the light is colored—by the golden glow from the dove painted on the window. The core of the *Cathedra Petri* is the old—actually medieval—throne of St. Peter, formerly housed in the church's Baptismal Chapel; its relocation in the apse, behind the high altar, required the new, grandiose, and monumental setting.

After acceptance of Bernini's design, a small model was prepared in

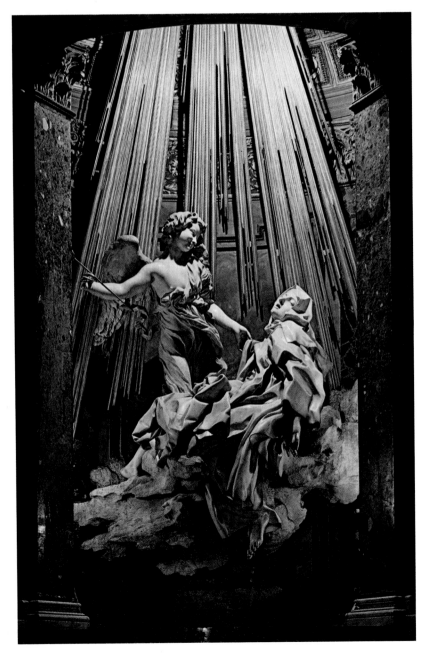

Bernini used every facet of his talent as a sculptor, architect, and designer to create one of the supreme expressions of human emotion, whether religious or secular, in the Ecstasy of St. Teresa (left). In contrast to the passion of Bernini's work, François Duquesnoy's statue of the early Christian martyr St. Susanna (right, above) possesses a classical calm. René-Michel Slodtz's St. Bruno (right, below) was one of a series of statues— commemorating founders of the major religious orders—that were placed in St. Peter's during the eighteenth century.

1657. A full-scale model was erected *in situ* in 1660; its appearance led to further enlargement of the scale of the object. Then, casting began in 1661. Work was finished and the new *Cathedra Petri* unveiled in January 1666. Bernini necessarily relied on a host of assistants for the execution of this work—about thirty-five artist-collaborators, as well as numerous lesser artisans. Yet the work is his in concept and style.

On the marble base stand four Doctors of the Church, flanking the raised, bronze-encased throne. Elegant angels stand at the throne's corners, while *putti* bearing the papal keys and tiara top its back. On it, the scene of Christ's command to Peter, that he should "feed my sheep," is depicted in relief. The throne seems to float against stucco clouds, as if a divine gift that has suddenly been offered. Above, from the oval window a golden light radiates over the flock of joyous angels, some modeled in the round, others in relief; they populate a heavenly ambience of golden rays and stucco clouds. Yet the Composite half-columns, echoing the architectural order of the apse's niches, rising on either side of the throne, anchor the *Cathedra Petri* to its site.

Such a unification of the arts was seldom equaled by later artists except for designers of the interiors of Rococo churches in southern Germany in the eighteenth century. Among the most important of these designers were the brothers Cosmas Damian and Egid Quirin Asam, the former a painter and architect, the latter a sculptor, stucco-worker, and architect. Sons of a fresco painter, they had studied at Rome from 1711 to 1713. Egid Quirin's decoration of the choir of the Augustinian church at Rohr, executed in 1721–23, reflects his knowledge and admiration of Roman Baroque art, notably that of Bernini. The scene represented is a miraculous event, the bodily assumption of the Virgin Mary into heaven after her death.

The Baroque power of Bernini's sculpture does not represent the only current in sculpture in seventeenth-century Rome. One major practitioner of the art, whose work in a restrained, classical style offers an alternative to Bernini's dramatic forms, was François Duquesnoy. Born in Brussels, the son of a sculptor, he went to Rome in 1618; there he counted among his friends the painters Poussin and Sacchi, who also worked in an idealizing, classicizing vein. Duquesnoy remained in Rome almost all his life; he died prematurely in 1643.

Duquesnoy's most famous piece is the figure of the early Christian martyr St. Susanna, installed in 1633 in the church of Sta. Maria di Loreto. Duquesnoy avoids indicating the grimness of her death by beheading, except for the traditional martyr's palm, now lost, which she held; nor does he depict her in a momentary state. Instead, he has fashioned a tranquil and eternal presence, with a serious but sweet face and a calm pose articulated by delicately modeled draperies. However, she does not exist entirely in her own space, as did her classical models (one was an antique muse in the Capitoline Museum). She is designed to look out at the worshipers in the church while, with her pointing hand, she directs their gaze to the altar.

The presentation of a saint as an idealized figure rather than as a protagonist in a narrative was the concern of the eighteenth-century French sculptor René-Michel Slodtz, called Michel-Ange, when he was

chosen by the Carthusian order to design the figure of its founder, St. Bruno. In order to return to an ascetic life of spiritual retreat, Bruno had twice refused bishoprics. Slodtz depicts him as backing off, indeed recoiling, from the attributes of a bishop—the mitre and crozier—which a small angel offers him. Bruno's life as a monk is indicated by his shaved head, his simple habit, and the objects of his contemplation—his book of Scriptures and a skull.

The location of the sculpture is significant: a niche in the southeast pier of the crossing of St. Peter's. Recognizing the prominence of the site, Slodtz first set a full-scale plaster model in the niche in 1740 to gauge its effect. This version was modified because of criticism from his patrons, notably of the size of the angel, as well as because of his study of a similar sculpture unveiled at Genoa in 1668 by the earlier French sculptor Pierre Puget. Slodtz went to see Puget's work in 1741, while en route to Carrara for the marble for St. Bruno. He completed his *St. Bruno* three years later. The diagonal upward movement of the group from the angel back to the saint's head is typically Baroque—and is more emphatic than in Puget's sculpture—yet Slodtz's refinement and elegance reveal this as an eighteenth-century work. Elegance also characterizes the work of Ignaz Günther, an eighteenth-century German sculptor who worked primarily in Munich.

Bernini's tomb of Urban VIII had initiated a new type of papal monument, a genre restricted to Rome. Yet the design of tombs continued to be a major challenge to sculptors, not only in Rome, but also in all of Europe. France particularly created numerous impressive sculptural compositions as funerary memorials to important men of the seventeenth and eighteenth centuries.

One of the most affecting is the tomb of Cardinal Richelieu in the church of the Sorbonne in Paris by François Girardon, a sculptor trained in Paris and Rome who worked primarily for the French monarchy. In this case, however, Girardon had accepted a private commission—from the niece and heiress of Richelieu. In 1675 she approved, with slight modifications, Girardon's small model for her uncle's monument, essentially identical with the completed work. Unlike Bernini's papal wall-tombs, this group is freestanding; like them, some of the figures are symbolic. Here, Faith supports the cardinal, and Christian Doctrine, at his feet, weeps at his death. A full-scale model was placed on the tomb's site in 1677; as a result, the sizes of the figures were changed. The tomb was not finished until 1694.

Jean-Baptiste Pigalle was humbly born in Paris in 1714, a year before Girardon's death, and achieved considerable fame in France in the 1740s. Pigalle's tomb of the Marshal of Saxony, in comparison to Richelieu's monument, indicates clearly the ambitiousness of scale and elaboration that could result from royal patronage.

Silhouetted against an inscribed cenotaph, the marshal is surrounded by several allegorical figures as he walks fearlessly toward the shrouded, skeletal figure of Death. The anguished personification of France tries to intercede between Death and his victim, stretching her arms across the space between them. Behind her, a cupid with torch downturned weeps before an array of triumphal flags.

Egid Quirin Asam's Assumption of the Virgin Mary, *a decoration executed for the high altar of the Augustinian church in Rohr, Germany, shows the direct influence of Bernini's work in the dramatic use of hidden light sources and the multitude of figures that overwhelms the vault. In this grandiose treatment of the* Assumption, *white, gilt-trimmed stucco figures of the apostles surround Mary's empty coffin, while she rises toward Heaven upheld by angels covered with flowing draperies.*

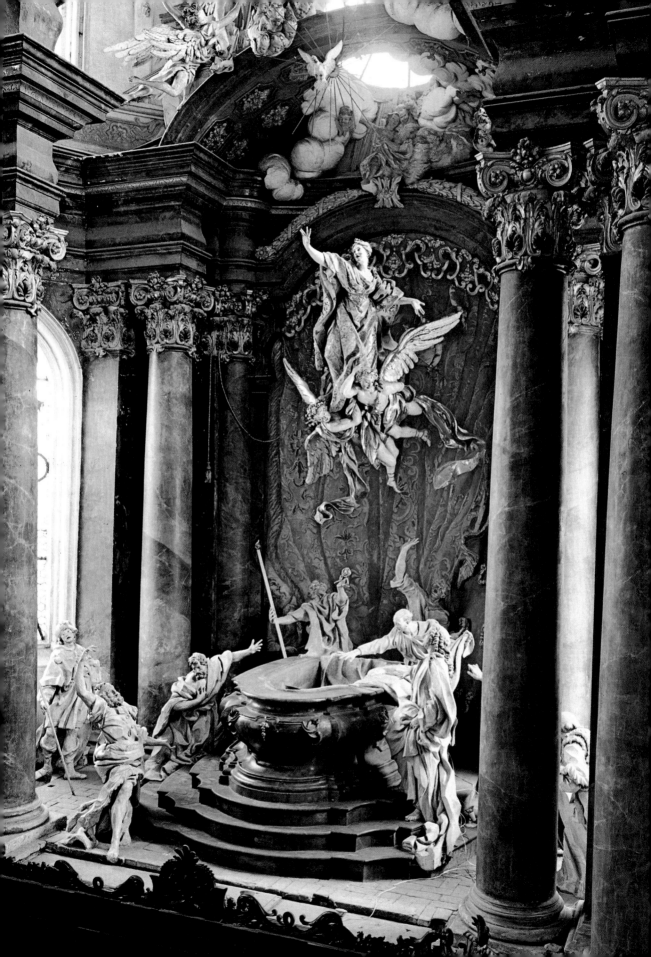

Bernini's *Emperor Constantine* had turned the equestrian monument into a religious image designed to glorify the Church. More typically, as with his *Louis XIV as Hercules*, the Renaissance tradition of using the equestrian monument to aggrandize secular rulers was continued in the seventeenth and eighteenth centuries. Andreas Schlüter's monument of the Great Elector Friedrich Wilhelm, ruler of Brandenburg and Prussia, is an impressive example; yet perhaps it is less important in its own right than as an extant reflection of several French royal monuments destroyed in 1792 in the Revolution.

The essential concept of Schlüter's monument derives from Giovanni Bologna's design for the monument of Henry IV (1604–14) in Paris. There, too, the horse and rider were atop an elaborate pedestal enriched with reliefs, inscriptions, and four symbolic figures of slaves; like Bologna's monument, Schlüter's was originally placed on a bridge. The treatment of the figure—clothed in antique-style armor but with a modern curly coiffure, with drapery sweeping over his right shoulder, and his head turned to his left—has been drawn from Girardon's equestrian monument to Louis XIV (1683–99) in the Place Vendôme in Paris. The gait of Schlüter's spirited horse goes back to the antique statue of Emperor Marcus Aurelius on the Capitoline Hill in Rome and had been repeated by numerous modern sculptors.

The monument was executed in 1696–1710 for the Great Elector's heir, Frederick I, Elector of Brandenburg and first king of Prussia, who also had had part of the nearby palace rebuilt to Schlüter's designs. Schlüter, born around 1660 in Danzig, worked as both architect and sculptor, mostly in Eastern Europe; he died in Russia in 1714.

Baroque memorials to outstanding political and military leaders include tombs such as those of Cardinal Richelieu (above, left), executed by François Girardon, and the Marshal of Saxony (detail above), designed by Jean-Baptiste Pigalle. Andreas Schlüter and Etienne-Maurice Falconet found in the equestrian statue the perfect form in which to commemorate, respectively, the lives of such political personages as the Great Elector of Brandenburg (right, below) and Peter the Great (right, above).

PETRO PRIMO
CATHARINA SECUNDA
MDCCLXXXII

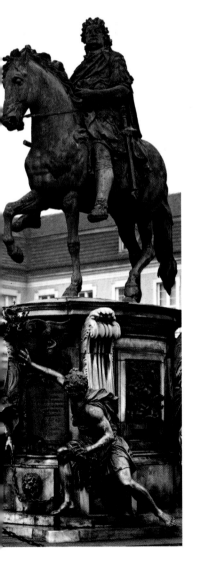

A similarly propagandistic ambition led to one of the grandest equestrian monuments of the eighteenth century, that of Peter the Great on Senate Square in St. Petersburg (the present Leningrad). The sculptor was Etienne-Maurice Falconet. Born in Paris in 1716, he studied there with Jean-Baptiste Lemoyne and first became famous for a series of erotic nudes. Never receiving significant royal patronage in France, he accepted with alacrity Catherine the Great's invitation to visit Russia to design an important monument to her dynamic predecessor. Falconet remained in that country from 1766 to 1778, then returned to France, where he died in 1791.

As part of Peter's program to modernize Russia, he had founded St. Petersburg on the inhospitable, marshy banks of the Neva River. With forceful determination he had seen the city built and had made it his country's capital as his "window on the West." The placement of the monument, hence, contributes to its grandeur—in the huge main square at the center of Peter's special city, facing the Neva.

Falconet critically considered a number of equestrian monuments that had previously been erected, finding elements of Bernini's *Louis XIV* most adaptable. Yet his sculpture of Peter the Great proclaims the artist's originality in a way that Schlüter's monument to the Great Elector does not. Peter's horse rears up on a huge, sloping, rough granite rock, symbol of the harsh difficulties that Peter had surmounted in establishing his city and his rule over the empire. The serpent being crushed under the energetic animal's rear hoof represents Powerless Envy. The calm figure of the tsar—dramatized by the vigorous pose of the horse—wears a timeless, idealized costume, neither Roman nor Russian, and extends a benevolent hand over his people.

Contemporary with the aggrandizing portraiture of official monuments, funerary and celebratory, was a new informal type of portrait, usually bust-length. Initiated by Bernini in two works of the 1630s, the *Cardinal Scipione Borghese* and the *Costanza Bonarelli*, this new realistic type emphasized the individuality of the subject's character and facial features. Eighteenth-century French and English sculptors excelled at the genre. Outstanding among them was Jean-Antoine Houdon (1741–1828). Though a son of a concierge, he became passionately committed to the art of sculpture as a youth. After studying in Paris with René-Michel Slodtz and in Rome, he worked in France and, briefly, in the United States, preeminently as a portraitist. He based his portraits on extremely careful observation, even to taking measurements and making life-masks of his subjects.

Such life studies are evident in his *Voltaire*'s casual mien, extraordinary facial animation, and convincingly fragile aged figure (Voltaire was eighty-four years old when Houdon began the portrait). Doubtless because of the official location planned for the statue, this image of the writer is not a bust-length study; instead, it evokes antique statues of philosophers, with the full-length seated pose, toga, Roman-style chair, and, circling Voltaire's head, "the fillet of immortality."

Sculptures of mythological figures continued to appeal to patrons of art throughout the seventeenth and eighteenth centuries, just as Bernini's marble *Apollo and Daphne* and other works had been sought by

Bernini's bust of his mistress Costanza Bonarelli (below) is one of the finest informal character studies completed in the Baroque period. Jean-Antoine Houdon's portrait of the aged Voltaire (plaster model completed in 1780 shown at right) is distinguished by his subject's animated expression.

Scipione Borghese. Their locations include both gardens and residential interiors, and materials and size vary according to function.

A specific French royal commission produced Girardon's ambitious and fanciful marble group of *Apollo and the Nymphs of Thetis* at Versailles. The mythology was invented by court advisers as flattery of the young Louis XIV, already identified as the Sun King. Developed from the notion of the sun sinking into the ocean when day is done, the scene of Apollo relaxing in the grotto of the Nereid Thetis, being served by her nymphs, represents the king resting at Versailles, being refreshed after his duties as monarch. Despite the classicism of the figures—the Apollo clearly depends on the Hellenistic *Apollo Belvedere*—the composition of the circular group had no antique prototypes.

Girardon had worked, mostly in stucco, for the French royal family for over ten years before beginning the Apollo group. Its

Classical and Baroque elements are deftly combined in Pierre Puget's Milo of Crotona *(above) and Girardon's* Apollo and the Nymphs of Thetis *(right). Puget's figure was intended to be displayed outdoors in the gardens of Versailles, while Girardon's group originally occupied the central spot in a luxuriously appointed grotto near the château.*

maquette was approved in 1666, but his work at the grotto was not over until 1673.

In marked contrast to the classical poise of Girardon's group is one of the most dramatic Baroque sculptures produced in France, the *Milo of Crotona* by Pierre Puget. Rarely depicted before Puget's example, Milo was a Greek athlete who caught his hand in a tree stump; unable to extricate himself, he was attacked by wild animals and suffered a gruesome death. Puget obviously had looked to the *Laocoön* for a similar subject in antique art, and for the straining musculature of the body and the tormented expression of the face. Yet his design is extraordinarily inventive in its daring open space between the body and the tree trunk and in its taut counterdiagonals, with the lines of legs and left arm opposing the lines of torso, drapery, and tree trunk. Puget always intended *Milo* for the gardens at Versailles. Eleven years elapsed between his receiving approval to begin work, in 1670, and its completion and delivery in 1681. The statue's many years out-of-doors have abraded the subtly modeled marble surface.

The sculptured group *Diana and Her Nymphs* at Caserta near Naples, the work of four Italian artists, recalls Girardon's *Apollo* group at Versailles in that, again, classically modeled marble figures are deployed in a modern pattern, here a pyramidal composition. Unlike Girardon's subject, though, the *Diana* group illustrates an ancient mythology, one that had been selected, as elsewhere in the Caserta gardens, for its setting—woodland and pool.

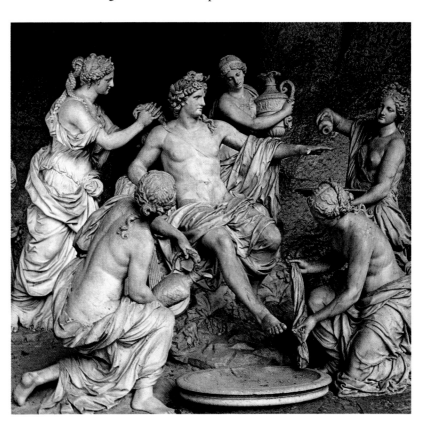

The virgin huntress goddess Diana and her nymphs were bathing when the mortal Actaeon inadvertently came upon them. Enraged at having been seen nude, Diana turned the young man into a stag; he was then pursued and destroyed by his pack of hunting dogs. At the apex of the sculptural group is the goddess, whose imperious gesture indicates her anger, as two nymphs try to shield her with drapery. Two subsidiary trios of nymphs betray fright and astonishment at Actaeon's unexpected arrival. On the other side of the pool are Actaeon and his dogs, another pyramidal group. His tragic metamorphosis has begun: stag-headed, he runs from Diana, while his dogs spring at him. The two-part composition was planned by Carlo Vanvitelli and executed by sculptors Paolo Persico, Angelo Brunelli, and Pietro Solari around 1775. Their concern in portraying the dramatic climax of the myth reveals

Luigi Vanvitelli and the three sculptors who assisted him integrated sculpture and landscape in creating at Caserta the group of figures called Diana and Her Nymphs *(below). Mythological characters were also the subject of Pigalle's* Mercury *(right, above) and Clodion's* Cupid and Psyche *(right, below).*

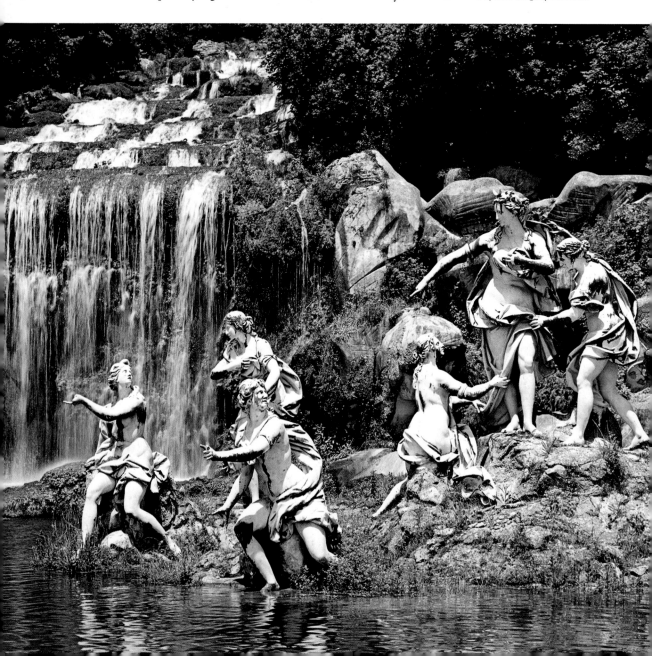

their indebtedness to works such as Bernini's *Apollo and Daphne*.

A number of individual nude sculptured figures also were produced in the eighteenth century, especially in France. While their subjects were mythological, they were rarely meant as instructive allegories but as works to be enjoyed for their playful, sensuous, even erotic qualities. Often these works began as artists' own inventions, were exhibited in small form, whether in terra-cotta or marble, and were later executed in large scale on commission from individual patrons.

One of the most famous works of eighteenth-century sculpture, Pigalle's *Mercury*, has such a history. The artist presented the terra-cotta version to the Académie in 1741; he exhibited a marble version, considerably regularized in comparison to the terra-cotta, at the Salon in 1742. The latter was so well received that a companion piece was commissioned (Pigalle carved a Venus); then large marble versions of the pair were ordered by the king as a gift for Frederick the Great, who set them out as garden sculptures.

Pigalle has depicted Mercury, the messenger of the gods, as pausing on a cloud to tie his winged sandal. The compressed pose of the figure conveys the temporariness of his action; he seems about to spring up nimbly. The rippling surfaces and outlines of the terra-cotta also effectively suggest his airborne yet muscular nature. The *Mercury* was much copied in various media; small plaster versions appear in Chardin's still-life *Allegories of the Arts* (1766), representing both the art of sculpture and Mercury as the tutelary deity of the arts and crafts.

Pigalle's marble versions of the *Mercury* lack the immediacy of his terra-cotta. In contrast, a number of other eighteenth-century French sculptors treated the surfaces of their finished marbles so sensuously as to create the effect of soft, delicate flesh in their nude figures. Notable examples, all now in the Louvre, include Edmé Bouchardon's impish *Cupid Testing His Bow* (1739–50); Falconet's dainty *Bathing Nymph* (1757); Pierre Julien's classicizing *Nymph Amalthea* (1786–87, designed for a grotto at Rambouillet); and Augustin Pajou's rather salaciously realistic *Abandoned Psyche* (1782–90).

Claude Michel, known as Clodion, was one sculptor who worked primarily in the medium of terra-cotta, producing small-scale works for connoisseurs. Born into a family of sculptors in 1738, he trained in Paris with his uncle and with Pigalle and in Rome, where he lived for almost a decade until 1771. His handling of mythological subjects—whether *putti*, satyrs, nymphs, gods, or goddesses—delights with its joyful exuberance. The *Cupid and Psyche*, executed probably about 1780–90, shows the handsome young god rescuing his beloved Psyche (who has fainted from smelling poisonous fumes) and carrying her off to Olympus, where they will be married. Several chubby *amorini* assist him in supporting the lusciously modeled unconscious figure.

Although he was the last major Rococo sculptor, Clodion, too, reveals his kinship to the young Bernini of a century-and-a-half earlier. This is evident in the beautifully differentiated textures of the *Cupid and Psyche* and in his choosing to design this amorous pair caught in a moment of flight.

ELEANOR PEARSON

127

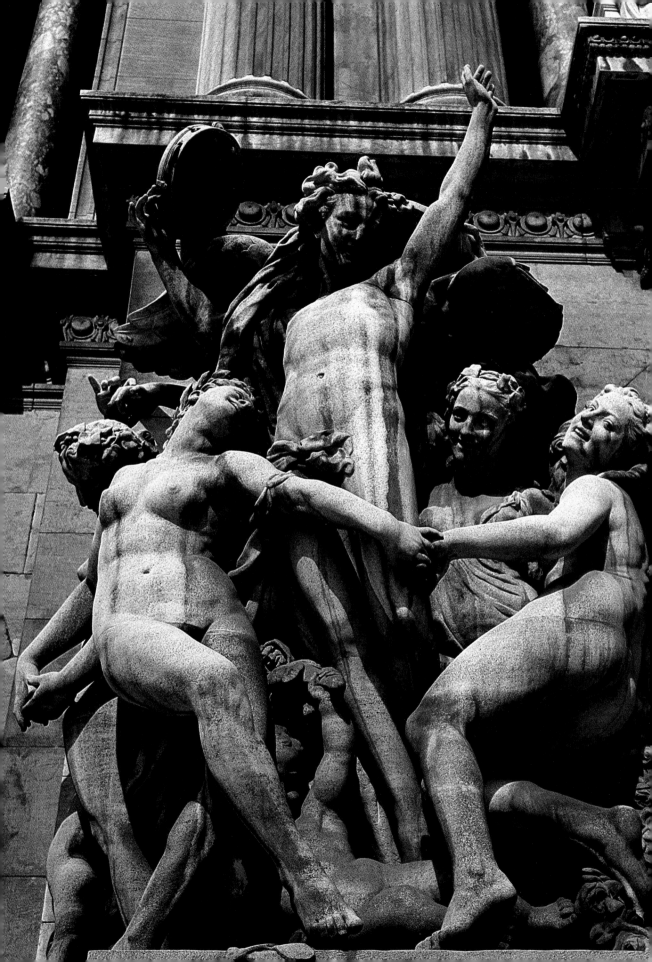

8

Sculpture's Expanding Horizons

In its free-flowing rhythm and grace, Jean-Baptiste Carpeaux's group The Dance *(left), completed in 1869 for the façade of the Paris Opéra, is an outstanding example of the Romantic spirit in mid-nineteenth-century sculpture. To prevent further deterioration from the effects of air pollution,* The Dance *was recently moved from its original place on the Opéra to a gallery in the Louvre.*

DURING MUCH OF THE NINETEENTH CENTURY sculpture suffered in comparison to painting. The predominant artistic movements of the period, Romanticism, Naturalism, and Impressionism, were more suited to execution on canvas than in freestanding statuary or relief. Most sculptors, therefore, tended to look to the past—to Greece and Rome—for a mode of expression.

This conservative tendency was further reinforced as the source of patronage shifted from royalty, the Church, and wealthy individuals to republican governments and, to a lesser extent, the newly affluent commercial class. The vast numbers of skillfully crafted monuments found in city squares or adorning public buildings throughout Europe are testimony to the important role such objects played in the celebration of civic events. But they also affirm the high value their sponsors placed on respectability and stability, often at the expense of artistic creativity. Moreover, the hidebound taste of the academies and salons reigned supreme through much of the nineteenth century.

Despite the mediocre atmosphere within which they were forced to work, several noteworthy talents emerged. The Italian-born sculptor Antonio Canova was the preeminent personality in European sculpture at the end of the eighteenth century and the beginning of the nineteenth. Most of his figures were characterized by a disarming combination of neoclassic form and sensual animation. Canova frequently portrayed mythological figures such as his *Cupid and Psyche* (1793) with great flair. Later Canova rendered two large likenesses of Napoleon in the style of the heroic classical nude.

France's outstanding sculptors of the period vivified their work with a strong dose of the romantic spirit. François Rude's relief *The Departure of the Volunteers in 1792* (1835–36) on the Arc de Triomphe was fashioned with unmistakable passion and national pride. An equally skilled artist was Antoine-Louis Barye, whose studies of animals, such as *Lion and Snake* (1832), were enhanced by his careful attention to anatomical detail.

Jean-Baptiste Carpeaux was undoubtedly the finest exemplar of the romantic style in sculpture. Throughout his career Carpeaux, who lavished his work with a degree of spontaneity and movement unmatched by his contemporaries, unfortunately found these skills placed him far in advance of public taste. The dismay voiced by Parisians following

the appearance of his striking bronze group of *Ugolino and His Sons* (1861–63) was only a precursor of the shock that greeted the figures representing *The Dance*, which Carpeaux executed for the façade of the Paris Opéra. His young dancers capture all the grace and rhythm of that art, and today the work is acknowledged to be Carpeaux's masterpiece. In a different vein, Honoré Daumier—better known as a caricaturist—turned his gifts for social satire into a small but satisfying body of sculptural works. His style was shown to particular advantage in the small statue called *Ratapoil*, completed in 1850.

Yet for all the skill manifested by these artists, they could not lift sculpture from the rut of traditionalism in which it was floundering. That task was to be accomplished by Auguste Rodin, whose broad talents and striking personality reasserted sculpture's position as a vital art form in modern times.

Rodin was officially recognized by established artistic and social cir-

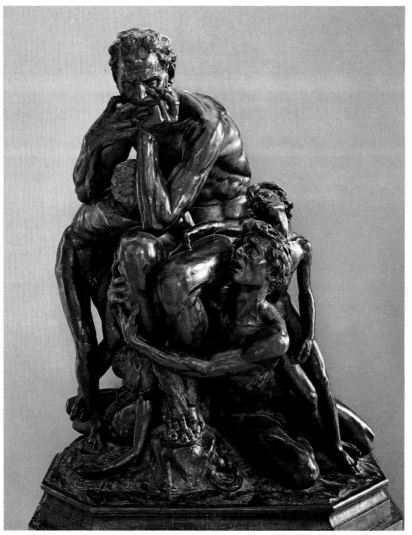

Antonio Canova was the unquestioned master of neoclassical sculpture. The mythological figures of Cupid and Psyche *(above) illustrate the purity and restraint of Canova's technique. While working and studying in Rome, Carpeaux executed the dramatic portrait* Ugolino and His Sons *(left). The work caught the attention of the French art public, including Napoleon III, who later made Carpeaux his official sculptor. Auguste Rodin's memorial sculpture* The Burghers of Calais *(right) succeeds in portraying graphically both the individual and collective emotions of these self-sacrificing men.*

cles in 1880, when two of his most famous figures, *The Age of Bronze* and *St. John the Baptist Preaching*, won acclaim at salons in Paris and Brussels. The irony of such acclaim was not lost on the forty-year-old sculptor, who just three years earlier had had to defend himself against charges that a realistic life-size study of a young soldier had been cast directly from a live subject rather than modeled freely. A proud and self-confident man, Rodin did not need official recognition to assure him that he possessed talents. But the sanction of the authorities did bring a degree of financial security that was in sharp contrast to the poverty of his early years.

Born into a poor Parisian family and unable to gain admission to the prestigious Ecole des Beaux-Arts, Rodin faced significant obstacles in pursuing a career as a sculptor. Following graduation from a school of decorative arts, Rodin was employed as a stone carver. Later, he worked in the studio of the prominent French sculptor A. E. Carrier-

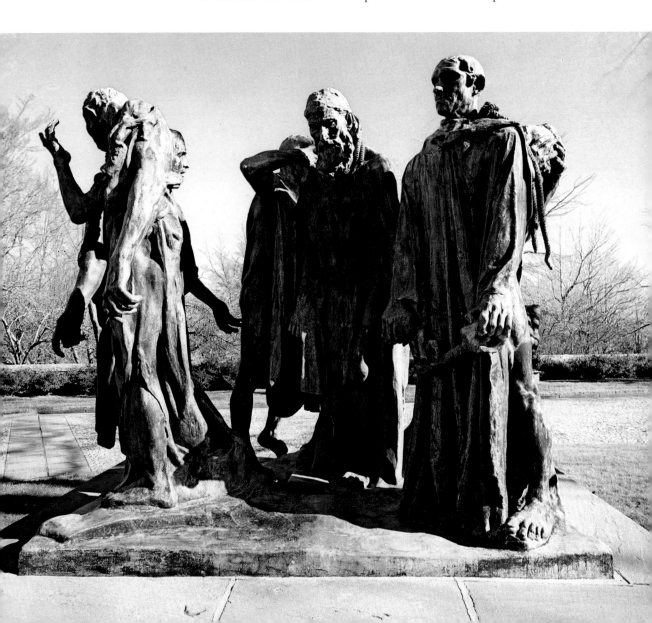

Belleuse in Paris and then moved to Brussels to aid Carrier-Belleuse in fulfilling commissions for statues in that city. While in Brussels, Rodin also received some independent assignments, ones that further demonstrated his skill within the conventional styles of the period. But as yet Rodin had not found the imaginative framework within which to overcome the limitations of the prevailing academic fashion.

In 1875 he traveled to Italy to study the work of such Renaissance masters as Michelangelo and Donatello. Struck by the magnificence of their accomplishments, Rodin returned to Brussels and immediately began to use the knowledge he had gained in the modeling of *The Age of Bronze*.

The key to Rodin's facility as a sculptor rests with his unmatched ability to translate emotional and psychological insights into specific gestures and movements. In Rodin's eyes every human feeling had a gestural possibility and, as one critic remarked, he "knitted emotion and form together in unequaled intimacy."

Asked by the city of Calais to create a monument to honor the six citizens who sacrificed their lives to save the city in 1347, Rodin chose to portray the entire group rather than a single symbolic figure. By designing the renowned *Burghers of Calais* (1884–86) in this manner, Rodin produced a dynamic and unforgettable examination of individual and collective courage.

The Thinker and *The Kiss*, familiar works that have been reproduced around the world, are only three of 186 figures Rodin created for his most intricate work, *The Gates of Hell*. Rodin began the project in 1880 after receiving a commission from the French government to design the entry gates for a proposed Museum of Decorative Arts. The museum was never built, but Rodin continued to work on the gates,

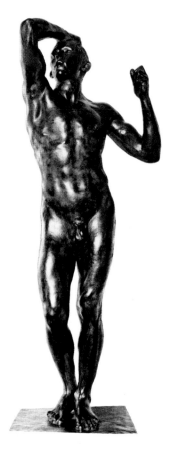

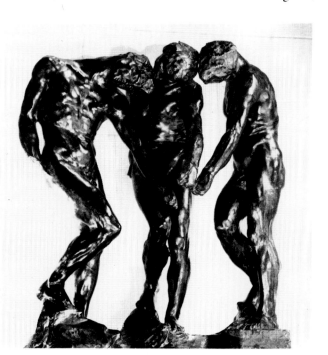

It did not matter if he was creating a portrait of a specific individual, such as the preliminary nude study for his Balzac *(above, far right), or simply shaping anonymous figures as in* The Kiss *(above, right),* The Age of Bronze *(above), or the grouping from* The Gates of Hell *called* Les Ombres *(left); Rodin invested each one with the same unforgettable sense of realism and humanity that distinguishes the great works of Michelangelo and Donatello.*

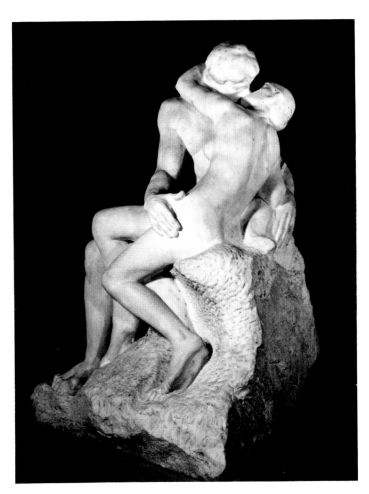

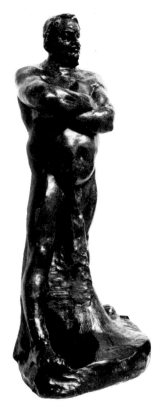

whose theme was inspired by Dante's *Inferno*, throughout his lifetime.

At many stages of his career Rodin's uncompromising attitude toward his work caused him to become embroiled in heated disputes with art critics and the public. But none was as intense as the controversy that flared up over his statue of the French novelist Honoré de Balzac. In 1891 the Société des Gens de Lettres commissioned Rodin to create a memorial to Balzac. For seven years Rodin steeped himself in material about the celebrated author's life and produced scores of clay and terra-cotta models before selecting his final approach to the statue. The result is a towering figure swathed in a great robe, simple in outline but, in the words of the German poet Rainer Rilke, capturing Balzac's creative "pride, arrogance, ecstasy, and intoxication."

When Rodin exhibited his *Balzac* in 1898, the Société and the public in general were horrified. Rather than try to convince his critics of the statue's merit, Rodin repaid the money advanced him for his work and reclaimed the figure. It was finally cast in bronze and erected in Paris in 1939, twenty-two years after the sculptor's death, and there it magnificently justifies Rodin's faith in its eventual triumph.

By accident of birth Rodin should be considered an Impressionist, but it detracts from the scope of his achievement to classify him with that label or any other. As one critic wrote, Rodin's contributions to sculpture begin with his restoration of its primary strength in western art, "a knowledge and sumptuous rendering of the human body."

Moreover, Rodin cleared away the last vestiges of academic limits on the sculptor's imaginative freedom and thus prepared the way for the twentieth-century artist's unlimited experimentation with the form and mass of his materials.

The most talented sculptor to work in a purely impressionist mode was Medardo Rosso. Expelled from the Brera Academy in Milan in 1883 for inciting his fellow students to protest against traditional teaching methods, Rosso journeyed to Paris, where he worked at the studio of Jules Dalou and became acquainted with Rodin and other leading personalities in the art world. Rosso attempted to solve some of the difficulties of transferring impressionist principles from painting to sculpture by limiting the expressive area of his work to those features picked up by a specific source of light, and leaving the rest of a figure roughly cast in amorphous forms. Through his deft modeling of wax and clay in such pieces as *Conversation in a Garden* (1893) and *Madame X* (1896), Rosso did indeed need only a minimum of detail to express a rich variety of movement and character.

While sculptors such as Charles Despiau and Antoine Bourdelle created significant works in Rodin's style, it was inevitable that a reaction against his influence would begin to develop. And it is almost further proof of Rodin's enormous influence to note that this opposition produced not only new paths for sculptural development, but perhaps the finest twentieth-century French sculptor, Aristide Maillol.

Maillol originally came to Paris from his home in southern France in 1887 to study at the École des Beaux-Arts. After working with the Nabis, adherents of the bright, rhythmic painting style of Paul Gauguin, Maillol became intrigued by the expressive possibilities of the decorative arts and crafts and eventually gave up painting entirely in order to design and weave tapestries. This close and delicate work strained Maillol's eyesight and he was forced to shift mediums again, now turning to modeling statues in wood and terra-cotta. Maillol's friends Ambroise Vollard and Edouard Vuillard had several of these works cast in bronze and arranged a one-man show of Maillol's sculpture in Paris in 1902—and his reputation was established.

With supreme self-assurance, Maillol needed only a single form—the female body—to express himself completely. His figures are characterized by their full volume and simple, composed demeanor. Contrasting his style to Rodin's, Maillol commented, ". . . I must return to more stable and self-contained forms. Stripped of all psychological details, forms yield themselves up more readily to the sculptor's intentions." Little in the way of expressive technique separates early Maillol figures such as *Mediterranean*, designed in 1910, from *The River*, completed in 1943, a year before his death. Throughout his career Maillol combined a classical sense of harmony with a modern eye for nature and beauty.

Among the young sculptors drawn to Paris in the early twentieth century by the fame of Rodin was Constantin Brancusi, whose work, along with that of the Cubists, would provide the two main currents of what is now termed modern sculpture.

Born of peasant parentage in a Romanian farming village in 1876, Brancusi left home at the age of eleven to find work as a shepherd and wood carver. He then entered the Bucharest School of Fine Arts, graduating with honors in 1902. After successfully exhibiting Greek-style statues in Bucharest and Vienna, Brancusi made his way to Paris on foot, where he enrolled in the Ecole des Beaux-Arts and studied in the studio of Antonin Mercier. In Paris Brancusi sculpted in a style similar to Rodin's and soon attracted the master's attention. Brancusi's biographers agree that Rodin asked the young sculptor to join his studio

The Italian-born sculptor Medardo Rosso manipulated his surfaces to unleash the expressive qualities of light and shadow in a unique manner. Rosso himself is the dominant figure in one of his finest works, Conversation in a Garden *(near left), while the French entertainer Yvette Guilbert is the subject of the portrait bust shown at far left. The rich fullness of form and classical serenity characteristic of Aristide Maillol's work is amply demonstrated in the* Three Nymphs *(below, left) and* The River, *dramatically displayed below.*

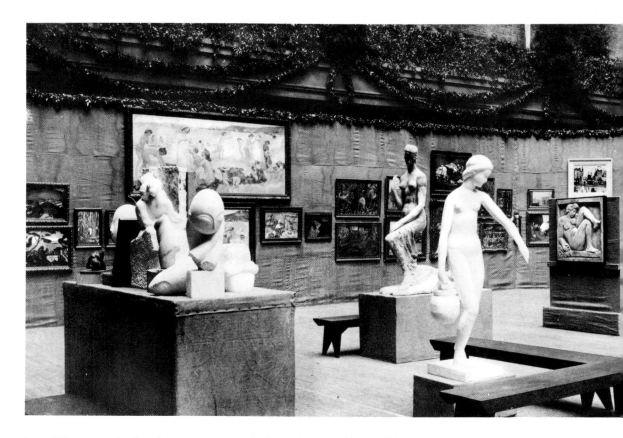

but differ on whether he ever accepted the offer, or, if he did, the
length of time Brancusi might have spent there. For his part, Brancusi
indicated his attitude toward working with so forceful a personality by
saying, "nothing can grow in the shadow of the great trees."

Evidence that Brancusi intended to pursue sculptural goals very dif-
ferent from those of Rodin soon became apparent. In 1909 he com-
pleted two important works: *The Prayer*, a figure of a kneeling girl
that was executed with elongated physical proportions, a smooth sur-
face, and minimal facial features; and *Sleeping Muse*. The latter work, a
head resting on its side, introduced the simple egg shape that became
the most familiar form in the Brancusi lexicon. With both pieces of
sculpture, Brancusi made a decisive break from the dramatic style of
Rodin while also rejecting the classicism of Maillol.

Although he lived to the age of eighty-one and was an active sculp-
tor for more than fifty years, Brancusi only completed some two
hundred pieces of sculpture, a relatively small production. His minimal
quantitative output is due in large part to a seemingly tireless desire to
refine just a few basic forms. The famous head entitled *Mlle. Pogany*
was initially rendered in marble and bronze versions in 1913 and then
returned to again in 1919, 1920, and 1931. With each succeeding varia-
tion the facial details became more architectural in shape, until all that
remained were the eyes, nose, and ears indicated by a few deeply cut,
sweeping curves.

One of the most accomplished stone carvers in the history of sculp-
ture, Brancusi lavished an extraordinary amount of care and affection
on his work, cutting and finishing the pieces himself. Shortly before his
death in 1957 Brancusi bequeathed everything in his studio—some

eighty completed objects—to the Museum of Modern Art in Paris with the proviso that they be displayed just as he had left them, surrounded by the tools of his trade. Brancusi's contributions to the development of modern sculpture are manifold. But perhaps the keystone of his legacy was the reduction of form to its essential, organic nature in order to create universal symbols of expression.

When the United States Circuit Court ruled in 1928 that Brancusi's symbolic evocation of flight, *Bird in Space*, could enter the United States as sculpture even though its form did not in any way resemble that of an actual bird, it was acknowledging one of the central canons of modern sculpture. The sculptor had been freed of the necessity of imitating nature and could experiment directly with the expressive qualities of sculptural mass and form. In the work of Brancusi virtually abstract mass is the predominant element. But the Cubists and those who followed them expanded on this breakthrough by opening up an object's bulk to produce a revolutionary new sense and purpose for sculpture's space. The modern sculptor's awareness of primitive sculpture also influenced the development of his work, for both modern and prehistoric objects lean toward a clear structural formulation free of literary references.

The cubist revolution began in painting, but it required only a small step to move from the cubist collage and relief to freestanding sculpture. As he did in so many other areas, Pablo Picasso led the way. The architecturally modeled bust entitled *Woman's Head* (1909) and the more adventurous painted bronze construction *Absinthe Glass* (1914) were pioneering efforts. Although chiefly concerned with painting during most of his career, Picasso produced many delightful objects. In

the 1930s he collaborated with his fellow Spanish artist Julio Gonzalez in developing metal construction, an important element in recent sculptural innovations. But it fell to artists who were primarily sculptors to explore fully the possibilities of cubist sculpture.

The Ukranian-born artist Alexander Archipenko was one of the more innovative members of the cubist group. He moved to Paris in 1908 to study at the academies but within two years found himself in the midst of the avant-garde, exhibiting with the leading artists in the Section d'Or. Archipenko endowed his forms with a sense of movement and rhythm by counterpointing solid, flat planes with open volumes. In *Boxing Match*, completed in 1913, Archipenko isolated vigorous physical action through the interplay of abstract planes. Later, in *Woman Combing her Hair* (1915), the sculptor combined this effect with another important innovation—the use of voids to define what normally would be solid areas. Archipenko left Paris at the beginning of World War I and continued to travel for several years after the war before settling in the United States. His mature sculpture became increasing idiosyncratic, and Archipenko found himself isolated from the main currents of twentieth-century sculpture that he had helped to create.

Raymond Duchamp-Villon's death in 1918, while fighting with the French army, robbed modern sculpture of an exceptionally creative talent. Just prior to entering military service in 1914, Duchamp-Villon completed one of the most striking products of the cubist period, *The Horse*. He began with realistic equestrian drawings and progressively reduced this conception until all that remained was the basic animal energy represented through its structural components. *The Horse* is a direct and unmistakable translation of physical energy into solid matter.

Henri Laurens was introduced to Cubism in 1911 when he met Georges Braque and began a friendship that lasted until Laurens'

The scope of the cubist achievement in sculpture is captured in this selection of objects by the movement's leading artists: (clockwise from above) Pablo Picasso's Man with Sheep; *Henri Laurens'* Woman with a Guitar; *Jacques Lipchitz'* The Song of the Vowels *and* Reclining Nude with Guitar; *Alexander Archipenko's* Boxers; *and Raymond Duchamp-Villon's* The Horse.

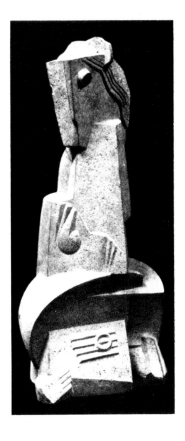

death in 1954. Under Braque's influence, Laurens created polychrome wood and metal reliefs that were widely exhibited in Parisian art galleries. His satisfaction with such constructed pieces began to wane, and without abandoning cubist principles, he soon turned to modeling solid forms, especially the female body. A further evolution in Laurens' style took place in the mid-1920s, when his figures began to take on a more sensual fullness, their sharp angles transformed into graceful curves. Such figures as *Les Ondines* (1933) and *The Crouching Figure* (1941) attest to the high degree of lyricism and emotional expressiveness that appeared in Laurens' mature sculpture.

In his own career, Russian-born Jacques Lipchitz paralleled Laurens' movement away from Cubism to a more personal and romantic sculptural style. *Reclining Nude with Guitar* (1928) and *Figure* (1930) are certainly two of the most widely known examples of cubist technique in sculpture. But by the mid-1930s Lipchitz had abandoned that style to produce monumental human figures that, infused with intense symbolism and psychological truth, shared a common ancestry with the work of Rodin. One of the most sensitive modelers to appear since Rodin, Lipchitz limited his work on stone figures to surface finishing of pieces cut and shaped by stonemasons. *Song of the Vowels*, which Lipchitz completed in 1932, is a striking example of his mature style. At the beginning of World War II, Lipchitz left his adopted home of Paris to live in the United States, where he continued to produce monumental sculpture grounded in a strong humanist tradition.

At approximately the same time that artists in Paris were coming under the influence of Cubism, those in Italy were developing an associated style called Futurism. The Futurists proposed to break completely with the art of the past in order to create a visual mode more in keeping with the key features of modern life. In the manifesto of futurist sculpture he published in 1912, Umberto Boccioni, already a promi-

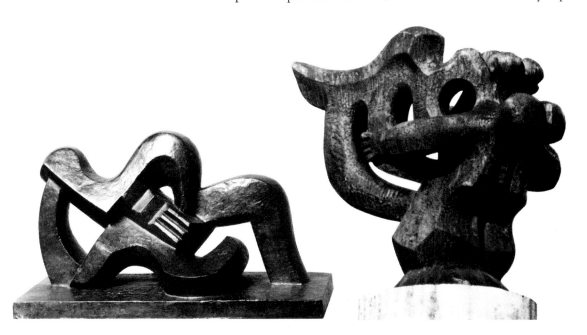

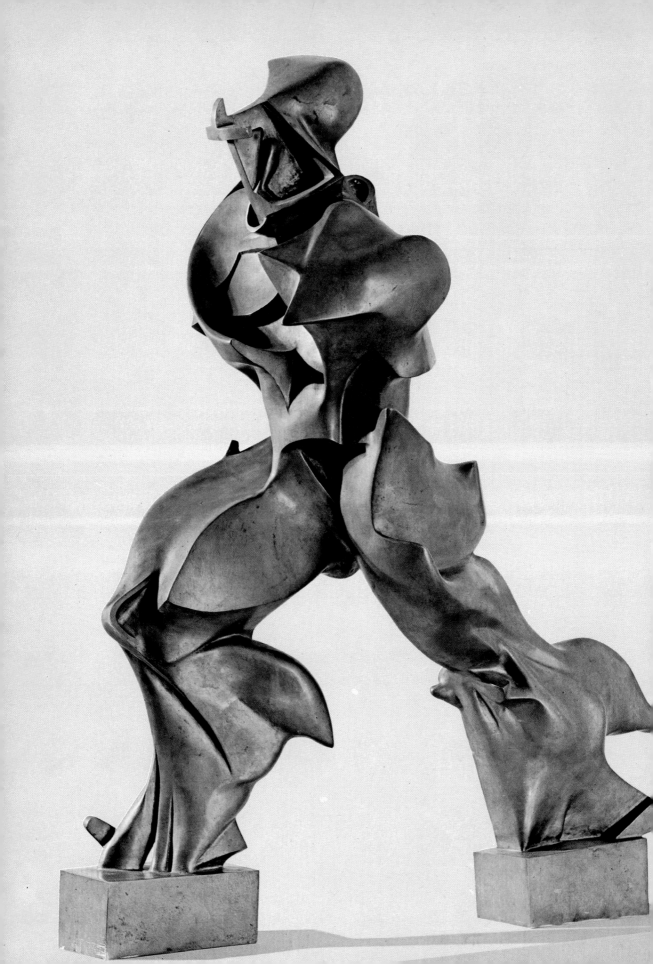

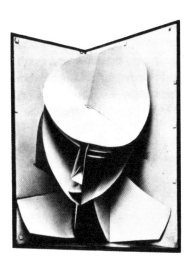

Umberto Boccioni applied the futurist technique of reducing objects to their basic interpenetrating planes to startling and powerful effect in the forty-four-inch-high bronze sculpture Unique Forms of Continuity in Space *(left).* Naum Gabo began his career working in the cubist idiom with such pieces as the celluloid and metal Head of a Woman *(right). But later, in collaboration with Antoine Pevsner, he moved toward a more abstract and scientific form of art that produced such elegantly crafted works in plastic as* Linear Construction in Space No. 2 *(shown at far right).*

nent painter, applied the futurist aesthetic to sculpture. After announcing the "absolute and completed abolition of the finite line and closed sculpture," he said, "Let us break open the figure and enclose the environment in it." While in practice Boccioni's work did not quite meet the extravagant claims of his theory, his masterwork, *Unique Forms of Continuity in Space* (1913), is a striking statement. The figure, caught in mid-stride, is alive with force and movement. Boccioni's death in 1916 deprived the movement of its finest talent. But despite its relatively short artistic life, Futurism isolated two of the central characteristics of our era—speed and technology—and challenged the art world to deal with them in a concrete manner.

The space in which concrete objects reside took on a new appearance in the works of constructivist sculptors Naum Gabo and Antoine Pevsner. The constructivist theory of art was born among Russian abstract artists in the years just prior to and following the Russian Revolution of 1917. Vladimir Tatlin and his followers envisioned a socially conscious art arising in Russia to parallel the new political climate.

At the time of the revolution Gabo and Pevsner (actually brothers: Gabo changed his family name to avoid confusion between their work) were both residing in Norway, working to develop a scientifically oriented sculptural aesthetic. They returned to Russia in 1917 and in 1920 issued the *Realist Manifesto*, an emotion-filled document in which they asserted, "space and time are the only forms on which life is built and hence art must be constructed." In such objects as *Linear Construction No. 1* and *Column of Peace* Gabo and Pevsner, respectively, carried out constructivist objectives by using transparent plastic or thin metal wires to create objects with little bulk that seem to move fluidly through space. As the Soviet political climate proved hostile to their art, both brothers left Russia—with Pevsner settling in Paris until his death in 1962 and Gabo becoming a resident of the United States.

The tightly drawn network of brass, copper, and steel wires Antoine Pevsner created in his Model for a Monument to an Unknown Political Prisoner *(left) graphically reflects a prison environment. The monument itself, which Pevsner designed to stand more than 160 feet high, was never built. Jean Arp's penchant for free-flowing organic forms that was first revealed in reliefs such as* Bird in Aquarium *(near right) later found a fuller expression in* Shepherd of the Clouds *(right center) and* Giant Pip *(far right), two of his most widely-known works.*

Many highly individual sculptors whose work remained independent of the cubist and constructivist movements emerged in the mid-twentieth century. Jean Arp, Henry Moore, Barbara Hepworth, and Alexander Calder are key figures in modern sculpture who share a preference for abstract forms.

Jean Arp's standing as one of the most innovative minds in contemporary art would probably have been secured by his position as a founder of Dada and Surrealism as well as his production of a multitude of poems, brightly colored wooden reliefs, and fascinating collages. When he began creating freestanding sculpture in 1930, this French artist opened yet another area to his versatile talents.

The natural and organic forms Arp created are often compared to those of Brancusi in the simple beauty of their craftsmanship. But where the Romanian sculptor reduced his objects to the point at which only their essential features remained, Arp's sculpture reverses that process. In one of his earliest and most acclaimed forms, *Torso* (1931), the viewer senses he is watching a human figure in the process of taking shape and that Arp has captured the moment just prior to its achieve-

ment of a concrete form. Barbara Hepworth struck upon the key to Arp's greatness as a sculptor when she remarked that he had "fused land-scape with the human form in so extraordinary a manner."

Among all modern sculptors, Henry Moore has probably achieved a greater degree of popular recognition and success than any of his contemporaries. The general acceptance of Moore's work today tends to obscure the fact that it represents an amalgam of the most radical trends in sculpture to emerge in the last six decades. In a resolute and orderly process of personal development, Moore drew insights from the experimentation going on around him, shaping them into a unique and personal vision of human life.

Moore's study of African and pre-Columbian American art had a direct influence on his early works, especially the selection of the figure of a reclining female as his principle vehicle for expression. An exceptionally talented and sensitive manipulator of carving tools, Moore has come a long way toward realizing the natural properties of the materials he uses. Most of Moore's sculpture prior to World War II was executed in wood or stone, but in the postwar period he has turned to casting in bronze models originally shaped in plaster.

In the 1930s Moore came in contact with the leading surrealist and constructivist artists based in London, and this, too, had a profound impact on his style. In figures such as the impressive *Composition* (1934), Moore fused the imaginative freedom of Surrealism with his own strongly humanistic and psychological approach to art. The combination of naturalistic shape and dark recesses and cavities seen in this figure are hallmarks of Moore's finest accomplishments. Although the products of their work are very different, Moore may be compared to Lipchitz as a sculptor in whose hands human values came to dominate the necessities of form.

144

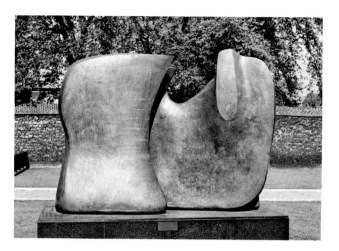

Henry Moore has often expressed the opinion that sculpture is seen to its best advantage outdoors in natural light, and in the brilliance of his own work he has proved the appropriateness of that contention. In 1972 more than two hundred pieces of Moore's sculpture were gathered for an exhibition in the gardens of Forti di Belvedere in Florence (photograph below, far left). Other works that are permanently displayed outdoors include Seated Woman (below), Knife Edge (left), and Family Group (far left).

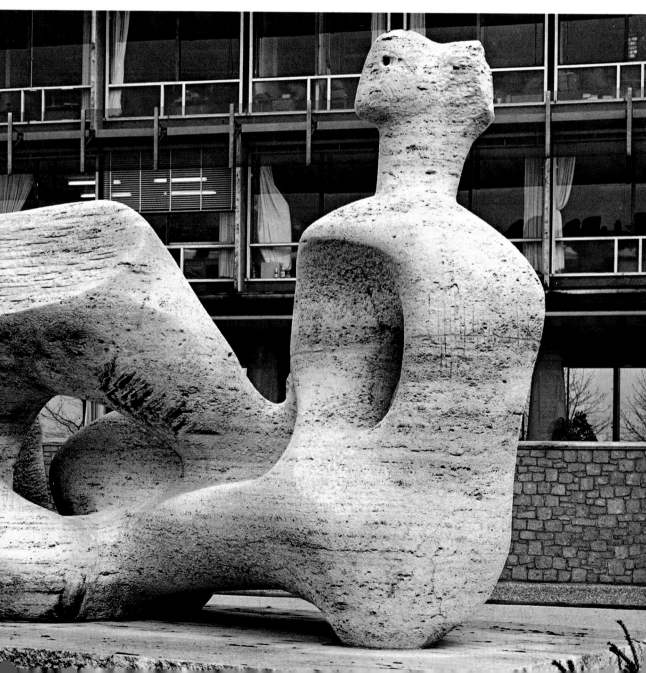

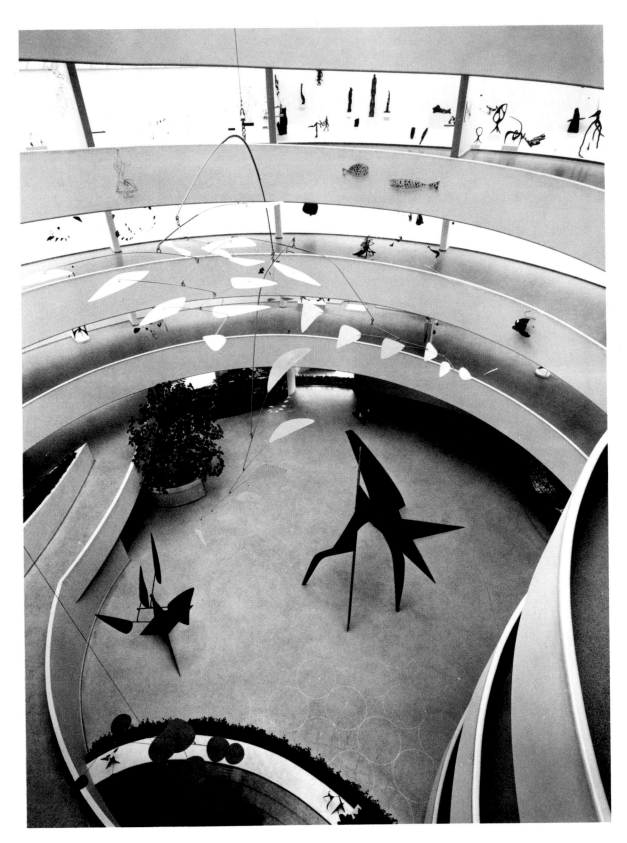

As the photograph at left clearly demonstrates, the circular galleries and large open central space of New York's Solomon R. Guggenheim Museum provided a spectacular setting for a major restrospective showing of Alexander Calder's mobiles and stabiles that took place in 1964. Although both reflect an abstract approach to subject matter, the serenity and perfection of Barbara Hepworth's carved mahogany form Head (Elegy) *shown below contrasts sharply with the richly but haphazardly textured welded metal surface of Theodore Roszak's* Spectre of Kitty Hawk *(right).*

By virtue of their common English background and schooling, the work of Moore and Barbara Hepworth is logically linked. They shared a strict devotion to the natural properties of materials and, in the 1930s, pursued common experimentation in the dimensions of sculptural mass. But unlike Moore, Hepworth pursued the abstract qualities of sculpture even further and only rarely introduced human forms into her work.

With the debut of his motor and air-driven metal sculptures in Paris in 1932, Alexander Calder became the first American artist to make a significant and original contribution to the development of abstract art in Europe. Calder earned a college degree in mechanical engineering but within a few years after graduation had abandoned that career to become a commercial artist. His path then led to Paris, where an animated circus of wood and wire figures he designed attracted the attention of many leading artists. Despite friendships with surrealist painters Joan Miró and Ferdinand Léger, Calder managed to remain aloof from the artistic currents sweeping Paris until a chance visit to the studio of Piet Mondrian suddenly opened his eyes to the exciting new possibilities of plastic expression.

Dubbed "mobiles" by Marcel Duchamp, Calder's sculptures typically consist of a series of metal disks, painted in primary colors and black and white and suspended by wires from a delicately balanced arrangement of metal rods. As air circulates around these disks, their movement shapes and reshapes the space surrounding them. In 1933 Calder added a second mode of design to his repertoire with the exhibition of steel constructions that Jean Arp called "stabiles," a term that accurately suggests their bulk and firm placement on the ground.

The School of Paris, whose influence had spread throughout Europe and the entire world, was supreme until World War II. When the war

was over in 1945, Europe was shattered, and many of the artists who had fled in the face of the holocaust did not return to the French capital. New centers of activity sprang up in the United States and England, with New York overshadowing Paris as the world center of creative artistic activity. Sculpture in the post-World War II period has been marked by a combination of old and new. Sculptors such as Lipchitz, Moore, Hepworth, Gabo, and Arp continued to produce important works and refine their personal styles. But at the same time other talents began to demand attention.

The overwhelming popular acceptance that greeted the slender and anguished figures produced by Alberto Giacometti beginning in the late 1940s marked the last new creative impulse to come out of the School of Paris. Celebrated in his youth as a fine sculptor in the surrealist mode, Giacometti had removed himself from public activity for more than a decade while he experiemented with modeling the human form. Whether placed alone, as in *Man Pointing* (1947), or grouped, as in *Three Men Walking* (1949), Giacometti's matchstick-thin figures are an almost perfect portrait of the isolation of modern man.

The strong American influence on contemporary sculpture is seen in the works of many sculptors, but never to greater advantage than in the constructions of David Smith. Originally trained as a painter, Smith decided to shift to metal constructions after studying the work of Picasso and Gonzalez. Already familiar with welding techniques as a result of working on an assembly line in his youth, Smith was ideally suited for this method and, in a workshop he called the Terminal Iron

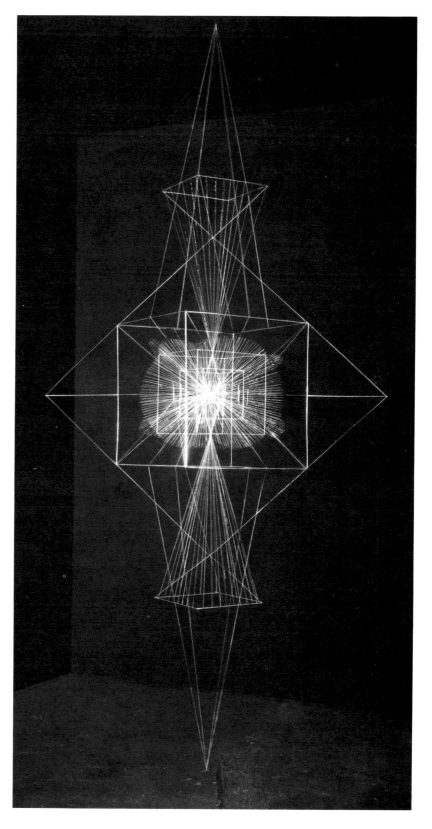

Turning away from a career as an industrial designer to become a sculptor, American-born Richard Lippold discovered a natural affinity for the geometrical approach of constructivist sculptors Gabo and Pevsner. Variation No. 7: Full Moon *(right)*, which measures ten feet from top to bottom, is constructed from a combination of materials including brass rods, chrome-nickel wire, and stainless steel. Just prior to his death in 1965, David Smith was engaged in the construction of a series of monumental stainless steel objects of which Cubi X *(far left)* is a prime example. In such works as Man Walking *(left, above) and* Seven Figures and One Head *(detail left, below)* Alberto Giacometti created human forms that by virtue of their slender and elongated mass appear small and distant from the spectator.

Works, produced an extraordinary body of abstract constructions.

In the years before his death in a truck accident in 1965, Smith embarked on his most ambitious and promising project. The stainless steel constructions he called *Cubis* dwarfed human proportions in their three-dimensional volume. Polished to reflect all variations of outdoor lighting, Smith's *Cubis* also suggest the stance of heroic and monumental figures. In assessing the entire scope of his work, art critic Hilton Kramer postulates that the greatness of Smith's achievement lies in the way he submitted "the rhetoric of the School of Paris to the vernacular of the American machine shop."

The 1960s and 1970s have seen a revival of interest in the ideas of modern art's most celebrated iconoclast, Marcel Duchamp. Amidst the flowering of Dadaism in Europe and the United States, Duchamp hit

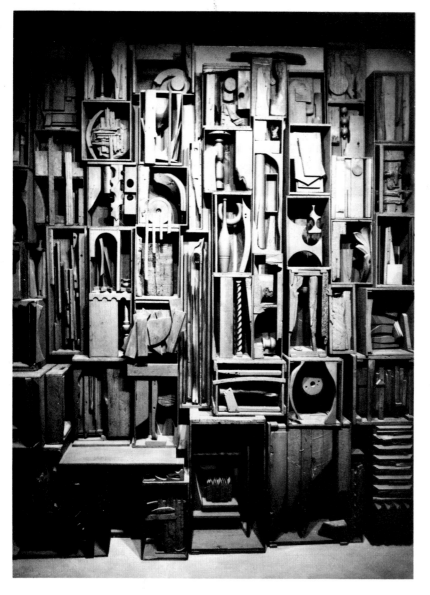

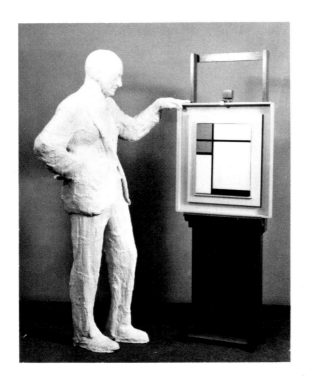

A willingness to experiment with form and content unites such disparate sculptural works as Marcel Duchamp's groundbreaking "readymade" Bottle Rack *(left); the more contemporary* Sky Cathedral *(left, below) by Louise Nevelson; John Chamberlain's abstract expressionist object* Untitled *(below); and George Segal's unusual combination of plaster sculpture and painting,* Portrait of Sidney Janis with Mondrian Painting *(right).*

upon one of the most clever parodies of the pretentiousness of museum art—the elevating of everyday objects to the status of artwork simply by selecting them and then putting them on display in a gallery. Duchamp exhibited the first of his so-called "readymades" in 1913, a snow shovel entitled *In Advance of the Broken Arm.* In contemporary sculpture the spiritual heirs of Duchamp are found in such diverse areas as the assemblages of "found" objects of Louise Nevelson, Mark di Suvero, and John Chamberlain; the "soft" sculptures of Claes Oldenburg; and the environments of Edward Kienholz and George Segal.

It is ironic that the chief feature of contemporary sculpture is its lack of unifying character. Sculpted art is being produced in a wide variety of materials, from the traditional mediums of bronze, wood, and stone to all manner of synthetic substances, as well as wire, steel, canvas, and paper. And the techniques used to produce these works vary as much as their materials. Carving and modeling have been overwhelmed by methods more normally associated with construction sites or factories. A willingness to add color to sculpted forms, used frequently in the past but rarely in early-twentieth-century works, now lends a brightness and vitality to many forms. Expanding upon Calder and Gabo's conception of moving sculpture, kinetic and optical art have developed with an increasing flamboyance.

And, finally, the public's attitude toward sculpture has changed. Bombarded by a bewildering profusion of forms and environments, and lacking firm guidance from critics and commentators by which to judge the works displayed before them, the public seems ready to accept almost any form of experimentation as worthy of serious consideration. This tolerance and receptivity creates a delightful opportunity for the creative artist—and ensures that one of man's most vital art forms has a bright and challenging future.

ELLEN KAVIER

SCULPTORS ON SCULPTURE

Although Auguste Rodin's sculpture eventually earned him great fame and considerable wealth, his early years were plagued with the poverty often endured by undiscovered talent. In a series of conversations collected under the title Reflections on Art, *Rodin was to reminisce about his first studio.*

My first studio! I will never forget it; I spent some hard moments there.

My funds not allowing me anything better, I rented a stable in the Rue Lebrun, near the Gobelins, for 120 francs a year. It seemed light enought to me, and I had the necessary perspective to be able to compare my clay with my model, a principle which has always been essential to me and from which I have never departed.

The air sifted in everywhere, through ill-shut windows, through the warped door; the slates of the roof, worn out by old age or skewed by the wind, established a permanent draft. It was glacially cold. A well was hollowed in one corner of the wall; the water was near the curb and kept up a penetrating dampness in all seasons.

Even today, I don't know how I managed to endure it.

It was there that I made the "Man with the Broken Nose." For tenacity in study, for sincerity in execution of form, I have never done more or better. I worked as completely as I could, thought of nothing else; the sketches, figures, finished bits papered the walls; the whole studio was cluttered with works in progress; but, since I didn't have enough money to have them cast, each day I lost precious time in covering my clay with wet cloths; despite that, at every turn I had accidents from the effects of cold or heat; entire sections detached themselves—heads, arms, knees, chunks of torsos fell off. I found them in pieces. . . . Sometimes I was able to put the fragments back together. You could not believe what I lost in that way.

A large completed figure was entirely lost. The winter that year was especially rude, and I couldn't have a fire at night. "The Man with the Broken Nose" froze. The back of his head split off and fell. I was able to save only the face, and I sent it to the Salon; it was refused.

I wasn't discouraged; I took another, slightly better studio, and I began a figure.

My model didn't have the grace of city women, but all the physical vigor and firm flesh of a peasant's daughter, and that lively, frank, definite, masculine charm which augments the beauty of a woman's body.

I immediately set up the armature; with clay, I fixed the large masses upon it.

It was a bacchante. Its movement was commonplace; that was not too important to me. For one thing, I didn't want to tire my girl by placing her in a pose which would be difficult for her to hold for a long time; for another, I was sure that to make something good, one must work "truthfully."

Desiring, then, to approach as closely as possible to nature, to the very point of extinction of form and without adornment from my brain, I settled upon a simple pose to which the model could easily return after her rests, thus allowing me to make the comparisons which are indispensable to a good and sincere execution.

To make that figure, I was in unremitting contact with nature for nearly two years. I was twenty-four years old then; I was already a good sculptor; I saw and executed the direct radiance of the form as I do today; I carried into the drawing of the contours an absolute scrupulousness; I was so slow to see and make them! I did them over ten times, fifteen times if I had to; I was never content with one that was merely close. I got through all the material difficulties I encountered; all artists who have been poor will understand. Those who, when young, had what was necessary to enable them to produce, can never know fully how lucky they have been.

Because the necessities of everyday life forced me to work for other people, we would work until dawn; we couldn't go back to it till nightfall, when I returned.

Sunday was our fête day; after a long session in the morning, and in recompense for the exhaustion of the week, we would go walking in the outskirts of Paris, through the fields and woods.

I wasn't what might be called an enthusiast, one swept away by his imagination, but simply one impassioned of work. I had the strength it gives, and the will for continual and patient effort.

I can affirm that I was already an experienced modeler; having begun drawing very young, I brought everything I knew to the modeling of my figure. In my life, I have made millions of drawings; even now I still draw almost every day. I could not tell you how much that knowledge has served me. It is not sufficiently a preoccupation today; it is neglected, and that is quite wrong.

They try to make a new style; but style comes without anyone's doubting it, with everyone's assistance; but can there be beauty in it without drawing?

Near my bacchante, I forgot all I had suffered. What discouragement when it wouldn't come right! What joy when at last I found a contour I had long sought! When the daylight interrupted my work under the progression of shadows, I saw my statue stripped of details, keeping only its large planes and its silhouette; then its mass alone appeared.

I waited impatiently for the moment when I would have enough money to have her cast, and I waited a long time.

I didn't even believe I would need to fight; I thought of nothing but my figure; I was simple, I didn't doubt my talent.

She was finished; I was happy, for I knew I had put into her all that was in myself.

But one day—I can't think of it without my heart breaking, and even speaking of it to you today distresses me terribly; it will always be

Many sculptors have produced delightful and accomplished sketches not generally known to the public. Auguste Rodin's Kneeling Nude *(no date)*, above, and the others that illustrate this section of excerpts are but a few of these often overlooked works.

painful for me—I had to change studios. Producing so much, the studio I was leaving was cluttered with all kinds of attempts, heavy and difficult to handle. At the end of the day, when we were all extremely tired, without any warning, my two movers took hold of the figure, one by the feet, they took a few steps; the armature swayed, twisted; the clay fell off at once. Hearing the crash I bounded forward. My poor bacchante was dead.

<div align="right">

AUGUSTE RODIN
Reflections on Art, 1913

</div>

In the evolution of sculptural technique, the work of Aristide Maillol stands as a link between the emotional expressiveness of Rodin and the ascetic abstractions of the modernists. Like his contemporary Rodin, Maillol rendered the human form with a classical exactness and sensitivity, but unlike his more celebrated colleague he was concerned more with the structural than with the inspirational elements of sculpture. Toward the end of his life Maillol examined many aspects of his career in a series of interviews with the French art critic Judith Cladel. This consideration of nature and sculpture is taken from those discussions.

We seek forms in nature, but we draw from these a composition in order to arrive at beauty. . . . "Nature is a dictionary," said Delacroix. One uses the dictionary to write a book, but the dictionary is not a book. The first thing that strikes you in Cézanne is not apples, but balance of tones. With elements drawn from nature, what did Shakespeare attempt? To create, to arouse powerful feeling, to awaken in the hearts of men that which is eternal in man. . . . When I was young, one came out of the Ecole des Beaux Arts knowing how to copy a nude figure, but one couldn't make a picture. Speaking of my figure, *The Cyclist,* Medardo Rosso said, "That's nothing, that's nothing but nature." My sculpture would be better if I copied less.

One must synthesize. In youth we do so naturally, like the Negro sculptors who have reduced twenty forms to one. Maurice Denis's figures were made up of two or three lines and a pleasant color, and by his simplification he has set an example of freshness, youth and tenderness in composition to all modern painting. We live in an epoch in which a great many things need to be synthesized. I should make better Egyptian sculpture than modern, and better gods than men.

The particular does not interest me; what matters to me is the general idea. In Michelangelo, so far removed from the art of Egypt, what fascinates you is the concept of power, the whole, the great point of view to which he committed himself. The *Slaves,* the *Tombs,* are sculpture made to be seen from one side only. For me, sculpture is the block; my figure, *France,* has more than twenty sides. I made her grow; she did not offer more than four. I had to keep working on her. Sculpture, for me, must have at least four sides.

Aristide Maillol,
Crouching Woman, *(n.d.)*

Nature is deceptive. If I looked at her less, I would produce not the real, but the true. Art is complex, I said to Rodin, who smiled because he felt that I was struggling with nature. I was trying to simplify, whereas he noted all the profiles, all the details; it was a matter of conscience. In his figure, *Enthusiasm,* the smallest reliefs are noted with an unheard-of scrupulousness.

When I made my first statuette in wood, I took a tree trunk and shaped it, trying to reproduce my general feelings about the grace of a woman. I have lost sight of that statuette. Thirty years later, looking at a photograph of it, I took it for Chinese sculpture. It seemed to me to have come out of another epoch. I had no other thought than to carve a beautiful form from the wood. That gave me the key to what the Ancients did.

It was only after having worked hard that I got excited about Tanagras. When I was painting, I had nothing to do with the Greeks. I was not interested in Rodin until much later; I worked without him. . . . What is appealing in my figures is the feeling I have put into them, something not self-explanatory. Some critics have written, à propos of the figure I call *Night,* that I am a sculptor concerned with the reproduction of form, without a preliminary idea as a point of departure, and they are surprised that I call it *Night.* Under such circumstances, we should call Michelangelo's *Night* a "Contorted Woman" and believe he wanted to produce something other than a contorted woman.

Others have maintained that I do not love Nature; I love no one else! Whatever I have made I have found in her; but one must interpret her. That alone counts. The public does not know it; people are ignorant; that is why we have to keep saying the same thing over again. The great difficulty is to pass from study to art. . . . An archaeologist has said that if one should suddenly encounter the *Venus de Milo* in the street one could not endure her gaze! What nonsense! The *Venus de Milo* is a beautiful girl, "a young girl who puts herself forward," said

Matisse. Where I live, in Banyuls, there are three hundred Venus de Milos. The *Kores* are alive; they are the young girls whom the Greeks saw in the street. Only the Greeks put into them the feeling with which all young girls inspired them. . . .

I did not arrive at this idea of synthesis by a process of reasoning, but through the study of Nature, from which I have drawn directly and according to my feeling.

ARISTIDE MAILLOL
His Life—His Work—His Ideas, 1937

The tenets of cubist painting were translated into vigorous sculptural images in the work of Henri Laurens. Although apprenticed as a decorative sculptor and stonemason, Laurens turned to monumental sculpture under the influence of such eminent associates as Picassso, Braque, and Gris. Just two years before his death in 1954, Laurens wrote a highly informative treatise on the nature and function of sculpture for the French art magazine XXᵉ siècle.

Essentially sculpture means taking possession of a space, the construction of an object by means of hollows and volumes, fullnesses and voids; their alternation, their contrasts, their constant and reciprocal tension, and in final form, their equilibrium.

The relative success of the work and the happy solution of its particular problem correspond to the intensity of this composition of forms. It should be static despite its movement when space radiates and forms about it. I have done polychrome sculpture; I wanted to do away with variations of light and, by means of color, to fix once and for all the relationship of the components, so that a red volume remains red regardless of the light. For me, polychrome is the interior light of the sculpture.

With nonpolychrome sculpture, I believe there is no need to think about the effects of light. When forms arrive at their maturity, their fullness, light will fall on them of its own accord, just as it falls on a ripe piece of fruit in a garden. The sculptured work has its intrinsic space: the space it occupies, and the space which depends on it, radiating from it, an indispensable part of the work. That is to say, it should not be stifled or lost in its surroundings.

Sculpture . . . is not made for museums. Arranging expositions in the open air . . . is only a compromise, but it is at least a progressive step. There the sculptor can place his work with greater freedom. . . .

Sculpture has its place in the moments through which it participates in the life of man. It is the natural ally of architecture and has always been during the great epochs. A Roman Christ or an Angkor dancer had a normal purpose. This usage of sculpture should be reconciled with the principle which I consider essential: the total occupation of space in three dimensions, with all the faces of the sculpture hav-

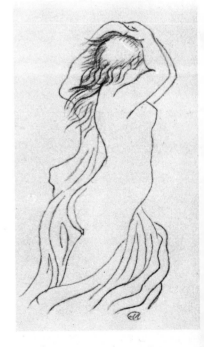

Aristide Maillol,
Nude Woman in the Wind, *(n.d.)*

ing an equal and selfsame importance, and perhaps a new assimilation of architecture.

This will be the task of the young sculptors. We others who derive from the cubist period are entirely devoted to inquiries, to experiments, to their slow development, and we cannot spend time on their applications. The time was not yet ripe for us, and architects wanted only to obtain perfect severity—their revenge on the excesses of ninteenth-century style. They were not disposed to any discreditable collaboration. But I think that in the future, because of the work accomplished by their elders, sculptors and architects will discover the conditions for a new alliance.

<div align="right">

HENRI LAURENS
XX^e *siècle*, January, 1952

</div>

Of the many artistic movements that flourished in Europe following World War I, Dada was perhaps the most iconoclastic and unpredictable. The Dadaists launched a frontal attack on what struck them as the unbridled smugness and pomposity of the contemporary art world. One of the movement's leading theorists was Jean Arp, a French-born sculptor, painter, and poet. The following essay on "concrete art" appeared in a collection of Arp's writings published in 1948.

When I exhibited my first concrete reliefs, I put out a little manifesto declaring the art of the bourgeois to be sanctioned lunacy. Especially these naked men, women and children in stone or bronze, exhibited in public squares, gardens and forest clearings, who untiringly dance, chase butterflies, shoot arrows, hold out apples, blow the flute, are the perfect expression of a mad world. These mad figures must no longer sully nature. Today, as in the days of the early Christians, the essential must become known. The artist must let his work create itself directly. Today we are no longer concerned with subtleties. My reliefs and sculptures fit naturally into nature. On closer examination however they reveal that they were formed by human hands, and so I have named certain of them: "Stone formed by human hands." . . .

we do not want to copy nature. we do not want to reproduce, we want to produce. we want to produce like a plant that produces a fruit and not to reproduce. we want to produce directly and not through interpretation.

as there is not the slightest trace of abstraction in this art, we call it: concrete art.

the works of concrete art should not be signed by their creators. these paintings, these sculptures, these objects, should remain anonymous in the great studio of nature like clouds, mountains, seas, animals, men. yes, men should return to nature, artists should work in community like the artists of the middle ages. in 1915 o. van rees, c. van rees, freundlich, s. taeuber and myself, made an attempt of this kind.

in 1915 I wrote: "these works are constructed with lines, surfaces, forms and colors. they strive to surpass the human and achieve the infinite and the eternal. they are a negation of man's egotism. . . . the hands of our brothers, instead of serving us as our own hands, have become enemy hands. instead of anonymity there was celebrity, and the masterpiece, wisdom, was dead. . . . to reproduce is to imitate, to play a comedy, to walk the tightrope. . . ."

the renaissance puffed up human reason with pride. modern times with their science and technology have made man a megalomaniac. the atrocious confusion of our epoch is the consequence of this overestimation of reason.

the evolution of traditional painting toward concrete art, beginning with cézanne and via the cubists, has often been explained, and these historical explanations have confused the problem. abruptly, "according to the laws of chance," the human mind underwent a transformation about the year 1914: an ethical problem presented itself. most of these works were not exhibited until about 1920. there was a blossoming of all the colors and all the forms in the world. these paintings, these sculptures, these objects, were liberated from conventional element. in every country adepts of this new art arose. concrete art influenced architecture, furniture, cinema, typography.

Jean Arp,
Automatic Drawing, *1916*

certain "surrealist objects" are also concrete works. without any descriptive content, they seem to me exceedingly important for the evolution of concrete art, for, by allusion, they succeed in introducing into this art the psychic emotion that makes it live.

concrete art aims to transform the world. it aims to make existence more bearable. it aims to save man from the most dangerous folly: vanity. it aims to simplify man's life. it aims to identify him with nature. reason uproots man and causes him to lead a tragic existence. concrete art is an elemental, natural, healthy art, which causes the stars of peace, love and poetry to grow in the head and the heart. where concrete art enters, melancholy departs, dragging with it its gray suitcases full of black sighs.

<div align="right">

JEAN ARP
On My Way, 1948

</div>

With the publication of a document called the Realist Manifesto *in 1920, Naum Gabo and his brother Antoine Pevsner (Gabo dropped his family name to avoid confusion between their work) proclaimed the beginning of the Constructivist Epoch in art. One of Gabo's dearest friends and most ardent defenders was the English art critic Sir Herbert E. Read, to whom the sculptor addressed the following notes on the nature of his work.*

Ever since I began to work on my constructions, and this is now more than a quarter of a century ago, I have been persistently asked innu-

merable questions, some of which are constantly recurring up till the present day.

Such as: Why do I call my work "Constructive"? Why abstract? If I refuse to look to Nature for my forms, where do I get my forms from? What do my works contribute to society in general, and to our time in particular? . . .

I am afraid that my ultimate answer will always lie in the work itself, but I cannot help feeling that I have no right to neglect them entirely and in the following notes there may be some clue to an answer for these queries.

(1) My works are what people call "Abstract." You know how incorrect this is, still, it is true they have no visible association with external aspects of the world. But this abstractedness is not the reason why I call my work "Constructive"; and "Abstract" is not the core of the Constructive Idea which I profess. This idea means more to me. It involves the whole complex of human relation to life. It is a mode of thinking, acting, perceiving and living. The Constructive philosophy recognizes only one stream in our existence—life (you may call it creation, it is the same). Any thing or action which enhances life, propels it and adds to it something in the direction of growth, expansion and development, is Constructive. The "how" is of secondary importance.

Therefore, to be Constructive in art does not necessarily mean to be abstract at all costs: Phidias, Leonardo da Vinci, Shakespeare, Newton, Pushkin, to name a few—all were Constructive for their time, but it would be inconsistent with the Constructive Idea to accept their way of perception and reaction to the world as an eternal and absolute measure. There is no place in a Constructive philosophy for eternal and absolute truths. All truths and values are our own constructions, subject to the changes of time and space as well as to the deliberate choice of life in its striving toward perfection. I have often used the word "perfection" and ever so often been mistaken for an ecclesiastic evangelist, which I am not. I never meant "perfection" in the sense of the superlative of good. "Perfection," in the Constructive sense, is not a state but a process; not an ultimate goal but a direction. We cannot achieve perfection by stabilizing it—we can achieve it only by being in its stream; just as we cannot catch a train by riding in it, but once in it we can increase its speed or stop it altogether; and to be in the train is what the Constructive Idea is striving for.

It may be asked: What has it all to do with art in general and with Constructive art in particular? The answer is—it has to do with art more than with all other activities of the human spirit. I believe art to be the most immediate and most effective of all means of communication between human beings. Art as a mental action is unambiguous—it does not deceive—it cannot deceive, since it is not concerned with truths. We never ask a tree whether it says the truth, being green, being fragrant. We should never search in a work of art for truth—it is verity itself.

The way in which art perceives the world is sensuous (you may call it intuitive); the way it acts in response to this perception is spontaneous, irrational and factual (you may call it creative), and this is the way of life itself. This way alone brings to us ultimate results, makes history, and moulds life in the form as we know it.

Unless and until we adopt this way of reacting to the world in all our spiritual activities (science above all included) all our achievements will rest on sand.

Unless and until we have learned to carry our morality, our science, our knowledge, our culture, with the ease we carry our heart and brain and the blood in our veins, we will have no morality, no science, no knowledge, no culture.

To this end we have to construct these activities on the foundation and in the spirit of art.

I have chosen the absoluteness and exactitude of my lines, shapes and forms in the conviction that they are the most immediate medium for my communication to others of the rhythms and the state of mind I would wish the world to be in. This is not only in the material world surrounding us but also in the mental and spiritual world we carry within us.

I think that the image they invoke is the image of good—not of evil; the image of order—not of chaos; the image of life—not of death. And that is all the content of my constructions amounts to. I should think that this is equally all that the constructive idea is driving at.

(2) Again I am repeatedly and annoyingly asked: Where then do I get my forms from?

The artist as a rule is particularly sensitive to such intrusion in this jealously guarded depth of his mind—but, I do not see any harm in breaking the rule. I could easily tell where I get the crude content of my forms from, provided my words be taken not metaphorically but literally.

I find them everywhere around me, where and when I want to see them. I see them, if I put my mind to it, in a torn piece of cloud carried away by the wind. I see them in the green thicket of leaves and trees. I can find them in the naked stones of hills and roads. I may discern them in a steamy trail of smoke from a passing train or on the surface of a shabby wall. I can see them often even on the blank paper of my working-table. I look and find them in the bends of waves on the sea between the open-work of foaming crests; their apparition may be sudden, it may come and vanish in a second, but when they are over they leave with me the image of eternity's duration. I can tell you more (poetic though it may sound, it is nevertheless plain reality); sometimes a falling star, cleaving the dark, traces the breath of night on my window glass, and in that instantaneous flash I might see the very line for which I searched in vain for months and months.

These are the wells from which I draw the crude content of my forms. Of course, I don't take them as they come; the image of my per-

ception needs an order, and this order is my construction. I claim the right to do it so because this is what we all do in our mental world; this is what science does, what philosophy does, what life does. We all construct the image of the world as we wish it to be, and this spiritual world of ours will always be what and how we make it. It is Mankind alone that is shaping it in certain order out of a mass of incoherent and inimical realities. This is what it means to be Constructive.

NAUM GABO
Letter to Sir Herbert E. Read, 1944

The career of Jacques Lipchitz is marked by two distinct phases. In his youth, Lipchitz joined forces with the cubist avant-garde that was making its mark in Paris. Later on, he moved beyond the confines of Cubism to create massive bronze figures in a highly emotional and heroic style. Culling subjects from the Bible and mythology, Lipchitz began to express himself more forthrightly about man and his relationship to the world around him. It was in this mood that he undertook the task of creating a modern interpretation of the story of Prometheus. However, as the sculptor relates in an article originally written for the magazine Art in Australia, *his efforts became entrapped in the deepening political crisis affecting Europe in the mid-1930s.*

The thought of sculpturing a Prometheus had been germinating in my mind for a long time. But of a Prometheus not enchained, rather the guardian of the flame. The events of 1933 convinced me that it was premature, to say the least, to think of such an Olympian attitude. The world gradually grew darker and darker, the forces of evil took possession of all the vital, young sources of the universe.

Then the thought occurred to me to make a Prometheus more real. I began with the idea that Prometheus, who personifies human progress, acting independently according to man's own will, must, first of all, be freed from his shackles. It is not as chained to a rock, with a vulture picking at his entrails, that he can dream of coming to the aid of stricken mankind.

I then undertook to liberate him. It seemed to me that in making a statue according to that conception, I must wield my stone with my mind fixed upon the necessity for such action. Alas! I had not estimated completely the enormity of the force with which I was compelled to deal.

The first sketches which I made, in 1933, showed Prometheus triumphant. He had already broken his chains, and a small vulture, barely alive, was no longer able to bar his forward path.

This expressed my desire for reality.

The events which followed in Europe showed me that I anticipated too much, and that my finished work could not give me the satisfaction that I felt in my preliminary sketches. It came about that, in 1936, the

Director of the International Exposition of 1937 asked me, on behalf of the Palais de la Découverte (Discovery and Invention), if I would participate in the decoration of the Palais. I accepted enthusiastically.

There was a place exactly suited for Prometheus!

Better equipped than in 1933, I understood that the moment of triumph had not yet sounded: quite the reverse, the moment of death struggle approached. And since my statue was going to crown one of the entrances of the Palais de la Découverte, which sheltered the evidence of all the Promethean work accomplished by man up to the present day, I wished that my statue would be, so to speak, a message.

I wished to say to men: "If you desire to continue freely in your creative work, it will be necessary for you to enter the struggle and conquer the forces of darkness that are about to invade the world."

And feverishly I set to work.

After many attempts, I made a Prometheus young and robust, coifed with a Phrygian bonnet, symbol of democracy; and an enormous vulture, with a force almost equal to that of Prometheus, and with both feet armed with huge claws, gripping the vitals of his antagonist. But Prometheus battled well. With one powerful hand he choked the bird; with the other, he assuaged the wounds inflicted by the carrion claws.

The struggle is terrible, but it needs only a glance of the eye to see on which side Victory will lie.

The vulture is conquered. It needs only time and stone to vanquish this preying bird.

You appreciate the fact that such a statue has not been in accordance with everyone's taste. Especially so when, after having remained in the interior of the Grand Palais, they have been obliged, in the autumn of 1937, to take away all that belonged to the Palais de la Découverte to make room for the Salon de l'Automobile. My statue was taken down and placed outside in the open air, before one of the entrances of the Palais de la Découverte, near the Champs Elysées.

I knew very well that that was not the right place for my statue of Prometheus. Very large, and fashioned with rapid execution, and intended to be viewed from a very great distance, and from an elevation of twenty-five metres above the ground, it could not be at all satisfying there, close to the eyes, and only two metres high. But the violence of the campaign launched against it, and especially its tenor, could deceive no one.

Moreover, events which followed fully justified our premonitions.

In the month of April, 1938 (I do not have the documents, so I cannot give the exact date), a great Parisian newspaper, *Le Matin*, launched a violent campaign on the front page of this journal—without selling this space and heaven knows how much it would have cost—a vulgar campaign, with corroborating photographs and gross caricatures, was carried on, demanding the removal of this "seditious statue."

At the same time, all of those who in the art world have shown

Jacques Lipchitz,
The Rape of Europa, IV, *1941*

themselves satisfied with the recent turn of events launched a parallel attack. They obtained the signatures of artists who said that my statue ought to be destroyed in the name of the safety of national art, pretending that I was the carrier of God knows what noxious virus.

I was easily consoled. Without comparing myself to my illustrious forerunners, I realised that those who were attacking me thus were the very ones who, under the same pretexts, forty years before, had opposed the Balzac of Rodin, had condemned the Manets, the Cézannes, the Renoirs, the Pissaros, the Seurats, the Van Goghs, the cubists, and, in general, all that French Art counted great and young, and which has become renowned throughout the entire world.

They went from door to door, seeking signatures, often becoming noisy, as if they were coming to a class in the L'Ecole des Arts Décoratifs. But enough of this campaign; I can now proceed to relate the story of my statue.

At the end of May, 1938, the statue, which was cast in plaster, was smashed to bits, and the pieces carried to the National warehouse, where I think they remain at this very hour. A eulogy of protest, led by M. Louis Lapique of the Institute, and by M. Jean Perrin, Nobel Prize-winner, was the last flower thrown upon the tomb of my martyred statue, which, by its destiny, foreshadowed all that was going to happen over all the earth.

But my Prometheus is not dead!

All the preparatory work, which in my opinion is more important than the statue itself, remains. It is of that I wish to speak.

Having received the command of the Palais de la Découverte, I began to work. That was in the summer of 1936. At first, by a series of sketches, I tried to focus my thought. Having clarified it, little by little, I made a model in terra cotta, which did not satisfy me. Then I began to search anew.

In the first sketch, Prometheus choked the vulture with both hands. From the standpoint of composition, this created a volume which warped the ensemble. I then tried to overcome this by having him choke the vulture with one hand only, and use the other to defend himself against the claws of the bird. In this way, my composition became more eloquent, at the same time that it opened up space and permitted one to see the depth.

Having decided that the statue ought to be visible from a great distance, and placed twenty-five metres above the ground, the proportions preoccupied me greatly. It was then that I made a second sketch. The second sketch having been shown to the commission, and having been accepted for execution, I began to make a model two metres high. Following this model, I enlarged the statue into a model six metres high.

For three months, I worked solely on this statue, with several companions, the work almost being mechanical, it went so rapidly. Afterward I retouched the plaster, high in its place on specially constructed scaffolding. This period was one of the most beautiful moments of my

life as an artist. Perched under the immense stained-glass window of the Grand Palais, I was there from morning to night, all alone, struggling with the dim light of this building.

Finally, in 1939, I made a new model. This latter model, with the terra cotta model of 1933, and both of those of 1936, and the two-metre model, plus the thirty-six sketches, were intended to be shown in an exhibition of my work at the Brummer Gallery in New York in the winter of 1939. The war upset our plans.

And now, here am I in New York, after the greatest hazards, with only the models of one statue and thirty-five sketches. I have the firm conviction that my Prometheus will live again!

<div align="center">

JACQUES LIPCHITZ
"The Story of My Prometheus," 1942

</div>

In 1947, after virtually disappearing from the international art scene for more than a decade, Alberto Giacometti prepared a selection of his recent sculpture, paintings, and drawings for presentation at the New York City gallery of Pierre Matisse. In retrospect, it is clear that the mature style for which Giacometti became celebrated as a master of contemporary sculpture was first revealed in this collection. But as we see in a charming and modest letter that Giacometti sent to Matisse shortly before the exhibit opened, the artist himself regarded these works as just another step in a continuing struggle to realize his personal "vision of reality."

Here is the list of sculptures that I promised you, but I could not make it without including, though very briefly, a certain chain of events, without which it would make no sense.

I made my first bust from life in 1914, and continued during the following years throughout the whole period of my schooling. I still have a certain number of these busts and always look at the first with a certain longing and nostalgia. . . .

In 1920–21 I lived in Italy. In Venice first, where I spent my days looking mostly at the Tintorettos, not wanting to miss a single one.

To my great regret, on the day I left Venice, Tintoretto was a little dethroned by the Giottos in Padua, and he in turn some months later by Cimabue at Assisi.

I stayed nine months in Rome, where I never had enough time to do all I wanted. I wanted to see everything, and at the same time I painted, figures, somewhat pointillist landscapes (I had become convinced that the sky is blue only by convention and that it is actually red), and compositions inspired by Sophocles and Aeschylus whom I was reading at this time (*The Sacrifice of Iphigenia, The Death of Cassandra, The Sack of Troy*, etc.).

I had also begun two busts, one of them small, and for the first time I could not find my way, I was lost, everything escaped me, the head of

Alberto Giacometti,
Hands Holding the Void,
1934–35

the model before me became like a cloud, vague and undefined. I ended by destroying them before I left. I spent a lot of time in museums, in churches, in ruins. I was particularly impressed by the mosaics and the Baroque. I can recall each sensation in front of each thing I saw. I filled my notebooks. . . .

In 1922 my father sent me to Paris to attend the academy. (I would have preferred in a way to have gone to Vienna, where living was cheap. At this period my desire for pleasure was stronger than my interest in the academy.)

From 1922 to 1925 and later, I was at the Académie de la Grande-Chaumière, in Bourdelle's studio. In the mornings I did sculpture, and the same difficulties I had had in Rome began again. In the afternoons I drew.

I could no longer bear sculpture without color, and I often tried to paint them from life. I kept some of these for years, and then, mostly to make room, I had them taken out and thrown away.

Impossible to grasp the entire figure (we were much too close to the model, and if one began on a detail, a heel, the nose, there was no hope of ever achieving the whole).

But if, on the other hand, one began by analyzing a detail, the end of the nose, for example, one was lost. One could have spent a lifetime without achieving a result. The form dissolved, it was little more than granules moving over a deep black void, the distance between one wing of the nose and the other is like the Sahara, without end, nothing to fix one's gaze upon, everything escapes.

Since I wanted nevertheless to realize a little of what I saw, I began as a last resort to work at home from memory. I tried to do what I could to avoid this catastrophe. This yielded, after many attempts touching on cubism . . . objects which were for me the closest I could come to my vision of reality.

This gave me some part of my vision of reality, but I still lacked a sense of the whole, a structure, also a sharpness that I saw, a kind of skeleton in space.

Figures were never for me a compact mass but like a transparent construction.

Again, after making all kinds of attempts, I made cages with open construction inside, executed in wood by a carpenter.

There was a third element in reality that concerned me: movement.

Despite all my efforts, it was impossible for me then to endure a sculpture that gave an illusion of movement, a leg advancing, a raised arm, a head looking sideways. I could only create such movement if it was real and actual; I also wanted to give the sensation of motion that could be induced. . . .

But all this took me away little by little from external reality; I had a tendency to become absorbed only in the construction of the objects themselves.

There was something in these objects that was too precious, too

classical; and I was disturbed by reality, which seemed to me to be different. Everything at that moment seemed a little grotesque, without value, to be thrown away. . . .

It was no longer the exterior forms that interested me but what I really felt. (During all the previous years—the period of the academy —there had been for me a disagreeable contrast between life and work, one got in the way of the other, I could find no solution. The fact of wanting to copy a body at set hours and a body to which otherwise I was indifferent, seemed to me an activity that was basically false, stupid, and which made me waste many hours of my life.)

It was no longer a question of reproducing a lifelike figure but of living, and of executing only what had affected me, or what I really wanted. But all this alternated, contradicted itself, and continued by contrast. There was also a need to find a solution between things that were rounded and calm, and sharp and violent. It is this which led during those years ('32–'34 approximately) to objects going in directions that were quite different from each other: a kind of landscape—a head lying down; a woman strangled, her jugular vein cut; construction of a palace with a skeleton [of a] bird and a spinal column in a cage and a woman at the other end. A model for a large garden sculpture (I wanted people to be able to walk on the sculpture, to sit on it and lean on it), a table for a hall, and very abstract objects which then led me to figures and skull heads.

I saw anew the bodies that attracted me in reality and the abstract forms which seemed to me true in sculpture, but I wanted to create the former without losing the latter, *very briefly put.* . . .

And then the wish to make compositions with figures. For this, I had to make . . . one or two studies from nature, just enough to understand the construction of a head, of a whole figure, and in 1935 I took a model. This study should take (I thought) two weeks, and then I could realize my compositions.

I worked with the model [every] day from 1935 to 1940.

Nothing was as I had imagined. A head (I quickly abandoned figures, that would have been too much) became for me an object completely unknown and without dimensions. Twice a year I began two heads, always the same ones, never completing them, and I put my studies aside (I still have the casts).

Finally, in order to accomplish at least a little, I began to work from memory, but this mainly to know what I had gotten out of all this work. (During all these years I drew and painted a little, and almost always from life.)

But wanting to create from memory what I had seen, to my terror the sculptures became smaller and smaller. They had a likeness only when they were small, yet their dimensions revolted me, and tirelessly I began again, only to end several months later at the same point.

A large figure seemed to me false and a small one equally unbearable, and then often they became so tiny that with one touch of my knife

they disappeared into dust. But head and figures seemed to me to have a bit of truth only when small.

All this changed a little in 1945 through drawing.

This led me to want to make larger figures, but then to my surprise, they achieved a likeness only when tall and slender.

And this is almost where I am today, no, where I still was yesterday, and I realize right now that if I can draw ancient sculptures with ease, I could draw those I made during these last years only with difficulty; perhaps if I could draw them it would no longer be necessary to create them in space, but I am not sure about this.

<div align="right">

ALBERTO GIACOMETTI
Letter to Pierre Matisse, 1947

</div>

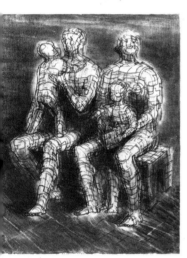

Henry Moore,
Family Group, *1950*

Ever since his students days at the Leeds School of Art, Henry Moore has been recognized as an unusual talent. The acclaim he received in his native Great Britain was later echoed in Europe, the United States, and Australia, and culminated in Moore's winning the International Sculpture Prize at the 24th Venice Biennale in 1948. The clear artistic vision and sense of personal strength and assurance that contribute so much to Moore's sculpture are also reflected in his thoughtful essay "The Sculptor Speaks," written in 1937.

It is a mistake for a sculptor or a painter to speak or write very often about his job. It releases tension needed for his work. By trying to express his aims with rounded-off logical exactness, he can easily become a theorist whose actual work is only a caged-in exposition of conceptions evolved in terms of logic and words.

But though the non-logical, instinctive, subconscious part of the mind must play its part in his work, he also has a conscious mind which is not inactive. The artist works with a concentration of his whole personality, and the conscious part of it resolves conflicts, organises memories, and prevents him from trying to walk in two directions at the same time. . . .

Appreciation of sculpture depends upon the ability to respond to form in three dimensions. That is perhaps why sculpture has been described as the most difficult of all arts; certainly it is more difficult than the arts which involve appreciation of flat forms, shape in only two dimensions. Many more people are "form-blind" than colour-blind. The child learning to see, first distinguishes only two-dimensional shape; it cannot judge distances, depths. Later, for its personal safety and practical needs, it has to develop (partly by means of touch) the ability to judge roughly three dimensional distances. But having satisfied the requirements of practical necessity, most people go no farther. Though they may attain considerable accuracy in the perception of flat form, they do not make the further intellectual and emotional effort needed to comprehend form in its full spatial existence.

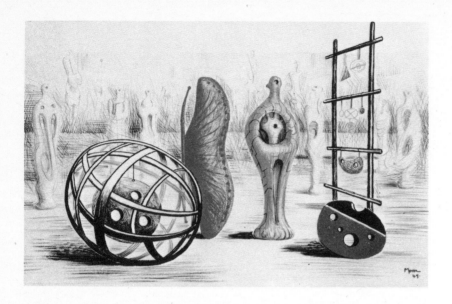

This is what the sculptor must do. He must strive continually to think of, and use, form in its full spatial completeness. He gets the solid shape, as it were, inside his head—he thinks of it, whatever its size, as if he were holding it completely enclosed in the hollow of his hand. He mentally visualises a complex form from all round itself; he knows while he looks at one side what the other side is like; he identifies himself with its centre of gravity, its mass, its weight; he realises its volume, as the space that the shape displaces in the air.

And the sensitive observer of sculpture must also learn to feel shape simply as shape, not as description or reminiscence. He must, for example, perceive an egg as a simple single solid shape, quite apart from its significance as food, or from the literary idea that it will become a bird. And so with solids such as a shell, a nut, a plum, a pear, a tadpole, a mushroom, a mountain peak, a kidney, a carrot, a tree trunk, a bird, a bud, a lark, a ladybird, a bulrush, a bone. From these he can go on to appreciate more complex forms or combinations of several forms. . . .

When first working direct in a hard and brittle material like stone, the lack of experience and great respect for the material, the fear of ill-treating it, too often result in relief surface carving, with no sculptural power.

But with more experience the completed work in stone can be kept within the limitations of its material, that is, not be weakened beyond its natural constructive build, and yet be turned from an inert mass into a composition which has a full form existence, with masses of varied sizes and sections working together in spatial relationship.

A piece of stone can have a hole through it and not be weakened—if the hole is of studied size, shape and direction. On the principle of the arch, it can remain just as strong.

The first hole made through a piece of stone is a revelation.

The hole connects one side to the other, making it immediately more three-dimensional.

A hole can itself have as much shape-meaning as a solid mass.

Sculpture in air is possible, where the stone contains only the hole, which is the intended and considered form.

The mystery of the hole—the mysterious fascination of caves in hillsides and cliffs.

There is a right physical size for every idea.

Pieces of good stone have stood about my studio for long periods, because though I've had ideas which would fit their proportions and materials perfectly, their size was wrong.

There is a size to scale not to do with its actual physical size, its measurement in feet and inches—but connected with vision.

A carving might be several times over life-size and yet be petty and small in feeling—and a small carving only a few inches in height can give the feeling of huge size and monumental grandeur, because the vision behind it is big. Example, Michelangelo's drawings or a Masaccio madonna—and the Albert Memorial.

Yet actual physical size has an emotional meaning. We relate everything to our own size, and our emotional response to size is controlled by the fact that men on the average are between five and six feet high.

An exact model to 1/10 scale of Stonehenge, where the stones would be less than us, would lose all its impressiveness.

Sculpture is more affected by actual size considerations than painting. A painting is isolated by a frame from its surroundings (unless it serves just a decorative purpose) and so retains more easily its own imaginary scale.

If practical considerations allowed me, cost of material, of transport etc., I should like to work on large carvings more often than I do. The average in-between size does not disconnect an idea enough from prosaic everyday life. The very small or the very big takes on an added size emotion. . . .

The violent quarrel between the abstractionists and the surrealists seem to me quite unnecessary. All good art has contained both abstract and surrealist elements, just as it has contained both classical and romantic elements—order and surprise, intellect and imagination, conscious and unconscious. Both sides of the artists's personality must play their part. And I think the first inception of a painting or a sculpture may begin from either end. As far as my own experience is concerned, I sometimes begin a drawing with no preconceived problem to solve, with only the desire to use pencil on paper, and make lines, tones and shapes with no conscious aim; but as my mind takes in what is so produced, a point arrives where some idea becomes conscious and crystallises, and then a control and ordering begin to take place.

Or sometimes I start with a set subject; or to solve, in a block of stone of known dimensions, a sculptural problem I've given myself, and then consciously attempt to build an ordered relationship of forms, which shall express my idea. But if the work is to be more than just a sculptural exercise, unexplainable jumps in the process of thought occur; and the imagination plays its part.

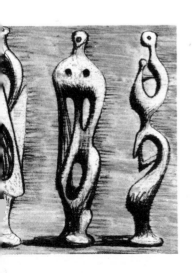

Henry Moore,
Sculptural Objects *(left), 1949,
and* Figures *(below), (n.d.)*

It might seem from what I have said of shape and form that I regard them as ends in themselves. Far from it. I am very much aware that associational, psychological factors play a large part in sculpture. The meaning and significance of form itself probably depends on the countless associations of man's history. For example, rounded forms convey an idea of fruitfulness, maturity, probably because the earth, women's breasts, and most fruits are rounded, and these shapes are important because they have this background in our habits of perception. I think the humanist organic element will always be for me of fundamental importance in sculpture, giving sculpture its vitality. Each particular carving I make takes on in my mind a human or occasionally animal, character and personality, and this personality controls its design and formal qualities, and makes me satisfied or dissatisfied with the work as it develops.

My own aim and direction seems to be consistent with these beliefs, though it does not depend upon them. My sculpture is becoming less representational, less an outward visual copy, and so what some people would call more abstract; but only because I believe that in this way I can present the human psychological content of my work with the greatest directness and intensity.

HENRY MOORE
"The Sculptor Speaks," 1937

Britain produced two of its finest modern sculptors in Barbara Hepworth and her contemporary Henry Moore. Hepworth's beautifully constructed abstract forms are the product of a romantic sensibility that was movingly described by the sculptor in her autobiography.

All my early memories are of forms and shapes and textures. Moving through and over the West Riding landscape with my father in his car, the hills were sculptures; the roads defined the form. Above all, there was the sensation of moving physically over the contours of fulnesses and concavities, through hollows and over peaks—feeling, touching, seeing, through mind and hand and eye. This sensation has never left me. I, the sculptor, *am* the landscape. I am the form and I am the hollow, the thrust and the contour.

Feelings about ideas and people and the world all about us struggle inside me to find the evocative symbol affirming these early and secure sensations—the feeling of the magic of man in a landscape, whether it be a pastoral image or a miner squatting in the rectangle of his door or the "Single form" of a millgirl moving against the wind, with her shawl wrapped round her head and body. On the lonely hills a human figure has the vitality and the poignancy of all man's struggles. . . .

The artist works because he must! But he learns by the disciplines of his imagination. Through moments of ecstasy or great despair, when all thoughts of self are lost, a work seems to evolve which has not only

the vivid uniqueness of a new creation, but also the seeming effortlessness and unalterable simplicity of a true idea relating to the universe. In our present time, so governed by fear of destruction, the artist senses more and more the energies and impulses which give life and are the affirmation of life. Perhaps by learning more and letting the microcosm reflect the macrocosm, a new way of life can be found which will allow the human spirit to develop and surmount fear.

. . . My left hand is my thinking hand. The right is only a motor hand. This holds the hammer. The left hand, the thinking hand, must be relaxed, sensitive. The rhythms of thought pass through the fingers and grip of this hand into the stone.

It is also a listening hand. It listens for basic weaknesses of flaws in the stone; for the possibility or imminence of fractures. . . .

The sculptor must search with passionate intensity for the underlying principle of the organisation of mass and tension—the meaning of gesture and the structure of rhythm.

In my search for these values I like to work both realistically and abstractly. In my drawing and painting I turn from one to the other as a necessity or impulse and not because of a preconceived design of action. When drawing what I see I am usually most conscious of the underlying principle of abstract form in human beings and their relationship one to the other. In making my abstract drawings I am most often aware of those human values which dominate the structure and meaning of abstract forms.

Sculpture is the fusion of these two attitudes, and I like to be free as to the degree of abstraction and realism in carving.

The dominant feeling will always be the love of humanity and nature; and the love of sculpture for itself.

<div align="right">

BARBARA HEPWORTH
A Pictorial Autobiography, 1970

</div>

Alexander Calder, Sow, *1928*

At a Paris gallery in 1932, Alexander Calder exhibited the first of his revolutionary mobiles—sculptures that continually created new divisions of space and form by their movement. As he recalls the event, Calder's investigations in the realm of abstract sculpture began after a visit to the studio of another twentieth-century artist, Piet Mondrian.

My entrance into the field of abstract art came about as the result of a visit to the studio of Piet Mondrian in Paris in 1930.

I was particularly impressed by some rectangles of color he had tacked on his wall in a pattern after his nature.

I told him I would like to make them oscillate—he objected. I went home and tried to paint abstractly—but in two weeks I was back again among plastic materials.

I think that at that time and practically ever since, the underlying sense of form in my work has been the system of the Universe, or part

thereof. For that is a rather large model to work from.

What I mean is that the idea of detached bodies floating in space, of different sizes and densities, perhaps of different colors and temperatures, and surrounded and interlarded with wisps of gaseous condition, and some at rest, while others move in peculiar manners, seems to me the ideal source of form.

I would have them deployed, some nearer together and some at immense distances.

And great disparity among all the qualities of these bodies, and their motions as well.

A very exciting moment for me was at the plantarium—when the machine was run fast for the purpose of explaining its operation: a planet moved along a straight line, then suddenly made a complete loop of 360 degrees off to one side, and then went off in a straight line in its original direction.

I have chiefly limited myself to the use of black and white as being the most disparate colors. Red is the color most opposed to both of these—and then, finally, the other primaries. The secondary colors and intermediate shades serve only to confuse and muddle the distinctness and clarity.

When I have used spheres and discs, I have intended that they should represent more than what they just are. More or less as the earth is a sphere, but also has some miles of gas about it, volcanoes upon it, and the moon making circles around it, and as the sun is a sphere—but also is a source of intense heat, the effect of which is felt at great distances. A ball of wood or a disc of metal is rather a dull object without this sense of something emanating from it.

174

When I use two circles of wire intersecting at right angles, this to me is a sphere—and when I use two or more sheets of metal cut into shapes and mounted at angles to each other, I feel that there is a solid form, perhaps concave, perhaps convex, filling in the dihedral angles between them. I do not have a definite idea of what this would be like, I merely sense it and occupy myself with the shapes one actually sees.

Then there is the idea of an object floating—not supported—the use of a very long thread, or a long arm in cantilever as a means of support seems to best approximate this freedom from the earth.

Thus what I produce is not precisely what I have in mind—but a sort of sketch, a man-made approximation.

That others grasp what I have in mind seems unessential, at least as long as they have something else in theirs.

ALEXANDER CALDER
"What Abstract Art Means to Me," 1951

With the same boldness and utter self-confidence displayed in her work, the American sculptor Louise Nevelson lives with single-minded devotion to her ideals. As Nevelson explains in an autobiographical sketch written in 1971, she felt her calling as an artist at an early age and has spent the rest of her life fighting to fulfill it.

My life had a blueprint from the beginning, and that is the reason that I don't need to make blueprints or drawings for my sculpture. What I am saying is that I did not become anything, I was an artist. Early in school, they called me "the artist." When teachers wanted things painted, they called upon me, they called upon "the artist." I am not saying that I learned my name—animals can learn their names—I am saying that they learned it.

Humans are born from eggs and the shells make these eggs. We are born ready-made. People always ask children: What are you going to be when you grow up? I remember going to the library, I couldn't have been more than nine. I went with another little girl to get a book. The librarian was a fairly cultivated woman, and she asked my little girl friend, "Blanche, and what are you going to be?" And Blanche said that she was going to be a bookkeeper. There was a big plaster Joan of Arc in the center of the library, and I looked at it. Sometimes I would be frightened of things I said because they seemed so automatic. The librarian asked me what I was going to be, and, of course, I said, "I'm going to be an artist." "No," I added, "I want to be a sculptor, I don't want color to help me." I got so frightened, I ran home crying. How did I know that when I never thought of it before in all my life? I was only following the blueprint for my life. Then, as I matured, I was restless; I needed something to engage me, and art was that something. I knew I was a creative person from the first minute I opened my eyes. I knew it, and they treated me like an artist all of my early life. And

I knew I was coming to New York when I was a baby. What was I going to do anywhere but New York? Consequently, as a little girl, I never made strong connections in Rockland, because I was leaving. I told my mother I wasn't going to get married or be tied down. I planned to go to Pratt Art Institute so I could teach and support myself. Well, I did get married, and when I met my husband, I think I willed myself on him because I knew that he was going to propose.

Marriage was the only complication in my life. In retrospect, it was simple. My environment didn't suit me. I knew where my talents were and where I had to go. My energy, curiosity, and talent went in search of experience. It was the wrong experience for me. I learned that marriage wasn't the romance that I sought but a partnership, and I didn't need a partner. Anyway, I was married and we moved to New York. . . .

No obstacle was great enough to keep me from my art. But people always stay where they shine and are happy. In Maine, and at the Art Students League in New York, and then in Munich with [Hans] Hofmann, they all give me 100 plus. . . . You take a painting, you have a white, virginal piece of canvas that is the world of purity, and then you put your imagery on it, and you try to bring it back to the original purity. What can be greater? It is almost frightening. Well, the same thing happens with my sculpture. I have made a wall. You know that before I tune into this I go through a whole tantrum until I break in. I don't know how I have lived this long being such a wreck over these things. But I renew myself every time. I never got over it, and I imagine that if I hadn't done this physical attacking, I don't know how I would have survived. I mean, I think the thing that kept me going was that I wouldn't be appeased. You know some people get appeased, or they buy a dress or they buy a hat or, I don't know, they get something. But I couldn't be appeased.

I went to art school, and yet one only benefits from notes here and there. Creativity shaped my life. Now, for example, a white lace curtain on the window was for me as important as a great work of art. This gossamer quality, the reflection, the form, the movement, I learned more about art from that than in school. I can sit in this room ten years and just look up and feel I've seen miracles. The building across the street is a school-supply warehouse. That may be its practical function, but it has a different one for me. I see reflections, I see lights off, and once in a while lights are left on. In those windows the reflections I see are monumental, enormous, and every minute it changes with different light, the activity is endless. . . .

I feel that my works are definitely feminine. There is something about the feminine mentality that can rise to heaven. The feminine mind is positive and not the same as a man's. I think there is something feminine about the way I work. Today, I was working on small things in my living room. The reason I wasn't working downstairs in the big studio is because I've used up all of my large forms. The creative concept has no sex or is perhaps feminine in nature. The means one uses to

convey these conceptions reveal oneself. A man simply couldn't use the means of, say, fingerwork to produce my small pieces. They are like needlework.

I have always felt feminine . . . very feminine, so feminine that I wouldn't wear slacks. I didn't like the thought, so I never did wear them. I have retained this stubborn edge. Men don't work this way, they become too affixed, too involved with the craft or technique. They wouldn't putter, so to speak, as I do with these things. The dips and cracks and detail fascinate me. My work is delicate; it may look strong, but it is delicate. True strength is delicate. My whole life is in it, and my whole life is feminine, and I work from an entirely different point of view. My work is the creation of a feminine mind—there is no doubt. What I wear every day and how I comb my hair all has something to do with it. The way you live a life. And in my particular case, there was never a time that I ever wanted to be anything else. I was interested in being myself. And that is feminine. I am not very modest, I always say I built an empire.

. . . When I was young, if the Rockefeller wealth had been put at my disposal and someone had said, here, you can have a different job every day and have pearls from your neck down to your feet, I wouldn't have changed. There's all kinds of money, the banks are full of it, why should I be impressed. I was energetic and healthy, and I didn't care if I only had a piece of bread and butter and cheese to eat. We make our own decisions according to that blueprint. Women used to be afraid. I've met many of the women I studied art with; one of them said to me, "I am married and have three children. I was not willing to gamble." Well I wasn't afraid, I felt like a winner. And even if I didn't sell my work, I still felt like a winner. I am a winner.

In the end, as you get older and older, your life is your life and you are alone with it. You are alone with it, and I don't think that the outside world is needed. It doesn't have much influence on me, as an artist, or on us as individuals, because one cannot be divorced from the other. It is the total life. Mine is a total life.

LOUISE NEVELSON
An autobiographical statement, 1971

In a workshop named the Terminal Iron Works, and using tools and materials more commonly associated with a machine shop than an artist's studio, David Smith crafted a series of iron and steel structures that are recognized as landmark achievements in the development of modern sculpture. Among the great sculptors of this era, Smith revealed himself to be an intrinsically American figure. A man of obvious talent and erudition, he functioned with equal success in the academic settings where he taught art and in the small upstate New York village of Bolton Landing where he made his home. In 1968, three years after Smith's death in a truck accident, the art critic Clive Gray

published a collection of Smith's writings that adds immeasurably to our understanding of the man and the sculptor. In the following selection Smith describes his typical workday.

My work day begins at 10:00 or 11:00 A.M. after a leisurely breakfast and an hour of reading. The shop is 800 ft. from the house. I carry my 2:00 P.M. lunch and return to the house at 7:00 for dinner. The workday ends from 1:00 to 2:00 A.M., with time out for coffee at 11:30. My shop here is called the Terminal Iron Works, since it closer defines my beginning and my method than to call it "studio."

At 11:30, when I have evening coffee and listen to WQXR on AM, I never fail to think of the Terminal Iron Works at 1 Atlantic Ave., Brooklyn, and the coffee pot nearby, where I went same time, same station. The ironworks in Brooklyn was surrounded by all-night activity —ships loading—barges refueling—ferries tied up at the dock. It was awake twenty-four hours a day, harbor activity in front, truck transports on Furman St. behind. In contrast, the mountains are quiet except for occasional animal noises. Sometimes Streevers' hounds run foxes all night, and I can hear them baying as I close up shop. Rarely does a car pass at night, there is no habitation between our road and the Schroon River four miles cross-country. I enjoy the phenomenon of nature, the sounds, the northern lights, stars, animal calls, as I did the harbour lights, tugboat whistles, buoy clanks, the yelling of men on barges around the T.I.W. in Brooklyn. I sit up here and dream of the city as I used to dream of the mountains when I sat on the dock in Brooklyn.

I like my solitude, black coffee and daydreams. I like the changes of nature, no two days or nights are the same. In Brooklyn what was nature was all man-made and mechanical, but I like both; I like the companionship of music—I sometimes can get WNYC but always WQXR, Montreal, Vancouver or Toronto. I use the music as company in the manual labor part of sculpture of which there is much. The work flow of energy demanded by sculpture, wherein mental exhaustion is accompanied by physical exhaustion, provides the only balance I've ever found, and as far as I know is the only way of life.

After 1:00 A.M., certain routine work has to be done—cleaning up, repairing machines, oiling, patining, etc. I tune in WOR and listen to Nick's, Cafe Society, Eddie Condon's, whoever is on. After several months of good work, when I feel I deserve a reward, I go to N.Y., to concerts at the YMHA, gallery shows, museums, eat seafood, Chinese, go to Eddie's, Nick's, Sixth Ave. Cafeteria, Artists Club, Cedar Tavern, run into late-up artists, bum around chewing the fat, talk shop, finish up eating breakfast on Eighth St. and ride it as hard and as long as I can for a few days, then back to the hills. . . .

When I begin a sculpture I am not always sure how it is going to end. In a way it has a relationship to the work before, it is in continuity to the previous work—it often holds a promise or a gesture toward the one to follow.

David Smith,
Medals for Dishonor, *c. 1940*

I do not often follow its path from a previously conceived drawing. If I have a strong feeling about its start, I do not need to know its end, the battle for solution is the most important. If the end of the work seems too complete and final, posing no question, I am apt to work back from the end, that in its finality it poses a question and not a solution. Sometimes when I start a sculpture, I begin with only a realized part, the rest is travel to be unfolded much in the order of a dream. The conflict for realization is what makes art not its certainty, nor its technique or material. I do not look for total success. If a part is successful, the rest clumsy or incomplete, I can still call it finished, if I've said anything new by finding any relationship which I might call an origin. I will not change an error if it feels right, for the error is more human than perfection.

When it [the sculpture] is finished there is always that time when I am not sure—it is not that I am not sure of my work, but I have to keep it around for months to become acquainted with it, and sometimes it is as if I've never seen it before, and as I work on other pieces and look at it, all the kinship returns, the battle of arriving, its relationship to the preceding work and its relationship to the new piece I am working on. Now comes the time when I feel very sure of it, that it is as it must be and I am ready to show it to others and be proud I made it.

DAVID SMITH
Autobiographical statement, 1968

A Chronology of Sculpture

Sculpture	Date	Historical Context
Paleolithic cave art flourishes in southwestern Europe; first sculptural artifacts appear in the form of elaborately carved tools and small stone "Venus" figurines	32,000–10,000 B.C.	Age of the Upper Paleolithic big-game hunter; Cro-Magnon man evolves in Europe; man reaches the Americas via the Bering Strait land bridge
Neolithic artists produce clay fertility statuettes and carve bas-reliefs of animals on temple walls; the first cylinder seals are made in Mesopotamia	10,000–4,000	The domestication of plants and animals in the Fertile Crescent heralds the Neolithic Revolution; farming communities spring up in the Nile valley
Simplistic fertility figurines establish the basic patterns of Egyptian sculpture	4000–3000	Cultivation of corn in Tehuacán valley leads to rapid expansion of Mesoamerican cultures
The earliest Mesopotamian commemorative stelae and inlaid worshiper statuettes are produced; Egyptian *Narmer Palette* is the first sculpture with a historical subject	3500–3000	Protoliterate period in Mesopotamia; rise of the first city-states; writing invented; Egyptian cultures, stimulated by Mesopotamian influences, enter Protodynastic period
	3000–2340	Classical Sumarian Age
Great Sphinx and the pyramids and temples at Giza are erected; a new naturalism appears in such works as the Mesopotamian victory stele of Naram-Sin and the Egyptian *Seated Scribe*	2680–2150	Period of the Old Kingdom in Egypt; first pyramid texts appear; Akkadians under Sargon the Great rise to power
Pharaonic portrait statues and Neo-Sumerian votive figures are produced; Babylonian artists carve the *Stele of Laws* bearing Hammurabi's famous judicial code; Minoan sculptors model snake priestess figurines and carve intricate designs on steatite	2130–1600	Second Intermediate Period in Egypt; third Ur dynasty ushers in a vast revival of Sumerian culture; rise of the Babylonian state under Hammurabi the Great
Kassites introduce the *Kudurru*, or boundary stone	1600–1150	Kassites rule in Babylon
Egyptian reliefs use perspective for the first time; colossal statues of the last pharaohs are erected	1570–1085	Rise of the Egyptian New Kingdom and empire brings widespread foreign contact
Mortuary masks and repoussé cups are crafted in gold by Mycenaean artists; Shang dynasty sculptors carve bronze ritual vessels and jade figurines	1550–1100	Late Helladic period in Greece marked by the dispersion of Mycenaean culture; Shang dynasty rules in China
Greek Geometric sculptors create a profusion of bronze animal figurines; in the Ohio valley, Adena-Hopewell Indians work copper into ornaments and produce massive burial mounds	1000	Iron Age begins in Greece; Adena-Hopewell Mound Builders develop a flourishing culture
Assyrian *lamassu* and martial wall reliefs embellish Mesopotamian temple complexes	935–612	The city-state of Assur becomes a dominant political force in northern Mesopotamia
Massive Olmec stone heads carved at La Venta in southeast Mexico	800–400	Preclassical Period in Mesoamerica
The Doric temple and the first Greek *kouros* emerge; Etruscans fashion funerary sculptures from clay, terra-cotta, and bronze	700–500	Beginning of Archaic period in Greece; Etruscan civilization flourishes in Italy
Greeks discover the process of hollow bronze casting; Siphnian Treasury frieze shows the fully developed Archaic style	525	Samians conquer the island of Siphnos
Kritios Boy is modeled for the Athenian Acropolis	509	Roman Republic is founded
Pediment groups and reliefs are sculpted for the Olympian Temple of Zeus; Polykleitos achieves the athletic ideal in his *Spear Bearer*; he writes "The Canon"	480–50 460–51	Early Greek Classical period
Phidias supervises the sculptural decoration of the Parthenon; completion of freize, metopes, and pediment groups mark the culmination of the Greek Classical style	450–400 447–31	Greek Classical period
Marble Victories are carved for the Temple of Athena Nike	431–04 410–407	The Great Peloponnesian War
Praxiteles, Scopas, and Lysippus develop the refined style of the pre-Hellenic period; the imperial Mauryan sculptural style emerges in India, carved *yakshas* and *yakshis* representing its secular style	350–300	Dispersal of Hellenism through the conquests of Alexander the Great; the decline of the golden age of Greece; Maurya dynasty brings the first flowering of native Indian civilization
Rhodian sculptors model the *Laocoön* group and the *Victory of Samothrace*	300–200	Early Classic Period in Mesoamerica; Rome conquers Etruria

Altar of Zeus is erected at Pergamum; narrative reliefs on the *stupa* at Bharhut recount episodes from the life of Buddha; plundering and diffusion of Greek art forms results in the hybrid Greco-Roman tradition; first Roman Republican portraits and narrative reliefs appear	200-100	Hellenism spreads to Asia Minor; Greece becomes a Roman province; Maurya dynasty gives way to the Shunga of north-central India
	44	Julius Caesar is assassinated
Portrait statue of Augustus from Prima Porta, commissioned by the emperor, marks the emergence of a distinctive Roman art style; creation of the *Gemma Augustae*, an elaborate cameo	27 B.C.- A.D. 14	Reign of Augustus Caesar, Rome's first emperor
	4	Birth of Jesus of Nazareth
Gateways of the great *stupa* at Sanchi are carved with anthropomorphic representations of Buddha	A.D. 50	
Kushana school develops the first humanized Buddha images at Mathura and Gandhara	78	Nomadic Kushana Tartars form a dynasty in northern India
Relief from the Arch of Titus depicts the Roman victory over Jerusalem in A.D. 70	81	Death of Titus; Domitian succeeds him
The Column of Trajan, erected in Rome, is the first such triumphal column ever constructed	116	Death of Roman emperor Trajan; he is succeeded by Hadrian
Romantic elements begin to modify the classical Roman style; column of Marcus Aurelius marks transformation to the Late Antique period	180-92	Reign of Emperor Commodus marks the end of the Antonine era
Disintegration of traditional Roman sculptural forms; Badminton sarcophagus and portrait of Trebonianus Gallus are produced	220-323	Roman civilization declines with the emergence of a new spiritualism; Constantine reunites the Roman Empire and becomes the first emperor to embrace Christianity
Arch of Constantine recapitulates the entire history of Roman sculpture	312-315	
Hindu Gupta artists develop the first "international style" of Buddhist art, one that standardizes the form of Buddha's image	320-480	Chandragupta I unites northern India and inaugurates the classical age of Indian art
	330	The first Christian basilicas are built in Rome
Early Christian sculptures depict themes from the Old Testament; Theodoric commissions the sculptural projects in Ravenna	400-550	
	476	Traditional date of the collapse of the Western Roman Empire
Longobard goldsmiths' art flourishes; temple sculptures at Teotihuacán depict rain gods and plumed serpents; Shiva and Vishnu images emerge in central India; earliest Buddhist images introduced to Japan	550-750	
	552-645	Asuka period in Japan
Colossal bronze Buddha, carved for Todai-ji in Nara, marks the apogee of Buddhist art in Japan	710-84	Tempyo (Nara) period in Japan
	726	Emperor Leo III issues edict prohibiting religious images
Carolingian sculptors model an equestrian statue in the likeness of Charlemagne	800	Charlemagne is crowned Holy Roman Emperor, marking the revival of the empire in the West
Byzantine sculpture flourishes; Indian art forms reach Indonesia: great *stupa* of Borobudur is erected in Java; Angkor Thom and Angkor Wat rise in Cambodia	843-900	Treaty of Verdun divides the Carolingian empire; Leo III's edict is reversed; Cambodia is united under the rule of Jayavarman II; Yasovarman I establishes the capital at Angkor
Bishop Bernward establishes workshops for bronze casting at Hildesheim; he commissions the Easter Column and doors for the Church of St. Michael	1015	
Jocho carves the statue of Amitabha for Phoenix Hall near Kyoto; the joined wood-block technique is perfected in Japan	1053	Fujiwara clan reaches the height of its power in Japan
King Ferdinand of Spain commissions an ivory cross as a gift to a Léon church; it depicts the Last Judgment, the dominant theme in Romanesque sculpture	1054	Death of Leo IX, who restored the spiritual primacy of the Holy See
A tympanum depicting the Mission of the Apostles is carved for the church at Vézeley	1120-32	
Romanesque sculptural tradition flourishes in Burgundy; Giselbertus carves the Temptation scene for Autun Cathedral	1130	Schism in the Church is precipitated by the corrupt election of Antipope Anacletus II

The first Ife bronzes appear, including naturalistic portrait heads cast by the lost-wax process	1150-1400	
Miniature liturgical objects are crafted in France; Nicholas of Verdun produces tiny Mosan figurines for the Shrine of the Magi; figures for the Royal Portal of Chartres Cathedral completed	1170-1200	
Benedetto Antelami designs a relief for Parma Cathedral depicting the Descent from the Cross	1178	
Japanese Kei school develops a naturalistic sculptural style that is manifested in the works of Unkei and Kaikei	1185-1333	Kamakura period in Japan, during which contact with China is reestablished after a period of complete cultural isolation
Annunciation and *Visitation* groups for Reims Cathedral are completed; *Synagogue* figure is carved for Strasbourg Cathedral	1245	
Choir statues of Naumburg Church founders Ekkehard and Uta represent mature Gothic sculpture in Germany; Nicola and Giovanni Pisano complete work on the Pisa Baptistery pulpit	1250-60	
Giovanni Pisano creates his *Madonna and Child* for the high altar of Pisa Cathedral	1314	King Louis IV of Bavaria becomes Holy Roman Emperor; death of Pope Clement V
Veronese sculptors design the equestrian statue of Can Grande della Scala	1330	Louis IV returns from Italy, where a "lay coronation" has validated his claim as emperor
Andrea Pisano depicts scenes from the life of John the Baptist in quatrefoil reliefs for the doors of Florence Baptistery	1348	The Black Death decimates one third of the population of Europe
	1378	Great Schism in the Church results in the division of papal authority between Rome and Avignon
Dutch sculptor Claus Sluter designs *The Moses Well* for the Chartreuse of Champmol; it represents the culmination of medieval sculpture in the International Gothic style	1395-1406	
Early Renaissance style emerges; Lorenzo Ghiberti's design for Florence Baptistery doors wins the Wool Merchants' Guild competition	1401	
Decorative work on the Or San Michele begins; Nanni de Banco produces his *Four Saints* for the Stone and Woodcutters' Guild	1410	Luxembourg King Sigismund is crowned Holy Roman Emperor; he attempts to reunite Church at the Council of Constance
Donatello completes *St. George* for the Or San Michele	1417	
Donatello models the prophets for the campanile of the Duomo	1428	King James of Scotland institutes vigorous reforms and founds St. Andrew's University
Donatello blends naturalism and classicism in the magnificent bronze *David* commissioned by the Medici family; Luca della Robbia invents a method for coating reliefs with enamel-like glazes; he executes a magnificent marble *Cantoria* for Florence Cathedral	1430-35	Jeanne d'Arc is captured by Burgundians at Compiègne; she is later found guilty of witchcraft and burned alive by the English at Rouen
Donatello completes his *Cantoria* for the Duomo and revives the equestrian tradition with his statue of Gattamelata	1450	Nicholas V founds the Vatican Library
Renaissance artists experiment with atmospheric perspective; Ghiberti completes the *Gates of Paradise* for Florence Baptistery	1452	Domination of Florence by the Medici; Frederick III crowned emperor
Andrea del Verrocchio creates his most endearing work, *Putto with Dolphin*, for a Medici villa	1470	King Edward IV of England flees to Flanders, only to be restored to the throne by the Duke of Warwick
Verrocchio completes his version of David and an equestrian monument of Bartolommeo Colleoni	1488	The Portuguese establish coastal trading stations in Africa; King James III of Scotland is murdered by rebellious nobles
The Medici subsidize Michelangelo; two years later they fall from power and the sculptor flees to Bologna, where he is influenced by the works of della Quercia	1492	Fall of Granada marks the end of Islamic influence in Spain; Christopher Columbus makes the first of four voyages to the New World
Ife bronze-casting techniques matched by Benin as Bini court artists produce stylized portrait heads, relief plaques, and exquisite ivorywork	1500	
Michelangelo completes the Vatican *Pietà* and travels to Florence two years later to execute the renowned *David*	1501	

Selected Bibliography

Aldred, Cyril. *The Development of Egyptian Art*. London: Tiranti Ltd., 1965.

Anton, Ferdinand, and Dockstader, F.J. *Precolumbian Art and Later Indian Tribal Arts*. New York: Harry N. Abrams, Inc. Publishers, 1968.

Bianchi Bandinelli, Ranuccio. *Rome: The Center of Power*. New York: George Braziller, Inc., 1970.

Blunt, Anthony. *Art and Architecture in France: 1500 to 1700*. 2nd ed. Baltimore: Penguin Books, 1970.

Childe, V. Gordon. *The Dawn of European Civilization*. New York: New York University Press, 1956.

De Tolnay, Charles. *Michelangelo*. 5 vols. Princeton, N.J.: Princeton University Press, 1943–60.

Evans, Joan. *Art in Medieval France: 987–1498*. New York: Oxford University Press, 1969.

Frankfort, Henri. *The Art and Architecture of the Ancient Orient*. Baltimore: Pelican Books, 1970.

Giedion-Welcker, Carola. *Contemporary Sculpture*. New York: George Wittenborn, Inc., 1955.

Godfrey, F.M. *Italian Sculpture, 1250–1700*. New York: Taplinger Publishing Company, Inc., 1967.

Hibbard, Howard. *Bernini*. Baltimore, Penguin Books, 1968.

Janson, H.W. *The Sculpture of Donatello*. 2 vols. Princeton, N.J.: Princeton University Press, 1972.

Kähler, Heinz. *The Art of Rome and Her Empire*. New York: Crown Publishers, 1963.

Kalnein, Wend Graf and Levey, Michael. *Art and Architecture of the Eighteenth Century in France*. Harmondsworth, England: Penguin Books Ltd., 1972.

Keutner, Herbert. *Sculpture: Renaissance to Rococo*. Greenwich, Conn.: New York Graphic Society, 1969.

Krautheimer, R. *Lorenzo Ghiberti*. Princeton, N.J.: Princeton University Press, 1956.

Launde, Jean. *The Arts of Black Africa*. Berkeley, Calif.; University of California Press, 1973.

Lee. Sherman. *A History of Far Eastern Art*. New York: Harry N. Abrams, Inc., 1962.

Lullies, Reinhard. *Greek Sculpture*. New York: Harry N. Abrams, Inc., 1962.

Licht, Fred. *Sculpture: Nineteenth and Twentieth Century*. Greenwich, Conn.: New York Graphic Society, 1967.

Matz, Friedrich. *The Art of Crete and Early Greece*. New York: Crown Publishers, 1963.

Moortgat, Anton. *The Art of Ancient Mesopotamia*. London: Phaidon Press Ltd., 1969.

Morey, C.R. *Medieval Art*. New York: W.W. Norton & Co., Inc., 1942.

Paine, Robert Treat and Soper, Alexander. *The Art and Architecture of Japan*. 2nd ed. Baltimore: Penguin Books, 1974.

Pope-Hennessy, John. *Introduction to Italian Sculpture*. London: Phaidon Press Ltd., 1055–62.

————*Italian High Renaissance and Baroque Sculpture*. London: Phaidon Press Ltd., 1963.

Powell, T.G.E. *Prehistoric Art*. New York: Praeger Publishers, Inc 1966.

Richter, G.M.A. *The Sculpture and Sculptors of the Greeks*. New Haven, Conn.: Yale University Press, 1970.

Rontand, Benjamin. *The Art and Architecture of India*. 3rd ed. Baltimore: Penguin Books, 1967.

Sauerlander, Willibald. *Gothic Sculpture in France: 1140–1270* New York: Harry N. Abrams, Inc., 1973.

Selz, Jean. *Modern Sculpture*. New York: George Braziller, Inc., 1963.

Seuphor, Michel. *The Sculpture of This Century*. New York: George Braziller, Inc., 1960.

Seymour, Charles, Jr. *Sculpture in Italy, 1400–1500*. Baltimore: Penguin Books, 1968.

Picture Credits

The Editors would like to thank the following individuals and organizations for their assistance:

Museum of Fine Arts, Boston—Elaine Zetes
Museum of Modern Art, New York—Mikki Carpenter
Museum of Primitive Art, New York—Elisabeth Little
Barbara Nagelsmith, Paris

The following abbreviations are used:
(G) —(Giraudon)
MFAB —Museum of Fine Arts, Boston
MMA —Metropolitan Museum of Art
MOMA—Museum of Modern Art, New York
MPA —Museum of Primitive Art, New York
NMF —National Museum, Florence
(S) —(Scala)

HALFTITLE: Symbol by Jay J. Smith Studio FRONTISPIECE: Duomo, Florence (S)

CHAPTER 1 **6** Natural Historical Museum, Madrid (Oronoz) **8** top (Fiore); bottom St. Germain-en-Laye, Paris (Bevilacqua) **9** St. Germain-en-Laye, Paris (Lauros-G) **10** top MPA (Uht); bottom (Tony Linck) **11** MPA (Little) **12** left Regional Museum of Jalapa (Groth); right National Archeological Museum, Mexico City (Groth) **13** left (Groth); right (Teuscher) **14** Both: National Archeological Museum, Mexico City **15** left National Archeological Museum, Mexico City (Groth); right: British Museum **16** Both: MPA (Uht) **17** top MPA (Little); bottom MPA (Uht) **18** left MPA (Uht); right MPA (Little) **19** MPA (Little) **20** Both: MPA (Uht) **21** top MPA (Uht); bottom Musée de l'Homme, Paris

CHAPTER 2 **22** Archeological Museum, Baghdad (Fiore) **24** MMA, Fletcher Fund, 1940 **25** top Louvre; bottom MMA, Harris Brisbane Dick Fund, 1959 **26** Louvre **27** top Pierpont Morgan Library; bottom British Museum **28** MMA, Gift of John D. Rockefeller, 1932 **29** Egyptian Museum, Cairo **30** Egyptian Museum, Cairo **30–31** (TWA) **31** top Louvre (G); bottom Egyptian Museum, Cairo **32** William Rockhill Nelson Gallery, Kansas City **33–35** Egyptian Museum, Cairo **36** (Newsweek Archives) **37** left Heraclion Museum (S); right Heraclion Museum (Bevilacqua) **38** (S) **39** top National Museum, Athens; bottom National Museum, Athens (S)

CHAPTER 3 **40** MFAB, Hoyt, Gould & Willard Funds **42** left MFAB, Ross Collection; right (Fiore) **43** MFAB, Ross Collection **44** (Roger-Viollet) **45** top MMA, Rogers Fund, 1917; left MFAB, McLeod Fund; right MFAB, Ross Collection **46** Kodansha **47** top (Newsweek Archives); bottom Musée Cernuschi, Paris **48** top William Rockhill Nelson Gallery, Kansas City bottom Musée Guimet, Paris **49** left William Rockhill Nelson Gallery, Kansas City; right MFAB, Wetzel Fund **50–51** National Museum, Tokyo **51** (Pan American) **52** MFAB **53** Byodo-in, Kyoto

CHAPTER 4 **54** National Museum, Athens **56** top MMA, Rogers Fund, 1921; bottom MMA, Fletcher Fund 1932 **57** top National Museum, Athens (G); bottom, Acropolis Museum, Athens **58** Vatican Museum (S) **58–59** Delphi Museum (Boudot-Lamotte) **59** Corfu Museum (Boudot-Lamotte) **60** Both: British Museum **61** (Archivio B) **62–63** Louvre **63** Staatliche Museum, Berlin (Boudot-Lamotte) **65** Louvre (Bevilacqua) **66** left Archeological Museum, Florence (S); right Villa di Pape Giulio, Rome **67** top Villa Giulia, Rome (S); left MMA, Rogers Fund, 1917; right Vatican (Boudot-Lamotte) **68** Kunsthistorisches Museum, Vienna **68–69** (S) **69** (Anderson) **70** top MMA, Pulitzer Bequest, 1955; bottom Museo dei Conservatori, Rome, (Alinari) **71** top MMA, Rogers Fund, 1905; bottom (Alinari)

CHAPTER 5 **72** Vatican (S) **74** left Archeological Museum, Cividale Friuli (S); right Bibliothèque Nationale, Paris **75** left Musée Archiepiscopal, Ravenna; right National Archaeological Museum, Madrid **76** Louvre (G) **77** Cathedral Treasury, Hildesheim **78** Cathedral Treasury, Conques (G) **79** Musée des Augustins, Toulouse **80** top Rolin Museum, St. Lazare (S); bottom Cluny Museum, Paris (G) **81** (S) **82** (S) **82–83** Notre-Dame, Paris **83** Cathedral Treasury, Cologne **84** (S) **85** top Strasbourg Cathedral (G); bottom Naumbourg Cathedral (Roger-Viollet) **86** Duomo, Parma (S) **87** top Duomo, Parma (S) left Duomo, Florence (S); right Baptistry, Pisa (S) **88** Castelvecchio Museum, Verona (S) **89** left Duomo, Pisa; right Chartreuse de Champmol, Dijon (Lauros-G)

CHAPTER 6 **90** Baptistry, Florence (S) **92–93** All: Baptistry, Florence (S) **94** San Michele, Florence (S) **95** top and bottom NMF (S); right Duomo, Bologna (S) **96** NMF (Alinari) **97** top NMF (S) bottom Baptistry, Florence (S) **98–99** Both: Duomo, Florence (S) **100** Both: NMF (S) **101** NMF (S) **102** NMF (S) **103** top (Fiore); left & right (S) **104** (S) **106** Vatican (S) **107** Accademia, Florence (S) **108** St. Peter's, Rome (S) **109** Accademia, Florence (S) **110-111** All: Sacristry, Florence (S) **112** Kunsthistorisches Museum, Vienna (Mella) **113** top Loggia dei Lanzi, Florence (S); bottom (Archivio B)

CHAPTER 7 **114** St. Peter's, Rome (S) **116** top Borghese Gallery, Rome (S); bottom St. Peter's, Rome **117** Piazza Navona, Rome **118** Sta. Maria della Vittoria, Rome (S) **119** top Sta. Maria di Loreta, Rome; bottom St. Peter's, Rome **21** Rohn Cathedral (S) **122** left Sorbonne Chapel, Paris (G); right St. Thomas Church, Strasbourg (Lauros-G) **123** top (S); bottom (Lauros-G) **124** left National Museum, Florence (S); right Bibliothèque Nationale, Paris (G) **125** top Louvre (G); bottom (Archives Photographiques, Paris) **126** (S) **127** top Staatliche Museum, Berlin; bottom Victoria and Albert Museum, London.

CHAPTER 8 **128** (Fiore) **130** left Louvre (S); right Hermitage, Leningrad **131** Hirshhorn Museum (Veltri) **132** top Rodin Museum, Paris; bottom Rodin Museum, Paris (Bulloz) **133** left Rodin Museum, Paris (G); right MOMA, Gift of B.G. Cantor Art Foundation **134** top left National Gallery of Modern Art, Venice; top right National Gallery of Modern Art, Rome; bottom Tate Gallery, London **135** MOMA, Mrs. Simon Guggenheim Fund **136** MOMA, Gift of Louise Smith **136–137** MOMA **137** left Philadelphia Museum of Art, Arensberg Collection; right Peggy Guggenheim Museum, Venice **138** top Private Collection (G); bottom left and right MOMA **139** top Leiris Gallery, Paris; bottom left Tate Gallery, London; bottom right MOMA **140** Private Collection, Milan (S) **141** Both: MOMA **142** Tate Gallery, London **143** left MOMA; center National Museum of Modern Art, Paris; right National Museum of Modern Art, Paris (S) **144** top Tate Gallery, London; bottom (S) **144–145** Unesco, Paris (S) **145** (Fiore) **146** Solomon R. Guggenheim Museum **147** top MOMA; bottom Hirshhorn Museum, Washington **148** top Foundation, Zurich (Lauros-G); center Kunsthaus, Zurich (Lauros-G); bottom MOMA **149** MOMA, Mrs. S. Guggenheim Fund **150** top MOMA; bottom MOMA, Mr. and Mrs. Ben Mildwoff **151** top MOMA, Janis Collection; bottom MOMA

SCULPTORS ON SCULPTURE **152** Petit-Palais, Paris (Josse) **155–179** All: MOMA **155** Mr. and Mrs. Patrick Dinehart **157** Saidie May **158** Abby Aldrich Rockefeller **160** Anonymous gift **164** Philip L. Goodwin **167** Victor S. Riesenfeld **169–170** School Prints, Ltd., London **171** Purchase **173** Gift of the Artist **174** Mr. and Mrs. Peter A. Rubel **179** Gift of Lura Bean in memory of Louise Stevens Bryant

Index